home,

exile,

homeland

Previously published in the *AFI Film Readers* Series
edited by Charles Wolfe and Edward Branigan

Psychoanalysis and Cinema
E. Ann Kaplan

Fabrications
Jane M. Gaines and Charlotte Herzog

Sound Theory/Sound Practice
Rick Altman

Film Theory Goes to the Movies
Jim Collins, Ava Preacher Collins, and Hilary Radner

Theorizing Documentary
Michael Renov

Black American Cinema
Manthia Diawara

Disney Discourse
Eric Smoodin

Classical Hollywood Comedy
Henry Jenkins and Kristine Brunovska Karnick

The Persistence of History
Vivian Sobchack

The Revolution Wasn't Televised
Lynn Spigel and Michael Curtin

Black Women Film and Video Artists
Jacqueline Bobo

home,

exile,

homeland

film, media, and the

politics of place

e d i t e d b y

hamid naficy

routledge
new york and london

Published in 1999 by

Routledge
29 West 35th Street
New York, NY 10001

Published in Great Britain by

Routledge
11 New Fetter Lane
London EC4P 4EE

Copyright © 1999 by Routledge

Printed in the United States of America
Typography: Jack Donner

Library of Congress Cataloging-in-Publication Data

home, exile, homeland : film, media, and the politics of place / edited by Hamid
 Naficy.
 p. cm. — (AFI film readers)
 Includes bibliographical references and index.
 ISBN 0–415–91946–0 (alk. paper).—ISBN 0–415–91947–9 (pbk.: alk. paper)
 1. Motion pictures—Philosophy. 2. Motion pictures—Social aspects.
 3. Immigrants. 4. Exiles. 5. Motion pictures—United States—Foreign influences.
 I. Naficy, Hamid. II. Series.
 PN 1995.H65 1999
 791.43'01'5 — dc20 98 – 5993
 CIP

contents

part four: mediated collective formations

preface

arrivals and departures

homi k. bhabha

As we envision the "postmodern" imperium of a global media cul-
ture—CNN, MTV, perhaps even the less formal "public spheres" of
the CMCs (computer mediated communications)—we are caught at
the cusp of an electronic ethical dilemma. For sure, we recognize the
difference between, on the one hand, the "new communitarians"
benignly homesteading on the 'Net, sharing herbal remedies and eco-
logical *apperçus,* and, on the other, ferocious neo-colonialists like the
Australian Rupert Murdoch and the Canadian Lord Thompson, who,
you might say, represent the belated revenge of settler-colonial-late-
capitalism upon the rest of the world. Part of us willingly grabs the
"virtual" glove, while the other side contemplates the withered hand
within. It is tempting to believe, in the midst of the instantaneous gar-
rulousness of all this wonderful gadgetry (even if its accessibility is
severely contained by class, geopolitics, literacy, and the gendered con-
ventions of everyday life and labor) that we are at the dawn of the digi-

tal diaspora. It is easy to forget, in the electronic "international" play between modems, workstations, and homepages, that, as the *New York Times* recently reported, the rate of homelessness of migrant workers and the unemployed in the urban centers of the West has never been as high as it is in these avowedly "global" times. We should become increasingly aware that we may also be in danger of producing a politics of informational "intimacy" that does not so easily translate into agency at the level of public action and representation.

However wondrous the protean possibilities of on-line ontologies— (you need not be who you say you are)—or of e-mail epistemologies (what you see is not what you necessarily need to know)—there is a danger that the "presentism" and simultaneity celebrated on the 'Net, however seductive, may drain everyday life of its historical memory (whether it is embedded in a material homeland, or to follow Salman Rushdie's title, in "imaginary homelands"). In saluting the emergence of cyberspace culture, or welcoming the creation of "virtual communities," we must remain aware that both these icons of the transformation of our times too often find their correlative metaphor in biology and organicism: "Biological imagery is often more appropriate to describe the way cyberculture changes," writes Howard Rheingold in *The Virtual Community. Homesteading on the Electronic Frontier*: "Think of cyberspace as a social petri dish, the Net as the agar medium, and virtual communities, in all their diversity, as the colonies of microorganisms that grow in petri dishes" ... "wherever CMC technology becomes available to people anywhere, they inevitably build virtual communities with it, just as microorganisms inevitably create colonies" (6).

There is, certainly, widespread concern amongst "virtual communitarians" about the illusory reality of on-line culture. However, the organic or biological metaphor through which the concepts of community and communication are constituted—both as media and mediation—does not permit the lifeworld of cyberspace to reach beyond the homogeneous empty time of the imagined community of the nation and its largely consensual, unitary peoples. Although cyberspace communities are not obviously "national" in character, their deterritorialization must not lead us into believing that they are detached from national policies of technological innovation, education provision, science policy. My obvious reference to the central argument of Benedict Anderson's brilliant essay is not merely gestural. It came as something of a disappointment to me, to find Rheingold suggesting that an appropriate sociology of a "community in cyberspace" may replicate the lines of Anderson's argument. This is to say nothing of the fact that the main communicational or media technology in Anderson's book—providing the narrative temporality of the

nation as a form of collective "imaginary" identification—derives
from two sources. Print capitalism provides the vernacular, popular
dialect of the nation-people; while the genre of Western narrative fic-
tion—the novel—and its "realist" or mimetic tradition represents the
model for national temporality. If the virtual community shares the
essential *temporal* structure of the modern nation-form and its social
imaginary, then what will prevent the reproduction on the Net of the
worst excesses of nationalism and xenophobia? the agonisms of center
and periphery? the travails of majoritarianism and minoritarianism?
Although cyberspace communities do not have the territorial impera-
tives of nationalism, it is interesting how active xenophobic nationalists
are on the Web, often in the cause of nations to which they no longer
belong, but to which they now turn to justify their fundamentalist
aspirations. The recreation of Athenian democracy in Appletalk—if
that is what you want, in the first place,—is unfortunately not to be
found at Emerald City or one of its many suburban outlets.

What form of "media"—in the most general and generic sense of
the technology of representation, the genre of mediation—would be
appropriate to the modern experience of exile? Is there a mediatic tem-
porality that could be usefully described as "exilic"? This is the kind of
question that can be posed in the margins of Jacques Derrida's *The
Spectres of Marx*, by reading his rather spectral and schematic comments
on the New Internationalism *against the grain. The* public sphere of our
time is both disturbed by, and articulated *through* what Derrida names
the "techno-tele-media apparatuses" and new rhythms of informa-
tion and communication. These new media apparatuses are distinctive
for their temporalities of "acceleration" and "tele-technic dislocation."
They enable us to "access" a range of materials and material cultures
with an ease never before imagined. What they disturb, therefore, is a
sense of ontology, of the essentiality or inevitability of being-and-
belonging by virtue of the nation, a mode of experience and existence
that Derrida calls a *national ontopology*. As I have been arguing above, this
assumption is unsettled by the apparent "emancipation" from home-
land and nation that cyberspace seems to offer—yet, as I have sug-
gested, that very freedom is severely limited by the authority and
locality of the nation whose presence may have somewhat diminished,
but whose power to determine the lives of its citizens through
national economic policy and political regulation should not be
underestimated. The event of historical culture or ethnic "affiliation"
must now be thought through a problematic break in the link
between the ontological value of present-being—subject or citizen—
and its situation in a stable and presentable determination of a locality,
"the topos of territory, native soil, city..." (82).

The delinking of present-being from the naturalistic and national-istic *topoi* of nativity—the move from organic temporality to disjunc-tive, displaced *acceleration*—*this* is the "exilic" move in thinking both the historical genealogy or "event" of the New Internationalism, and the "techne" of the media. Derrida relocates the "techno-tele-media appa-ratus as "event": it emerges neither at the *end* of "ideology" or history, nor even as the *"origin"* of the new (post-Soviet Bloc) globalization of the market. What I have interpolated as the "exilic," in the interstices of the argument, represents Derrida's sense that a "new international" in the next century must be sought in the singular sites of violence, inequality, exclusion, famine, economic oppression; its memory must extend to the awareness that all national rootedness in the West "is rooted first of all in the memory and anxiety of a displaced—or dis-placeable- population. It is not only time that is out of joint, but space, space in time, spacing" (83). The truth of this statement for an under-standing of our times, and the long history of ethnic cleansing in the twentieth century, is too obvious to need spelling out. Bosnia, for instance, is only a recent name for ahistorical barbarism that has afflicted the Jews under Hitler, the Palestinians under the Zionist state, the Tamils under the Sinhalas, and until recently, Black South Africans under the South African Apartheid State. In all these cases, and many more, nationalist awareness and authority has been brutally asserted on the principle of the dispensable and displaceable presence of "others" who are either perceived as being premodern and there-fore undeserving of nationhood, or basically labeled "terroristic" and therefore deemed unworthy of a national home, enemies of the very idea of a national peoples.

Where would we find an "optic" adequate to this exilic media "event" of our time? Look no further than the most celebrated and cited essay on the technology of the media in the annals of "postmod-ern" cultural theory—Walter Benjamin's ubiquitous "The Work of Art in the Age of Mechanical Reproduction." Recall his use of the word "accelerated" as he describes the optical intervention of the cam-era: and suddenly, the "media" innovations of the 1860s become the medium for the spectral ethics of the revolutions of 1848, on the limi-nal threshold of the 21st, century—the times are, indeed, out of joint:

> Here the camera intervenes with the resources of its
> lowerings and liftings, its interruptions and isolations,
> its extensions and *accelerations,* its enlargements and
> reductions. The camera introduces us to unconscious
> optics as does psychoanalysis to unconscious impulses
> . . . the enlargement of a snapshot does not simply ren-

der more precise what in any case was visible, though
unclear: it reveals entirely new structural formations of
the subject" (236).... For it is another nature that
speaks to the camera than to the eye: other in the sense
that a space informed by the human consciousness
gives way to a space informed by the unconscious? (243).

Lowering, lifting, interrupting, extending, enlarging, and then, sud-
denly, in a shock of recognition we re-encounter the Derridean
term—*acceleration*—which leads us, through an analogy with psycho-
analysis, to the optical unconscious, and a new structural formation of
the subject. The subject is now inscribed—through the media of pho-
tography—at the point of the non-visible, a gap in the frame, an era-
sure at the moment of exposure, a lack in the structure of the look. But
this is not a "void" that becomes the ontological center for a simply
"negative," or negating, glance. It is by way of the process of erasure-
within-exposure that a certain media temporality—"a tiny spark of
contingency"—shuttles in an exilic movement to make *at once* contigu-
ous, and *in that flash,* contingent, the realms of human consciousness and
the unconscious, the discourses of history and psychoanalysis. It is this
juxtapositional movement that I want to describe as the inscription of
an exilic optic. It is a flickering moment, a restless movement of the
darkness that befalls the exposed frame, and sutures, *in a split-second,* the
conscious and the unconscious, the social and the psychic, without let-
ting them turn into a binary relation, or a unitary synthesis.

This hovering, exilic movement occupies the borderland between
the domestication of human consciousness and the estrangement of
the unconscious; its frontier falls in the very moment of culture's
Unheimlichkeit where, in Benjamin's words, "suddenly our taverns and
our metropolitan streets, our offices and our furnished rooms, our
railroad stations and our factories ... this prison world was burst asun-
der by [the filmic] dynamite of the tenth of a second, so that now, in
the midst of its far-flung ruins and debris, we calmly and adventur-
ously go travelling." (236)

In that same suddenness we realize that the defamiliarization of the
bourgeois metropolitan world in the exilic optic has lead us back to
the exilic event, to the destabilization of "a presentable determination
of locality, the topos of territory, native soil, city...." The cinematic
visuality of cultural modernity that Benjamin introduces as a "way of
seeing" the strangeness of ourselves, can be pushed in the direction of
a revision of what if is that we deem to be familiar, domestic, national,
homely. To mix and extend both "exilic" metaphors, then, we are
bound to a double duty: to locate Benjamin's spark of contingency and

its denaturalizing narrative of interruption, extension, enlargement, and acceleration, in the reinscription of the exilic condition of the (Derridean) tele-techne media, "... rooted, first of all in the memory and anxiety of a displaced—or displaceable population ... time out of joint, space-in-time...." From the exilic event and optic, I think we need to move to an exilic *ethic,* for as Miriam Hansen has so convincingly argued, the displaced, interruptive narrative of the "optical unconscious requires us to translate from individual experience into collective form." What would be our "duty," where our vigilance, in this dis-location? Whence the ethical *subject* of our discourse, somewhere between psychoanalysis and history?

It is time, I think, to activate an archaic root of the "exilic." If, in everyday speech and writing, we consciously read "exile" as enforced displacement and dislocation, then it is worth remembering that the term also carries within it, invisibly, unconsciously, its Latin root, *salire:* "to leap." It is the ethical "leap" that requires us, in a kind of bounding, boundary-breaking movement to move, as Benjamin suggests, beyond "our metropolitan streets and furnished rooms"; to revise our knowledge of some of the "savage" discourses of power, possession, knowledge and belonging, that rise from the uncanny far-flung ruins and debris of metropolitan discourse. Could this unconscious anteriority of the metropolitan location be the memory of the scene of colonial and postcolonial alterity? Might the anxiety of settlement and governmentality of nationhood be linked to the (mis)representation and regulation of those who must be displaced—at home and abroad—to constitute the "good" people, the right "stock," the true blood, the civilized?

We are not fated to choose those great apparatuses of mediation that structure our symbolic world: they somehow precede our presence and continue after it. What we can do, with all the modes of signification that lie to hand, is to wage our wars of "recognition" for lifeworlds that are threatened with extinction or eviction; and shape our words and images to frame those representations of home and exile through which we take possession of a world whose horizon is marked, all at once, by the spirit of arrival and the spectre of departure.

references

Anderson, Benedict. *Imagined Communities, Reflections on the Origin and Spread of Nationalism* (London: Verso, 1983).

Benjamin, Walter. "The Work of Art in the Age of Mechanical Reproduction" in *Illuminations* (London: Jonathan Cape, 1970).

Derrida, Jacques. *Spectres of Marx: The State of the Debt, the Work of Mourning, and the New International* (New York: Routledge, 1994).

Feingold, Howard. The *Virtual Community, Homesteading on the Electronic Frontier* (Reading, MA: Addison-Wesley, 1993).

acknowledgments

More than half of the chapters in this volume were first presented at House, Home, Homeland, a multisited, multimedia symposium which I organized at Rice University in October 1995. I want to thank all those who delivered papers there, particularly those whose substantially revised papers are included here. Thanks are also due those who were not present at the symposium but who contributed their work to the anthology. The symposium was generously funded by Rice University's Dean of Humanities Allen Matusow, Center for the Study of Cultures, and President Malcom Gillis as well as by the American Film Institute, Los Angeles. I thank them all. AFI Film Reader editors, Charles Wolfe and Edward Branigan were as usual generous and prompt in their dealings and I appreciate that very much. Finally thanks are given to Bill Germano who guided the project with good cheer and dexterity.

introduction

framing exile

from homeland

to homepage

h a m i d n a f i c y

o n e

As I began thinking about this introduction, I began wondering not only what to say but also what to call it. Introduction, opening, framing remarks . . .? Finally I decided on the last of these, "Framing Remarks." But as I began writing, the title gradually became "Framing Exile." Why? *Framing,* of course, means bracketing, structuring, constructing, or laying out the terrain of a topic—as in "providing a framework." This helps to define and differentiate one topic from another; it helps each topic stake a claim to its existence—an important strategy in alternative discursive formations. *Framing* also means delimiting the topic, boxing it in, predetermining it—as in "encasing the topic." This is something that my Ph.D. advisor, Teshome Gabriel, who has contributed an essay to this volume, had long ago warned me against doing. He'd say something

like: "Don't clearly define concepts like 'third cinema' because then they'll be appropriated and dismissed." By that definition, framing can become a means of control and domestication, and the refusal to frame becomes an oppositional strategy. Further, as the dictionary tells us, framing could also mean prearranging or concocting with a sinister intent—as in a frame-up.

In some ways, all of these modalities of framing are involved in this introduction and in the anthology itself, in the form of three interlocking conceptual frames of exile, consisting of house, home, and homeland. These are among the key concepts, symbols, and empirical entities that are most in dispute and under erasure today, and in what follows I will only sketch them in suggestively, not definitively. The diverse range of the contributing scholars also works against solidifying these and related key terms into conceptual edifices, for they hold divergent theoretical orientations, different departmental affiliations (or "homes"), and varying national, racial, ethnic, and gender identities. Among them are postcolonial critics and theorists ("poco"), but there are also those who have never identified themselves as such, and were even a bit wary of participating in a book project—which first began as a symposium at Rice University—whose topics have largely been relegated to that philosophical orientation.[1] In fact, non-poco scholars have been invited to contribute to this anthology as a way of intervening in the exile discourse—breaking the usual orientational framework. This has resulted in the felicitous situation of the anthology containing citations from a wide range of scholars rather than being limited to frequent citation of a few canonical works. I happen not to agree fully with the kind of general attack leveled against postcolonial studies scholars recently—as being elitists and lacking a commitment to home—but I think the "field," if that is a proper term for it, is in need of new blood, not only from younger and more divergent postcolonial critics but also from outsiders. Likewise, although the anthology is centrally concerned with media's work on exilic issues and identities, not every contributor belongs to a film, media, or communications arts department. However, they have all been asked to cross the threshold, to enter the room of media studies, and to bring their expertise to bear on the media and the mediations that both express and constitute exile. This is an aspect of exile and exile discourse that has not received the kind of detailed and rigorous attention that it deserves.

This is surprising because of the undeniable significant and signifying role of the media in creating, maintaining, and disrupting individual, communal, ethnic, national, and postnational identities in today's technologized and diasporized world. David Morley's chapter, "Bonded Realms; Household, Family, Community, and Nation," addresses these issues.

While technology, media, and capital are globalized and cross geographical boundaries of nation-states with ease, national governments everywhere appear to be tightening and guarding their physical borders more vigilantly than ever by enacting and enforcing narrowly defined and sometimes highly intolerant immigration laws and by militarizing their border spaces. Despite, or perhaps because of, these official measures, borders, particularly the two-thousand-mile border that links Mexico and the United States, have become sites of not only physical and political but also discursive and artistic struggles, where exilic and émigré subjects are turning to the global media and entertainment industries to situate themselves historically, creating locally situated syncretic communities of address and socially engaged historical and political agency. Rosa Linda Fregoso, in "Recycling Colonialist Fantasies on the Texas Borderlands," brings these issues into focus.

We have attempted to include a range of academic writing in order to represent more fully the variety of registers, experiences, and nuances of exilic conditions. As a result, there are chapters that are in different degrees autobiographical, essayistic, novelistic, and academic in style.

Exile is inexorably tied to homeland and to the possibility of return. However, the frustrating elusiveness of return makes it magically potent. Teshome Gabriel's "Intolerable Gift" is a moving meditation inspired by his own return. Today, it is possible to be exiled in place, that is, to be at home and to long for other places and other times so vividly portrayed in the media. It is possible to be in internal exile and yet be at home. It is possible to be forced into external exile and be unable to, or wish not to, return home. It is possible to return and to find that one's house is not the home that one had hoped for, that it is not the structure that memory built. It is possible to go into exile voluntarily and then return, yet still not fully arrive. It is possible to be able to return and choose not to do so, but instead continue to dream of and imagine a glorious return. It is also possible to transit back and forth, be in and

out, go here and there—to be a nomad and yet be in exile every-where. All these modalities of placement and displacement are mediated by one or another of the media, from the epistolary tech-nologies of letters, telephone, fax, and e-mail to the audiovisual media of photos, cassettes, films, and video, to print, electronic, and cyberspace journalism. Thanks to the globalization of travel, media, and capital, exile appears to have become a postmodern condition. But exile must not be thought of as a generalized condi-tion of alienation and difference, or as one of the items on the diversity-chic menu. All displaced people do not experience exile equally or uniformly. Exile discourse thrives on detail, specificity, and locality. There is a there *there* in exile.

Because of the prominence and prevalence of the exile popula-tions and of exilic conditions worldwide, however, exile and its allied concepts have become popular enough to be in danger of overexposure—of becoming de-fused by means of diffusion. Acad-emic and popular periodicals have devoted whole issues or lead articles to them.[2] Shelter magazines, a popular genre of mass-mar-keted periodicals devoted to house and home affairs, are now avail-able not only in hard copy but also on the World Wide Web. Although the move to the Internet is seen as an effective strategy for enhancing the marketing, subscription, and advertising impact of these periodicals (Trucco 1997:B4), it also signifies public interest in issues related to house and home. Likewise, television's foray into shelter programming has gone beyond providing specific shows to offering the first twenty-four-hour, full-service shelter magazine of the air, Home and Garden Television (HGTV), which began airing in early 1995 (Owens 1995:B5).

For many cosmopolitan "homeless" exiles who are physically displaced, an Internet homepage is an attractive method for becoming discursively emplaced. Like all acts of psychic displace-ment and condensation, however, homepage creation and cyber-community formations involve highly complex and cathected psychological and political economies that are, on one hand, fraught with anxieties, affects, associations, and politics of all kinds, and with intriguing possibilities for liberatory diasporic and femi-nist multicultural practices, on the other. Ella Shohat's "By the Bit-stream of Babylon: Cyberfrontiers and Diasporic Vistas" explores some of these.

Academic film conferences and research projects on émigré,

exile, and diaspora cinema have also been on the rise, yielding new insight into the significant impact that the émigré and exilic status of the European directors of the classical period has had on their films and the "classical cinema." Thomas Elsaesser's "Ethnicity, Authenticity, and Exile: A Counterfeit Trade? German Filmmakers and Hollywood," provides an engaging account of this period. Likewise, the study of the contemporary postcolonial exilic and diaspora filmmakers, chiefly from the third world, has led to, among other things, the conception of what I have called a postclassical "accented cinema" that is being produced in the interstices of dominant culture industries and social formations and is showcased in a variety of independent, alternative, artisanal, and collective venues. My chapter, "Between Rocks and Hard Places: The Interstitial Mode of Production in Exilic Cinema," explores this world.

Since the 1980s, film curators have put together festivals, series, and touring programs of films that deal with exilic issues.[3] In the meantime, the presence of exilic, ethnic, diasporic, and transnational broadcasting and music industries worldwide has dramatically increased the local and transnational impact of the displaced local communities and their hybridized musical and cultural formations. See George Lipsitz's chapter, "'Home Is Where the Hatred Is': Work, Music, and the Transnational Economy," for a study of this milieu, particularly of *banda* music among mexican immigrants in California. It now appears that one's relation to "home" and "homeland" is based as much on actual material access as on the symbolic imaginings and national longings that produce and reproduce them. Such mediations can generate intense utopian longings, dystopian imaginings, and often violence—particularly when they are associated with territorial struggles.

It is these multifaceted, multisited, and multimedia expressions of and exposures to exilic issues that have brought exile to the forefront of public consciousness, and has opened it to market forces and media manipulations. They have also led to the formation of what might be called an an "exilic unconscious". Such an unconscious necessitates theorization of an exilic optic and an exilic ethics, as Homi Bhabha initiates in his contribution "Arrivals and Departures."

The anthology is framed by exile and three of its allied key concepts: house, home, and homeland—a framing that moves from the literal to the abstract. *House* is the literal object, the material place in which one lives, and it involves legal categories of rights,

property, and possession and their opposites. *Home* is anyplace; it is temporary and it is moveable; it can be built, rebuilt, and carried in memory and by acts of imagination. Exiles locate themselves vis-à-vis their houses and homes synesthetically and synecdochically. Sometimes a small gesture or body posture, a particular gleam in the eye, or a smell, a sound, or a taste suddenly and directly sutures one to a former house or home and to cherished memories of childhood. Margaret Morse's "Home: Smell, Taste, Posture, Gleam," studies such evocations. Sometimes a small, insignificant object taken into exile (such as a key to the house) becomes a powerful synecdoche for the lost house and the unreachable home, feeding the memories of the past and the narratives of exile. Patricia Seed's "The Key to the House" explores this phenomenon. *Homeland* has been the most absolute, abstract, mythical, and fought for of the three notions. However, today more than ever, the empirical and metaphorical house, home, and homeland are in crisis. Millions of people do not or cannot live in their own homeland, many others are homeless within their native lands, and many of those who own houses are so afraid of what lies beyond that they have turned their dwellings into fortresses.

Walking through the neighborhoods of any major American city one comes across a range of community formations that are often based on fear and panic. The houses of some of the poor have metal bars on the windows that keep robbers out and at times trap the inhabitants inside, resulting in deaths by fire and other means. The operating sentiment is fear of what lies beyond the house. The heat wave of August 1995 in Chicago caused an unusually high number of deaths, 591 of them were attributed to lonely, elderly residents' inability or unwillingness to leave their non-airconditioned rooms because they feared being robbed or their place being broken into if they were away.[4] Paralyzed by fear and trapped in their overheated rooms, they perished. In the tony neighborhoods, too, fear of the outside has turned homes into "stealth houses," characterized by no windows or only small and high windows facing the streets. Security measures including motion sensors, smoke detectors, guard dogs, roving security officers, and remote-controlled garage doors, locks, and lights guard the perimeters and protect the cocoon. Once inside, windows open to verdant yards, which are turned into oases of privacy, leisure, and isolation. Often these stealth houses are located in gated communities, in which an

estimated four million Americans now live, where public space has become entirely privatized, involving private community government, schools, and police. These privatized communities are increasingly popular across the nation, especially in Arizona, Florida, Texas, California, and Washington, D.C. According to real estate agents, a third of new developments built in southern California in the past five years were gated and are regulated by private governments (Egan 1995). Whether they are called "bucolic villages," "green fortresses," or "stealth communities," they appear to be part of a national fear-driven trend toward balkanization and militarization of public spaces. The emergence of private communities that strictly enforce regulations on access, behavior, and association and eliminate random encounters and diversity is very different from the rise of ethnic "ghettos" and "enclaves," which, despite their oppressive and claustrophobic tendencies, have historically provided a measure of security and safety to a variety of immigrant families and businesses.

A similar to-and-fro movement at the level of nation-states has been taking place in this decade, involving expulsion, exclusion, and repatriation of massive numbers of people from their home places. Mass violence, massive cruelty, and destruction of houses and villages have occurred on an unprecedented scale. The most recent, intense, and enduring example of such atrocities over house, home, and homeland is the former Yugoslavia, now divided into half a dozen competing nation-states and nationalistic formations. The Bosnian Serbs' campaign of "ethnic cleansing" since the early 1990s has involved forced expulsion of large populations of others, particularly of Muslims, and to a lesser degree, of Roman Catholic Croats, from their houses, villages, and farms; destruction of their houses and properties; relocation of Serbs into the abandoned houses; systematic raping of girls and women as a weapon of war; maintenance of concentration camps for the detained male population; torture and summary execution of the detainees, and mass burial of the others—all in the name of a venal brand of ethnoreligious nationalism. As a result, some 800,000 Muslims were forced to become refugees abroad, many of them in Germany. Atrocities of a smaller scale were in turn perpetrated by the Croats and Muslims, who either took over the houses of the Serbs they had displaced or destroyed and burned them altogether (Hedges 1995a, 1995b; Bonner 1995a, 1995b). When the Dayton peace accord

and NATO guaranteed the return of all refugees, often those refugees became tragic pawns in the power games of the various local, regional, national, and international factions. For example, the Serbs either refused to allow the Muslims to return to their former homes in the Serb territory (Hedges 1997a) or just blew the houses up; 191 homes were demolished in a two-month period in late 1996 (O'Connor 1996a). In other cases, the displaced and exiled Muslims stormed their former villages to reclaim the homes they had lost to the Serbs, causing further fighting and bloodshed (O'Connor 1996b). In September 1997, when the Dayton-accord-mandated and NATO-supervised municipal elections took place, Bosnian Muslims had to be bused under guard to their former villages only long enough to cast their votes in their prewar "home" districts—places from which they had been evicted by the Serbs, who now occupy them. This is likely to create the ironic and bizarre situation in which Muslims will be elected in towns like Srebrenica, where thousands were massacred by the Serbs in 1995, but where currently no Muslims live (Hedges 1997b). Similar circumstances favored the election of Croats and Serbians in areas from which they had been expelled.

The impact of these ethnoreligious, sexual, and nationalistic atrocities worldwide has been particularly grievous on civilians and children—and not so much on military forces. According to a UNICEF report, *State of the World's Children 1996*, some two million children have been killed in the last decade in wars, four to five million disabled, twelve million made homeless, and more than a million orphaned, or homeless and unable to locate their parents (Crossette 1995). If the psychic scars left by these traumas are taken into consideration, the profound impact of unbridled particularism and *Heimat*ism on the displacement of civilian populations, especially children, will become clear. Both the physical violence and the psychic ruptures of war, exile, rapid change, disease, and other factors have led to a crisis of the body, where the first and most intimate, home of humans—namely, our bodies and skin—doesn't feel like home anymore. Some feel as though they are evicted from their own eviscerated bodies. Vivian Sobchack's "'Is Any Body Home?': Embodied Imagination and Visible Evictions" explores the body as home.

These cases demonstrate the manner in which house, home, and homeland are intimately intertwined with one another, and

how they bear on the conception of personhood and exile. There was a time when exile implicitly or explicitly involved a present or absent home, or a homeland, as referent. However, the referent is now in ruins or in perpetual manipulation, and the concept of exile, once stabilized because of its link to the homeland, is now freed from the chains of its referent. This destabilization has forced a radical redefinition of what constitutes exile, from a strictly political expulsion and banishment to a more nuanced, culturally driven displacement. From a homogeneous, unitary, and monolithic conception of exile has emerged one that consists of multiple and variegated exiles, big and small, external and internal, forced and voluntary. This evolution in the definition will surely continue, for every new epoch is dependent upon the emergence of its exilic other(s) for its own self-definition and self-fashioning. John Durham Peters's "Exile, Nomadism, and Diaspora: The Stakes of Mobility in the Western Canon" looks at the long history of ideas of mobility in the West.

Just to illustrate how the category of political exile alone has undergone redefinition, often opportunistically and situationally by the ruling regimes, one can point to the fascinating account of the Salvadoran government's attempt to help its own refugees obtain political asylum in the United States. The reason for this unusual concern with the welfare of its political refugees was the one billion dollars a year that they were sending home—a figure that rivals El Salvador's entire national earnings from export (Carvajal 1995:1). Throughout the 1970s, the 1980s, and part of the 1990s the United States interpreted political refugee status differentially, based on foreign-policy expediency, anti-immigration xenophobia, superpower rivalry, and the political muscle of particular groups of exiles as voting blocs (such as the Cuban exiles). Those fleeing the Salvadoran regime of terror and death squads, propped up by the U.S. administration, faced difficulties entering the country as political exiles, while those escaping the leftist Sandinista-led civil war and government in Nicaragua were easily so classified. Until recently, all people fleeing the Castro regime in Cuba were automatically granted political asylum, while the same treatment was denied those from Haiti on the debatable premise that they were economic refugees (even during the Duvalier family's dictatorship).

In another hemisphere and in a model-setting move, the United States and its allies who fought against Iraq in the 1990 Persian Gulf

War carved out a portion of northern Iraq as a safe zone for its Kurdish dissidents and refugees, instead of allowing them to escape to neighboring Turkey, where they could possibly join the already raging Kurdish rebellion for an independent homeland (Crossette 1996). We are now facing the gradual end of the classic asylum system, which protected refugees from forced repatriation. This process is illustrated by the cases of the Vietnamese boat people in the 1980s who were sent back to Vietnam when no country wanted them, Bosnian refugees who were repatriated to Sarajevo by Germany in 1995, Africans who were expelled by France in 1996, and the Hutus, who were first forced out of Rwanda and then forced back into that country in 1997.

This sort of forced relocation is not only being applied to exiles and refugees but also to émigré workers, often as a result of changed relations between sending and hosting governments. In 1990 Saudi Arabia evicted some 800,000 Yemeni workers to punish Yemen for supporting Iraq's invasion of Kuwait, while Kuwait did the same thing to nearly 500,000 Palestinian workers to the punish Palestine Liberation Organization and Yassir Arafat for supporting that invasion. Libya, which has from time to time expelled thousands of Egyptian and Sudanese workers, threatened to expel some 30,000 Palestinians to punish the Palestinian Authority for its peace accord with Israel (Jehl 1995). Expulsion is a grave threat for the 3.5 million Palestinians who live in Arab countries, because many of them are skilled workers who have no guarantee of jobs or safety, given the anemic Palestinian economy and the expansionist settlement policies of Israel, as well as its periodic collective punishment of Palestinians (including house demolition) in the West Bank and Gaza Strip for acts of terrorism and bombing against Israel.

Not only political exile but also other types of exile are similarly being legally, socially, and politically reinterpreted and modified, by subject people themselves as well as by ruling national governments and international institutions. The concept of exile, like the exilic subjects themselves, is a living, dynamic organism that lurks and thrives in the interstices of social and political formations.

* * *

The essays are divided into four general areas. Reference to each essay has been made throughout this introduction. Here I will provide only a brief organizational map of the anthology. In the first section, "Traveling Concepts," John Durham Peters provides an

intellectual history of tropes of mobility in the Western philosophical and literary traditions, focusing particularly on the way concepts of exile, nomadism, and diaspora are intertwined and have evolved with the Hebrew Bible, ancient Greece, early Christianity, romanticism, and recent social and cultural theory.

In the second section, "Synesthetic Homing," Vivian Sobchack, Margaret Morse, Teshome Gabriel, and Patricia Seed offer incisive theoretical, personal, autobiographical, and essayistic accounts of the problematic of the human body as our first home and of the manner in which a mother's gift, keys to houses, and sensory reports can serve to (re)locate dislocated individuals—at home, or elsewhere in diaspora and in exile from home.

Thomas Elsaesser and Hamid Naficy, in part three, "Cinematic Modes of Production," propose new interpretations of the lives and works of German émigré directors of the classic cinema period and of the postclassical, postcolonial era filmmakers, respectively.

In part four, "Mediative Collective Formations," David Morley, Rosa Linda Fregoso, George Lipsitz, and Ella Shohat offer wide-ranging formulations and analyses of the manner in which the global media of television and radio broadcasting, music, cinema, and cyberspace are being recruited by deterritorialized people on both sides of the Atlantic to create alternative, hybridized, but historically situated community formations. Both the celebratory and celibate discourses of the function of the new media in relation to home and exile are examined in these essays.

notes

I wish to thank George Marcuss, who reviewed the introduction and gave me suggestions for improving it.

1. The symposium "House, Home, Homeland: A Media Studies Symposium on Exile" was a multimedia and multisited event, organized by myself and held at Rice University from October 26 to October 28, 1995. It included an academic forum in which eighteen scholars, many of whom have contributed to this volume, presented papers. Two art gallery shows were curated for the occasion as well as a semester-long film series on exile and diaspora cinema.

2. Foremost among these, of course, is the respected journal *Diaspora*, edited by Kachig Tölölyan, which since its inception in 1991 has been instrumental in forming what might be called "exile studies." There are many examples of other serious periodicals with special issues devoted to exile, home, and allied topics, among them the following: Two special issues of *Critical* Inquiry (vol. 23, nos. 3–4, spring–summer, 1997) on "Front Lines/Border Posts"; a special issue of *Social Research* (vol. 58, no. 1,

spring 1991) on "Home: A Place in the World"; a special issue of *New Formations* on "The Question of 'Home'" (no. 17, summer 1992); a double issue of *Social Text* (nos. 31/32, 1992) on "Third World Issues" and "Post-colonial Themes"; *Yale French Studies*' two issues (nos. 82 and 83, 1993) on "Post/Colonial Conditions: Exiles, Migrations, and Nomadism"; *Socialist Review*'s special issue (vol. 24, no. 4, 1994) on "The Traveling Nation: India and Its Diasporas"; a thick special issue of *The New Yorker* on "The Home" (October 16, 1995); and the cover article of the *Texas Journal* on "Home, Community and the Spirit of the Place" (fall–winter 1996).

3. In 1985 Third World Newsreel created "Journey Across Three Continents Tour," a program of films made in Africa and the black diaspora that toured to over a dozen sites in the United States (Bowser and Tajima 1985). Third World Newsreel presented "Internal Exile," a program that showcased films and videos from Chile (Fusco 1990). The Goethe Institut in San Francisco organized, in 1978, a series of films made by German and Austrian émigré directors in Hollywood and in 1993 it organized "Homeless in the Homeland," a program containing films made in Germany by émigré filmmakers and by German directors about immigrants living in Germany. In 1993 UCLA's Film and Television Archive presented "Intercultural Europe," a series of films made by émigré filmmakers in Europe. In 1995 the archives presented "Constructing a Culture: Exile and Immigration in Southern California." In the same year, The Los Angeles Festival presented a large program of films and video made by exile filmmakers working in Europe and America. Rice University in Houston has presented several exile film programs, including "Cinema of Displacement" in 1995, a series of films made by exiles in Europe and the United States. In the 1990s the Museum of Fine Arts, Houston, programmed a series of films, "Jewish Worlds," that contained films from Israel as well as those made in the Jewish diaspora.

4. The extent of their loneliness is borne out by the fact that forty-one of the dead bodies, which were buried in a mass grave, were never claimed by anyone (Walsh 1995:8A).

works cited

Bonner, Raymond. 1995a. "Croats Discover Sadness in Finding a New Home," *The New York Times* (August 27): 1.

———. 1995b. "Croatian Forces Razing Serb Villages as They Withdraw," *The New York Times* (December 10): 4.

Bowser, Pearl and Renee Tajima. 1985. *Journey Across Threee Continents*. New York: Third World Newsreel.

Carvajal, Doreen. 1995. "In U.S. El Salvador Helps Own Refugees Get Asylum," *The New York Times* (October 27): A1, A13.

Crossette, Barbara. 1996. "The Shield for Exiles Is Lowered," *The New York Times* (December 11), part 4: 1, 10.

———. 1995. "Unicef Report Sees Children as Major Victims of Wars," *The New York Times* (December 11): 7.

Egan, Timothy. 1995. "Many Seek Security in Private Communities," *The New York Times* (September 3): 1, 10.

Fusco, Coco. 1990. *Internal Exiles: New Films and Videos from Chile*. New York: Third World Newsreel.

Hedges, Chris. 1997a. "Bosnia Refugees Return Home as Political Pawns," *The New York Times* (June 27): A6.

———. 1997b. "Bosnians Vote, but Animosity Is Unrelenting," *The New York Times* (September 14): 1, 6.

———. 1995a. "Bosnia Revolving Door: Muslims Get Serb Homes," *The New York Times* (September 25): A3.

———. 1995b. "Arson and Death Plague Serbian Region of Croatia," *The New York Times* (October 1): 4.

Jehl, Douglas. 1995. "To Palestinian Deportees, Peace Accord Brings Little Joy," *The New York Times* (September 30): 4.

O'Connor, Mike. 1996a. "Defiantly, Bosnian Serbs Blow Up Muslims' Homes," *The New York Times* (November 7): A6.

———. 1996b. "Fighting in Bosnia as Exiles Go Home," *The New York Times* (November 7): A1, A4.

Owens, Mitchell. 1995. "The Curtain's Up on All-Home TV," *The New York Times* (January 5): B5.

Trucco, Terry. 1997. "Scanning the Web: When Home Sites Are Worth a Click," *The New York Times* (February 27): B4.

Walsh, Edward. 1995. "Forgotten Victims Laid to Rest," *Houston Chronicle* (August 26): 8a.

part one

traveling

concepts

exile,

nomadism,

two

and diaspora

the stakes of mobility

in the western canon

j o h n d u r h a m p e t e r s

Such concepts as exile, diaspora, and nomadism are often invoked of late as alternatives and antidotes to the totaling character of Western society and thought. In fact, concepts of mobility lie at the heart of the Western canon; otherness wanders through its center. Exile is, perhaps, *the* central story told in European civilization: the human estate as exile from God, the garden of Eden, the homeland, the womb, or even oneself. Thus Eisen (1986, xi) recasts the opening line of the Book of Genesis: "In the beginning there was exile." Current notions of exile, nomadism, and diaspora are inescapably tied to the Hebrew Bible, ancient Greece, Christianity, and their divergent intellectual, artistic, and political afterlives. Stories of pilgrimage, displacement, and dispersion are central to Western tradition, and we can deploy these concepts more creatively the better we understand their multiple histories.

The vocabulary of social description, past and present, brims with mobility and displacement. Those scattered beyond the bounds of the city have long been the subject of puzzlement and fantasy by those within its walls, as well as a metaphor for ways of being in the world. Consider some of the personae characterized by their mobility: Abraham, the sojourner and a stranger, never to return to his home; Odysseus, who finally returns to Penelope after his odyssey; Oedipus, an outcast from his city; the legend of the wandering Jew; *flâneurs*, loafers, and bohemians; gypsies, gypsy scholars, sea gypsies, and gypsy truckers; hoboes, tramps, drifters, vagabonds, and flimflam artists; sociologists, private eyes, journalists, men and women of the street; sailors, soldiers of fortune, adventurers, and explorers; border crossers of all sorts; gauchos, cowboys, and guerrilla fighters; pioneers, pilgrims, and crusaders; knights errant, troubadours, minstrels, charlatans, and journeymen; Huns, Vandals, Goths, Mongols, Berbers, and Bedouins; tourists, travelers, *hajji*, refugees, immigrants, the stateless and the homeless; commuters, telecommuters, jet-setters, migrant workers, and *Gastarbeiter*; automobilists, bikers, and circus people. Movement is one of the central resources for social description.

The juxtapositions of this heterogeneous list may be striking or offensive to some: I do not mean to trivialize the suffering of real people or make light of cultures not my own. I do not, in fact, mean to talk about real people at all, but about the enduring metaphorical power of wandering in the fantasy life and social repertory of the West. Each of these labels may have named a particular population or way of life at some point, but each has had a rich afterlife as a metaphor. Nothing is more dispersed in intellectual life today than the concept of diaspora, nothing more nomadic than the concept of nomadism.

Current theory also makes much of mobility (Wolff 1995, chap. 7). Nietzsche aspires to be an alpinist who steps from mountaintop to mountaintop. Heidegger strays through the woods. Benjamin strolls through nineteenth-century Paris. Anne Friedberg nominates the window-shopper as a feminine subject-position in modernity. Michel de Certeau celebrates pedestrians and poachers as freedom fighters. Deleuze and his many disciples see the nomad as a figure equipped for postmodernity. Gloria Anzaldúa crisscrosses the borderlands; Victor Turner explores liminality. In media themselves, the language of travel and exile is explicit. Viewers

"graze" multiple channels like nomads or are "captivated" by shows. Broadcast voice-overs employ a special rhetoric of transport: "We now take you to Paris" (Dayan and Katz 1992, 11). In a way, media pose the problem of nomadism precisely: transport or transference across different spaces. This is, of course, also the problem of metaphor; *metapherein*, "to carry across." In modern Greek, *metaphor* can mean "bus." Every vehicle has its tenor, and mobility is both a topic of fantasy life and its modus operandi. My aim in this essay is to sound some of the genealogical depth of concepts of mobility and, in the process, to explore the mobility of concepts.

comparing concepts of mobility

Exile, diaspora, and nomadism are concepts with important differences. "Exile" suggests a painful or punitive banishment from one's homeland. Though it can be either voluntary or involuntary, internal or external, exile generally implies a fact of trauma, an imminent danger, usually political, that makes the home no longer safely habitable. Of the three notions, exile most explicitly invokes a home or homeland. Victor Hugo called exile the "long dream of home" (in Simpson 1995, 1). Salman Rushdie called it "a dream of glorious return" (in Naficy 1993, 17). In a recent essay, significantly titled "Exodus," Benedict Anderson (1994) makes much of Lord Acton's maxim that "exile is the mother of nationality." These quotes suggest another feature of exile: its fecundity in producing compensatory fantasies and longings. Exiles everywhere can agree with Odysseus's description of his homeland before the court of Alkinoös: "for my part, / I cannot think of any place on earth sweeter to look at" (*Odyssey* ix, 27–28).

The shock, disruption, or loss accompanying exile, together with the distance from the home's mundane realities, can invite the project of restoring the "original"—the original home, the original state of being. Idealization often goes with mourning. When Walter Benjamin (1968, 229) cites the stage actor's feeling of "exile" before the movie camera, for instance, he uses a rhetoric of displacement and loss to describe the shock of new audiovisual technologies. Restoration, however, often conjures something new, such as a social configuration among exiles that never obtained in the old country. Scholars from Robert Park (1922) to Hamid Naficy (1993) have noted how media such as the immigrant

press or exile television, in seeking to provide a substitute homeland in foreign climes, end up serving surprising and ambiguous functions—acculturation and integration for Park; nostalgia, fetishism, and new kinds of political struggle for Naficy. As a form of cultural invention, exile often conjures something new in the very act of looking backward.

Diaspora, like exile, is a concept suggesting displacement from a center. The paradigm case of a diaspora is of course the successive scattering and reconstitution-in-dispersion of the Jews after the Assyrian, Babylonian, and Roman conquests. In Jewish thinking, *exile* and *diaspora* are sometimes synonymous. The Hebrew terms *galut* and *golah* can be translated as both. Much in the Jewish historical experience of diaspora suggests the yearnings of exile: next year in Jerusalem! Yet despite their close affinities, in recent usage *diaspora* often lacks the pathos of *exile*, a term that is never without a deep sense of woe. Like exile, diaspora can be elective or imposed; perhaps the historical lack of zeal for returning to Jerusalem on the part of some Jews, grown comfortable in the diaspora, lifts the burden of homesickness from the notion of diaspora. The existence of the state of Israel likewise severs notions of diaspora from exile, since there is no political obstacle to return. The key contrast with exile lies in diaspora's emphasis on lateral and decentered relationships among the dispersed. *Exile* suggests pining for home; *diaspora* suggests networks among compatriots. Exile may be solitary, but diaspora is always collective. Diaspora suggests real or imagined relationships among scattered fellows, whose sense of community is sustained by forms of communication and contact such as kinship, pilgrimage, trade, travel, and shared culture (language, ritual, scripture, or print and electronic media). Some communities in diaspora may agitate for return, but the normative force that return is desirable or even possible is not a necessary part of diaspora today, especially with the loosening of its definition since the 1960s charted by Tölölyan (1996).

Quite in contrast to both exile and diaspora, *nomadism* dispenses altogether with the idea of a fixed home or center. Whereas exile often occurs in relation to some looming authority figure who wields power over life and death, nomadism can involve active defiance of or furtive avoidance of the sedentary authority of state and society (often to the peril of actual nomadic societies). If diaspora suggests a geographically dispersed network, the concept of

nomadism suggests a face-to-face community, usually linked by ties of kinship stemming from a real or imagined common ancestor, that travels as a unit. The attitude of stealth toward settled power and lack of a permanent homesite are celebrated in recent conceptual raids on nomadic life by some social theorists discussed below. For nomads, home is always mobile. Hence there is a subtle doubleness here: being at home everywhere, but lacking any fixed ground. Nomadism, as I will argue, has a different relation to home than exile or diaspora: in nomadism, home is always already there, without any hope or dream of a homeland. Nomadism sunders the notion of home from a specific site or territory, being homeless and home-full at once.

The mobility of concepts of mobility is again noteworthy. All three notions possess a remarkable capacity to multiply beyond the historic conditions that gave them birth. In psychoanalysis *exile* can describe the fact that time, by destroying the objects of our love, makes a desire for return (that is, repetition compulsion) a structural element of the human psyche. *Diaspora* has become a term of dizzyingly diverse applications to peoples and conditions (Band 1995; Chaliand and Rageau 1995; Clifford 1994; Tölölyan 1996). Nomadism has even been nominated as the epitome of postmodern subjectivity (Braidotti 1994). Curiously, exile, diaspora, and nomadism are both some of the newest stories in the Western world and some of the oldest. Our inevitable indebtedness to the ancients for our most recent and most resistant notions should be a puzzle for those suspicious of the shadow cast by canons. Otherness has tarried in a constant internal exile in European thinking. Its exodus from bondage is no simple matter.

brief history: bible to romanticism

Traces of the Bible inflect current debates about identity and difference. When W. E. B. DuBois wonders at the beginning of *The Souls of Black Folk* (1953, 3), "Why did God make me an outcast and a stranger in mine own house?" he explicitly uses a biblical idiom to describe double consciousness. When Stuart Hall (1994, 392), nine decades later, argues in a similar vein that we should consider "identity as a 'production' which is never complete, always in process, and always constituted within, not outside representation," his idiom is far from biblical, but his point is not (except for

his important renunciation of transcendental sources of the self). That human identity is discontinuous with itself is perhaps as central to Jewish and Christian visions of the human, in their different ways, as it is to poststructuralist theories of subjectivity. The incompleteness of the self and estrangement from the home are their common themes. The discovery of plural and fluid identities owes something to the long, divergent exploration of *galut* and pilgrimage in Jewish and Christian-romantic thought (Megill 1985, chap. 8; Handelman 1982).

Let me briefly rehearse the centrality of wandering to biblical narrative. Social categories of stranger, pilgrim, outcast, vagabond, tent dweller, and nomad all receive primordial formulation in the Hebrew Bible. Human history, according to Genesis, begins in the dual exile from the Garden of Eden and the presence of God. Death and labor are the constant markers of this exile. The quarrels between the brothers Cain and Abel or Jacob and Esau concern in large part the relative privilege of a sedentary agricultural life versus a nomadic hunting one (with different valences in each case). These modes remain in competition for much of the Hebrew Bible. The biblical history of the Jewish people more generally has been capable of almost infinite extension—to early Christians, Muslims, Puritans, Mormons, black nationalists, Rastafarians, radicals, reactionaries, and secularists of all stripes. Tent dwelling, covenant, captivity, exodus, forty years of wandering, entry into the promised land, battle with the Philistines, kingdom building, dispersion, exile, and return are all themes that have proved endlessly suggestive for political actors (Walzer 1985). The authors of Genesis and Exodus, together with those of the Deuteronomic historical writings, all had a keen sense of irony concerning the way that history turns against the best- and worst-laid plans of men and women. This history in many ways became history par excellence.

Galut and *golah* are used in the Hebrew Bible for captivity and deportation, especially for the Jews taken captive in Babylon after Nebuchadnezzar's conquests of Jerusalem in 597 and 587 B.C.E. When Babylon in turn fell to the Persians in 539 B.C.E., King Cyrus allowed the Jews to return to Jerusalem and rebuild the temple, a story told in the books of Ezra and Nehemiah. But not everyone chose to return, much to the dismay of some rabbis later, who followed the prophets in interpreting exile as a penalty for disobedience. Following Alexander's conquests in the fourth century B.C.E.,

Jews were scattered throughout the Mediterranean world, united by the Torah as scriptural center and Jerusalem as geographic center of annual pilgrimage (Acts 2:5–11; Menache 1996). In some sense, the diaspora recapitulates the early nomadic history of the Jews prior to the settledness of the Davidic dynasty (Boyarin and Boyarin 1993, 717).

The term *diaspora* first appeared in the Septuagint, a Greek translation of the Hebrew scriptures made for the Hellenizing Jewish community in Alexandria; begun sometime in the third century B.C.E., the Septuagint was the medium through which most early Christians, whether Jewish or gentile in origin, would encounter the Jewish law, prophets, and writings. Used in Deuteronomy 28:25, the term *diaspora* combines *dia* (through, throughout) with *spora* (sowing, scattering, dissemination; related to the English *spore*, *spread*, and *sperm*). The notion of the diaspora as the dispersed Jewish community outside of Judea was first developed in the Hellenistic era as well. The existence of a diaspora posed a theological dilemma, for residence outside the holy land was widely seen as a penalty for national transgression. After the Roman destruction of the Second Temple in 70 A.D. and the dispersion of Jews outside of Palestine, the rabbis reinterpreted the biblical notion of *galut* to refer also to a more abstract sense of exile and alienation. Ever since, exile has been a leitmotif of Jewish thought, not only political but metaphysical. As Gershom Scholem describes meditation on exile in one strain of Kabbalah, "All being has been in exile from the very beginning of creation and the task of restoring everything to its proper place has been given to the Jewish people, whose historic state and destiny symbolize that of the universe at large" (1974, 245). The task was a gathering or restoration (*tikkun*), at once political and cosmic, that would make redemption and the coming of the Messiah possible. Exile "is not, therefore, merely a punishment and a trial but is a mission as well" (Scholem 1974, 167). Lurianic Kabbalah even ventures to assert that God's presence can go into exile. Here Scholem finds a far more radical precursor to later meditations on alienation and homelessness in Marxism and existentialism.

From deportation to exile to alienation, to imagined communities, diaspora has had a long career. Today it has moved well beyond its historically unique tie to Jewish experience. Chaliand and Rageau (1995), for example, survey Jewish, Armenian, black, Chinese, Indian, Irish, Greek, Lebanese, Palestinian, Vietnamese and

Korean diasporas, and Clifford (1994) reviews the exploding litera-
ture on diaspora. But already in the New Testament, it was applied
to the far-flung community of Christians (James 1:1; 1 Peter 1:1),
and has been used for centuries among Greeks and Armenians. The
dispersion of *diaspora* has been occurring for a long time.

The notion of diaspora is quite suggestive for media studies.
First, diaspora suggests the peculiar spatial organization of broad-
cast audiences—social aggregates sharing a common symbolic
orientation without sharing intimate interaction. Indeed, broad-
casting stems from the same line of sowing imagery as *diaspora*
(Peters 1994). Second, the German term for *diaspora, Zerstreuung,* also
means "distraction." Hence, in German, diaspora has a double rele-
vance for media studies: scatteredness describes at once the spatial
configuration of the audience and its attitude of reception. To
indulge in popular entertainments, as the great theorists of *Zerstreu-
ung,* ranging from Heidegger to Adorno, have argued, is to go into a
kind of exile from one's authentic center. The classic complaints of
vicarious participation, sociability-at-a-distance, and pseudocom-
munity that accompany mass-cultural critique are also, in a sense,
the features that describe diasporic social organization. Such terms
as *diaspora* can sustain a variety of readings.

the tent as primal scene

Sources for the romance of nomadism in contemporary thought
are even more rich. The Bible partakes of a wide ancient fascination
with the tent as a symbol of rule, a cosmic link with the heavens,
and a redoubt against harm (Nibley 1966). The tent is an enduring
sign of both worldly authority and the flaunting thereof, and of
mobility as part of the human estate, and serves as a distant tem-
plate for much recent thinking about identity. Today and histori-
cally, the tent is an enormously charged site for making meanings
and relationships (Rasmussen 1996). Abraham, Isaac, and Jacob, the
patriarchs who became strangers in a strange land, all dwelt in
tents. The tabernacle bearing the ark of the covenant was clearly a
kind of tent, a mobile abode for God's presence. Long after the Jew-
ish people traded a nomadic existence for the settled life of farming
and cities, the pastoral life retained an ideological privilege. Even at
the pinnacle of the kingdom of Israel, King David boasted of his
childhood as a shepherd (imagery also used for the "Son of David"
in John 10). Isaiah compares the people of Israel to a tent (Isaiah

54:2; compare Isaiah 33:20). The sedentary emulation of mobile others is an enduring pattern; it continues in both social theory and social life today.

A superb example of the appropriation of tropes of mobility by the sedentary is the Jewish festival of tents, booths, or tabernacles, Sukkot. Authorized in Leviticus 23:33–44, Sukkot commemorates the Israelites' dwelling in tents in their forty years of wandering after the exodus from Egypt. After Passover and Shavuot, Sukkot is the third and final annual pilgrimage festival, which all recall different stages of the exodus from Egypt. Sukkot requires the celebrant to build a tent or hut (a *sukkah*) of specific kinds of leaves and branches, a transient dwelling in which one is to eat, study, and otherwise live for seven days (the fifteenth through twenty-first days of the month of Tishri). The dwelling must be temporary, to signal the impermanence of life and to remind its occupants that the people of Israel were once tent dwellers. In Sukkot an ancestral necessity (tent dwelling) becomes a religious holiday. As Moses Maimonides put it, "During these seven days one should regard his house as a temporary home and the booth as his permanent home" (in Goodman 1973, 60–61). What Strassfeld (1985, 147) says of the *sukkah* can be said of all tents: "The sukkah, then, evokes opposing sets of images: rootlessness and home, wandering and return, exposure and shelter." Unlike other forms of imaginative nomadism amid a sedentary order, ancestry, not allure, is the basis of identification in Sukkot. A host of others since, for better and for worse, have imitated the Jews in their imitation.

Like *diaspora*, *nomad* is of Greek origin. It comes from *nomas* (*nomados* in the genitive case), a word for feeding or pasturing, and is related to *nomos* (law) and *nemesis*, the root *nem-* having to do with allotment or sharing (Laroche 1949). The ancient Athenians argued about most everything but agreed that it was inhuman(e) to live without the benefits of community or *polis*, a conception that colored their forays into anthropology and their decidedly mixed views of nomadic peoples. For Aristotle, the solitary person was like a chesspiece without a board; only a beast or a god could live outside a city (*Politics*, 1253a). The *Iliad* (ix.63) denounces warmongers as "brotherless, lawless, without hearth or home," as if this were the worst possible curse, and Sophocles's *Philoctetes* dramatizes the impossibility of being human without friendship, companionship, and citizenship (MacIntyre 1984, 135). To Greek thinking, those who lived

sporadēn (related to *diaspora*) or in a dispersed and roving style necessarily lacked the human fellowship available in the *polis*. At the moment when Oedipus discovers what he has done, he wishes a curse on whoever found him *"nomados"*—that is, cast away or exposed—as a baby (*Oedipus Rex*, line 1350), a condition he must now reenter as a criminal and outcast. *Nomas* used with a feminine article could also mean "prostitute," suggesting an enduring pejorative link between mobility and femininity (compare the English *tramp*) and pointing to the long masculine gendering of travel (Wolff 1995). The English term *noma*, an ulcerating sore, is also related to *nomad*; it has the sense of grazing (destructively) across a surface. In ancient Athens, in sum, nothing nomadic was desirable: a wandering life was the curse of the outcast and the barbarian. In this the Greeks were opposed to Jewish, Christian, and Muslim thought.

A more literal flight into the wilderness than the festival of booths offered is a recurring theme in Judaism, Christianity, and Islam. In the desert one may transcend the opulence and temptations of a civilized life, a path taken by a diverse cast of characters: the Rechabites (Jeremiah 35) who moved to the desert for spiritual purification, voluntarily reenacting Israel's forty years of wandering; Jewish sectaries in the Hellenistic era who moved into the desert to preserve religious purity against the Hellenizers (1 Maccabees 2:29–31); early Christian monastics and pole-sitters, whose tradition grew out of the example of the Essenes and other voluntary exiles from Hellenistic civilization, a theme dramatized in Luis Buñuel's film *Simon of the Desert*; or the flight of Mohammed from Mecca to Medina, the *hijra*, a doctrine since elaborated to include concepts such as spiritual withdrawal, settlement, and migration (Masud 1990). That nomadic life is an invigorating escape from the decadence of the city is argued perhaps most distinctively by ibn Khaldun, the fourteenth-century Arab historian, who saw history moving cyclically between sedentary civilization and the refreshing harshness of the desert.

The Greek word for tent, *skēnē*, used in the Septuagint and New Testament for "tent" or "tabernacle," has its own fascinating history. The source of the English *scene*, *skēnē* once referred to the theatrical stage in classical Greece. Initially a booth built to house the actors, the *skēnē* had become by the fifth century B.C.E. a building holding mechanical devices for staging theatrical productions, including the famed *deus ex machina* (Arnott 1963). The tent is a place

26

for displays of power in the Hebrew Bible as well: the tabernacle served as a stage for God's presence (for instance, Numbers 9:15ff.). Yet while the *skēnē* in Athens was public and open, the holy of holies in the tabernacle was off-limits to spectators, though the tabernacle was a center of assembly for the people generally. The primal scene, then, is quite literally a tent: the place of theater is a temporary dwelling raised for that purpose. *Mise en scène* etymologically means "putting into a tent," creating conditions for the drama to unfold. The *skēnē* combines the transportation of the tent and the transport of fantasy. As an apparatus for performance, the Greek *skēnē* invites mental travel in the realm of identity, as actors project themselves into fictional roles and audiences identify with them; thanks to the *skēnē*, people momentarily are transported into identities not their own. The ancient *skēnē* was a machine for travel across space, time, and identities.

Christian teaching takes the tent metaphor further in a variety of ways. The Church fathers Origen and Jerome, among many others, compared the church to a tent, and the veil on the temple to the tent in which God dwells (Nibley 1966; compare Hebrews 8:2, 9:3). Perhaps the central Christian appropriation of the image of the tent is in the prologue to the Gospel of John (1:14): "And the Word was made flesh and dwelt among us (ὁ λόγος σάρξ ἐγένετο καὶ ἐσκήνωσεν ἐν ἡμῖν)." The word rendered as "dwelt" (*eskēnōsen*) literally means "pitched a tent" (*skēnē* again) but has the larger sense of "dwelling." Thus the word is figured as making a *scene* that God may be manifest. Some commentators take the writer of the Gospel of John to be figuring Christ as the new tabernacle or tent; in later Christian elaboration, the church becomes the body of Christ, an expanded tent and place of assembly (*ekklēsia*), like the Greek theater or Mosaic tabernacle (*skēnai* both). In short, the Gospel of John treats what Christian theologians call the incarnation as a tent. The implication is that even when God himself comes to earth, he is a temporary passenger who does not expect to find a homeland.

Probably the key development in Christian nomadic imagery is the equation of tenting with human existence generally, and with the body in particular. Though the body had been compared to a tabernacle or *skēnos* in Greek by Plato, Hippocrates, and Democritus, St. Paul does most to solidify this image. The human body for him is a temporary, mobile dwelling in which mortals sojourn on

earth. In Galatians 2:9 Paul even calls Peter, James, and John the three tent poles of the church—*styloi* (usually translated as "pillars"). It is fitting that Paul was by trade a tentmaker (*skēnopoios*; Acts 18:3). In his theology, mortals are subject to pain and suffering as they await the eternal dwelling God will provide (2 Corinthians 5:1–4; compare 2 Peter 1:14). Paul's views on the body are famously troubling for both women and men (Brown 1988), but he treats nomadic motion as the human condition: We are all tent dwellers in a desert space (the world), inhabiting tents made of flesh (our bodies).

The Pauline book of Hebrews is, as the title suggests, a New Testament book explicitly addressed to a Jewish audience. This book is a *midrash*, or interpretive expansion of older Hebrew themes, including the faithful as nomads in the desert. "By faith Abraham obeyed the call to go out to a land destined for himself and his heirs, and left home without knowing where he was to go. By faith he settled as an alien in the land promised him, living in tents, as did Isaac and Jacob, who were heirs to the same promise. For he was looking forward to the city with firm foundations, whose architect and builder is God" (Hebrews 11: 8–10, New English Bible). This passage gathers up an entire tradition of understanding the life of faith as a nomadic wandering. To dwell in a tent is to be in the world but not of it. Christians are to emulate the patriarchs in admitting that they are "strangers and pilgrims on the earth" (Hebrews 11:13; compare 1 Peter 2:11).

Hence St. Augustine, when he calls the faithful "pilgrims [who use] such advantages of time and earth as do not fascinate and divert them from God," is heir to a much longer tradition of Jewish straying and Christian appropriation. Augustine's centrality for notions of pilgrimage is not in doubt, but he is not an architect, only a developer (*pace* Bauman 1996). Augustine's principle is clear: The city of God is not on the earth, so the faithful must be wanderers, sojourners, pilgrims, exiles from Eden and heaven. They cannot expect to find a home on this earth. Their bodies are in the world, but their souls point elsewhere. The narrative of wandering outcasts was alive for that branch of Puritans immortalized in the national lore of the United States as the Pilgrims, for seventeenth-century Dutch settlers in southern Africa, and for the Mormons, with their enforced errand into the wilderness, each of the three self-consciously adopting the Judeo-Christian tradition of exodus

and resettlement to their own circumstances, including, in the first two cases, a violent stance toward native peoples. Whereas for Sophocles or Aristotle, wandering outside a city was a disgrace, it was an honor among Christian monks, mystics, and dissidents. The point in this long tradition is that the worldly scene of time and death cannot satisfy the divine spark within; all truces with the here and now must be temporary, lest we invest in stock destined to drop precipitously. Identity surpasses any construction it may receive.

As Hegel insisted, romanticism is continuous with Christianity, especially in its vision of the human condition as the infinite imprisoned within the finite. Quest, exile, and impossible love are major themes of medieval romance (Rougemont 1956). In nineteenth-century romanticism—in philosophy, literature, art, music, and politics—much of the picture of humans as sojourning pilgrims is preserved without the theological content. And much of current thinking about exile, diaspora, and nomadism is inescapably colored by romantic elements. The romantic ego, like the Christian pilgrim, suffers from the disproportion between capacity and circumstance. Not a romantic himself but a source for many who followed, Kant (1952, 11) wrote that the feeling "that the temporal is inadequate to meet and satisfy the demands of his existence" is found "in the breast of every man." Humans, defined romantically, are the eternal caught in time. "Philosophy," said the German archromantic Novalis (1969, 491), "is actually homesickness, the urge to be everywhere at home."

Novalis captures the two sides of romanticism: homesickness and being at home everywhere. To be schematic, the first option is exile and the second is nomadism. The Christian sojourn on earth was an exile from God's presence, a vision that could provide both a certain existential security (thanks to God or his providence) and a critique of any really existing homelands as inadequate. With the "disappearance of God," a central fact that romanticism confronts and contributes to (Miller 1963), many romantics start to look more anxiously for homelands on earth. Much of nineteenth-century European nationalism was fed by romantic lexicographers, folklorists, poets, composers, and reformers. Their sense of national disrepair and exile from glorious pasts inspired the creation of new homelands (which they of course claimed to be of great antiquity). Nationalist invention is a fine example of the prin-

ciple that nostalgia, while pretending to be only a by-product of loss, is in fact a productive cultural agent. The term *nostalgia*, in fact, is a neo-Greek loan translation of the German *Heimweh* (homesickness): *nostos* (return home) plus *algos* (pain). At first used to describe the pathologies of those long separated from their homelands, such as sailors, only by the 1920s did *nostalgia* assume its current sense of wistful yearning for days gone by. The migration of the term from nationalism and medicine to retrospective wishfulness and *Sehnsucht* (yearning) reminds us of the degree to which romantic cultural movements in nineteenth-century Europe were often conservative, sometimes even slouching toward fascism (as in the German case). The history of nostalgia also evinces a shift from a lost home in space (the patria) to a lost home in time (the past).

Nomadism represents the second side of Novalis's dictum: the desire to be everywhere at home. Conveniently enough, the term *nomadism* was coined, according to the *Oxford English Dictionary*, by Ralph Waldo Emerson in his 1841 essay "History." The term *nomad* is, as we have seen, at least as old as Herodotus, but *nomadism* is something new, a doctrine of how the soul may exist in the world. Emerson, heir to the Christian-romantic tradition of pilgrimage, suffered from philosophical homesickness, but found his home wherever he happened to be. He calls *nomadism* one of two competing forms of world-historical social organization: "In the early history of Asia and Africa, Nomadism and Agriculture are the two antagonist facts" (Emerson 1981, 117). Nomads were "terrors to the state," town, and market, which gave farming the sanction of a religious duty. But this antagonism is still with us: "in the late and civil countries of England and America these propensities still fight out the old battle, in the nation and in the individual" (117). In the nation, nomadism in Africa is driven by the gadfly, and in Asia by shifting pasturage; but in "America and Europe the nomadism is of trade and curiosity" (117). In individuals, the antagonism shows itself as "the love of repose" or "the love of adventure" (118). "A man of rude health and flowing spirits has the faculty of rapid domestication, lives in his wagon and roams through all the latitudes as easily as a Calmuc" (118). The "faculty of rapid domestication," Emerson continues, is also cognitive: what he calls "intellectual nomadism" allows one to find "points of interest wherever fresh objects meet his eyes" (118).

Whether Emerson was in fact the first person to write of

nomadism per se or not, several things are noteworthy. Nomadism for him includes the self, not only the other; it implies a set of attitudes about place and dwelling; and it is used to refer to "civil countries" and not only exotic lands distant in time, space, or culture. The concept of nomadism, in short, was born metaphorical. It always was extravagant. "Everything good is on the highway," Emerson wrote (1981, 335), prophesying a theme in the subsequent history of American letters. But he also saw that romantic longing could depreciate the here and now by locating our home in impossibly distant places: "Every ship is a romantic object except that we sail in" (327). As Stanley Cavell (1988) has argued, Emerson explored the uncanniness of the ordinary. The strangeness is not without but within; there is no home per se that is a safe place from the strangeness, since home is the site of the uncanny, the double, time, "language, sleep, madness, dreams, beasts, sex" (Emerson 1981, 4). "To the wise, nothing is strange," said Antisthenes, ancient founder of the Cynics; to the wise, Emerson would respond, nothing is ordinary. In Emerson there are no premature homecomings: no quick *nostos*, no ready identification of *Heimat, Blut,* or *Boden,* which we associate with fascism and nationalism. Emerson provides a model of cheerful homelessness. Further, his is not a macho romance of the road. He does not fear domestication (a quintessential masculine motive for travel) but embraces "the faculty of rapid domestication." His is the attitude of a tent-dweller for whom home is always already here. As his disciple Thoreau put it, the art is to travel without ever leaving home.

recent debates and echoes

The stance toward home and homelessness is crucially different between the attitudes of exile and nomadism. Exile locates the home in a homeland that is distant and for the time being unapproachable. Home becomes an impossible object, always receding with the horizon. In claiming a permanent residence on earth, to be away from the homeland is always to be homeless. Nomadism, in contrast, denies the dream of a homeland, with the result that home, being portable, is available everywhere.

These two stances represent options within contemporary debates about identity; globally speaking, exile goes together with notions of primordial identity and nomadism with constructed

identity. Broadly, exile is the attitude of critical race theorists, Afrocentrists, multiculturalists, and some versions of difference feminism, not to mention nationalist and ethnic movements. In this view, everyone has a culture (or home), but some are in exile from it, living the alienation of a double life, marked as other but never recognized for what they really are. The nomadic trope of "passing" thus describes precisely what is most traumatic about living in an alien culture: suppressing the soul for the sake of protective coloration. Such discourses often, and in an explicitly utopian way, portray some sort of Zion in which all could be authentically themselves (mother Africa, feminist utopias).

In contrast, nomadism is the attitude of poststructuralists (feminists, Marxists, and others), many liberals, cosmopolitans, and postmodernists generally. To the exilic doctrine of primordial identity they oppose a doctrine of social construction. To Herder's dictum that every people has its own folkways and history that must be remembered on pain of rootlessness they counter with Renan's formula that collective identity emerges out of forgetfulness (Anderson 1991). They take "passing" not to be a particular trauma but to be part of the characteristic motion of subjectivity through signs, otherness, and time. Most of them see in the nation-state no promised land, only another Pharaoh to challenge.

the critique of homesickness

Each of these two positions has a critique of the other. Nomadic thinkers generally find illusory the quest for any fixed identity or homesite. Romantic *Heimweh*, they argue, is explicitly dangerous. All homes are an accomplishment of sublimated violence, unities pasted together by the will to power and the fear of difference. The Nazi love for *Heimat*, the Freudian and feminist critiques of the domestic sphere, can all be invoked to show the dark side of homey unity. Germaine Greer puts it well: "Failure to recognize the fact that earthly home is a fiction has given us the anguish of a Palestine and the internecine raging of the Balkans. The ideology of home primes the bombs of the PPK and the IRA. The rest of us can face the fact that our earthly journey is a journey away from home" (in Simpson 1995, 233). Though she skids too lightly over the reasons some people might want a home and overcongratulates those strong enough to live without homesickness, Greer expresses the central thesis of much recent nomadic thinking: the salutary con-

sequences of seeing fictions everywhere and the terroristic conse-
quences of identity without difference, "the terrifying stupidity of
that illusion of unity" (Braidotti 1994, 12). And Greer does so in a
language that Augustine could accept. To see self, home, home-
land, world as works we collectively author liberates us, in the view
of both cosmopolitans and poststructuralists, from other-denying
dreams of communion and homogeneity. Here the nostalgia for a
home in exile and diaspora is directly attacked.

The nomad is explicitly a hero of postmodernist thinking.
Deleuze and Guattari (1986) are the main source; via Nietzsche
their thinking can trace a distant lineage to Emerson. The point of
the nomad, as of the philosopher, is to invent concepts that defy
settled power. As Braidotti (1994, 5) argues, "It is the subversion of
set conventions that defines the nomadic state, not the literal act of
traveling." Though she is careful to note the danger of romanticiz-
ing the nomad, Braidotti's description announces central romantic
themes: Nomads liberate thinking from dogmatism, break through
convention to new life and beauty, and prize the mobile diversity of
being. Nomads also provide a sort of mobility that avoids the rapac-
ity of the explorer and the gawking of the tourist. Ultimately at
stake in the concept of nomadism is the dream of radical liberty, of
roaming at will, beholden to nothing but the winds and the stars.
Freedom is the dream in Deleuze or Braidotti, as it is in the festival
of the tabernacles or Augustinian wandering, where dwelling in
tents signifies freedom from the Egyptian yoke or the earthly city.

Another attitude emerges from the same cluster as nomadism,
but with a very different tonality: *camp*. The term's association with
the tent is not accidental; camp glides across the surface and never
hammers the stakes too deep into the ground. In his witty book
Camp, Mark Booth (1983) scans debates about the origins of the
term. These lie, he argues, much deeper than mid-twentieth-cen-
tury theorists such as Christopher Isherwood or Susan Sontag.
Before even such avatars as Oscar Wilde and Beau Brummel, Louis
XIV's court at Versailles is the birthplace of camp. *Camp* comes from
a French reflexive verb: "*Se camper* is to present oneself in an expan-
sive but flimsy manner (like a tent), with overtones here of theatri-
cality, vanity, dressiness, and provocation" (Booth 1983, 33). The
semantic migration of *camp* from the military field or camp (*champ*)
to ostentatious self-display owes to the fact that the king's court
would accompany him on military maneuvers: "the spectacle and

display of court life was transferred to the camp, which differed only in its lightness and impermanence. The camp was an insubstantial pageant, a byword for transient magnificence where men were encouraged to wear their finest costumes, to preen themselves—indeed, to advertise themselves" (40). The person who camps it up quite literally makes a scene (*skēnē*). This notion of camp invokes a more ancient idea, that the court itself is a gigantic tent that anchors the universe—much like Genghis Khan's resplendent baldachin. "The idea of tents did not then call to mind the small khaki, utilitarian apologies of today, but great billowy creations of shining fabrics—satins and silks studded with jewels, tapestries, and gold banners" (39–40).

Booth (a writer aptly named for this argument) helps us sees how the campy attitude of decor, exaggeration, and theatricality irreverently fits with the Christian celebration of being in the world but not of it. Both Christian otherworldliness and camp meet in the wish to hover over the normal order of things. Camp does not seek to return to a primal unity; it transfigures boredom into giddiness. Nothing may be strange to the wise, but everything is potentially amusing to the camper; one learns to travel light. The privilege of campers, pilgrims, and nomads is the liberty is to imagine and present themselves as they please. In contrast to the distraction theorists, who see in popular entertainments exile from authenticity, the campers find here a place to linger awhile. They see neither loss nor lamentation, but lightness.

the critique of exoticization

The discourse of exile has a countercritique of nomadic camping and roving. Theorists of a more settled form of identity argue that the ability to "roam through all the latitudes" (Emerson) is based in privilege—that of race, gender, class, language, nation. Not everyone has the luxury of extravagant identity; some identities are kept in their place by forces such as white supremacy, patriarchy, and capital. The resources for self-invention are unequally distributed. Those in exile did not choose to lose their homes and homelands; mourning is not their fault but a fate. Moreover, nomadic identification often preys on the other without giving anything back. Metaphoric projection and political persecution go together. Dead others awaken romance, but living ones awaken hostility. Blackface, native mascots, and fascination with the other's vitality all

practice a kind of cosmopolitan chic—taking the allure but none of the pain. The center thus feeds at a prissy distance on the wild glamour of minorities while neither alleviating their hardships nor recognizing their autonomy. People of color thus have real reasons for suspecting a whiteness that joins—and effaces—all colors. Exoticization goes with oppression; Others can end up in a "sort of human zoo" (Lavie 1991, 29). Desire for the Other can be aggressive as well. Hence emulation of the Jews by Gentiles has gone intimately together with their persecution; in the same way, the romance of gypsy life has done nothing to protect nonmetaphorical gypsies from state oppression. Bonnie Honig (1997) summarizes the point well: "Nationalist xenophilia produces nationalist xenophobia as its partner." "Hell," as Salman Rushdie quips in *Midnight's Children*, "is other people's fantasies."

In this view, postmodern nomadism is precisely a case of dangerous imaginative projection. Gellner (1983, xi) notes that nomadic cultures have been a canvas for moderns to paint Rousseauist idylls: "Here every man was not merely shepherd, but also bard, orator, soldier, historian, senator, and minstrel." The fascination of nomads for anthropologists and tourists, then, consists in their offering a vision of wholeness quite at odds with a society with an advanced division of labor. Scholarship is thus continuous with larger wish-structures. Lila Abu-Lughod, surveying the anthropology of the Arab world, likewise notes the allure of nomadic groups, who, though barely 1 percent of the Arab population, have received a disproportionate share of scholarly attention. She argues that a masculine romance of tough rovers (one often cultivated by nomadic groups themselves) makes them appealing to anthropologists, especially men: "These are real men, free from the emasculating authority of the state and polite society" (1989, 286). Finally, Renato Rosaldo, in an essay titled "From the Door of His Tent" (1987), criticizes his fellow anthropologists for their imaginative affiliation with nomads as fellow itinerants, when in fact there is little symmetry between observer and observed. The anthropologist serves, in many cases, as a foreign correspondent for the center—a composer of court pastoral, itself a metropolitan genre that portrays the Arcadian wilds far from the intrigues of the court. The specter of "zoo groups" (Lavie) arises again: the anthropologist as circus showman, unwittingly trafficking in the frisson of otherness to a settled society.

Likewise, exile theorists have a very different take on camp. Instead of frivolous hermeneutics and vainglorious self-display, they would point to refugee camps as dreary and violent realities in which displaced peoples are forced to live. Here camp signifies not liberty but captivity; not a stance of play, but one of survival. Tenting can be a condition of misery and subjugation as well as autonomy. The critique continues that those with political rights and civil securities can extol homelessness all they want but that such talk is profoundly dangerous for those who are in fact homeless. Though nomadism may inspire theorists, actual nomads arouse disdain and disgust from nation-states and their citizens (Bourgeot 1994). A discourse of exile, with its requisite of a secure home, is superior to that of nomadism for political agitation on behalf of the oppressed. Identities are not only invented; they are also disciplined. For exile theorists, then, a militant defense of primordial identity, a rhetoric of rigid naming, and outrage at the poaching of exotics may serve as survival strategies, a salvaging of pride or security in a hostile world.

the inevitability of fantasy

Inasmuch as the world is cruel and its history one of oppression, we will always need a discourse of exile. As I have defined it, exile is the quest for an earthly home or homeland from which one is, for whatever reason, estranged. Exile is an idiom available for the uprooted and abused, an insurgent rhetoric that can comfort the captives or petition the captors.

In the exigencies of political struggle, however, some things get said that are far from robust truths about human experience. Exile talk can be a crucial intervention, but if institutionalized without care, it can distort the relationship between representation and oppression disastrously and exercise a tyranny over permissible forms of identity. Terms of identity (such as *nomad, queer, black, white*) have no literal ground, no singular site of origin; though they have real power, and real referentiality, they are born metaphorical. *Bohemian*, for example, came in mid-nineteenth-century France (and to a lesser extent in England) to denote an *artiste* who flaunted social convention. It was already a couple of removes from actual people: *bohemian* derives from a term for gypsy, a people falsely thought to originate in Bohemia (the name *gypsy* itself incorrectly

posits an Egyptian origin). No one expected a "bohemian" like Charles Baudelaire to speak Romany. The term suggested an extravagant sexual life, mobility in abode, and freedom from governing morality. These traits are less about Rom culture than they are a wish-image of bourgeois morality standing on its head. Nineteenth-century France described itself while dreaming of others. It would be foolish to fault Baudelaire for being an inauthentic bohemian or for vampiristically extracting the lifeblood of another's culture. That identity, like most others, existed first as a dream of itself. There is no ultimate property in identity. We do not own; we rent. That is, we camp—sometimes playfully, sometimes by necessity.

My foregrounding of the figure over the ground, the poaching over the property, again marks me as preferring nomadism, all things being equal, to exile. I fear the moral rigorism of identity politics, and more specifically, its ascetic attacks on fantasy and emulation. Fantasy arises from the human condition of incompleteness. Insofar as all identity is nomadic, a metaphor, a carrying-across, we must be prepared to find emulation, hybridity, mimicry, and parody everywhere (Bhabha 1994). Of course intergroup mimesis will be structured by power; what is not? The dignity of self-representation does not, in my view, include strict regulation of others' representations, even those of one's own group. In nomadism there is a potentially tolerant stance to the here and now; in exile the nostalgia for the one true home can, at its worst, iconoclastically smash whatever does not measure up. Our job is to fight the injustice without pretending that polymorphous affiliation can be eliminated. Settled Jews pretend to be tent dwellers; Puritans and Rastas pretend to be biblical patriarchs; middle-class white women pretend to be pagan priestesses; native peoples pretend to be primitive for the benefit (and dollars) of the tourists. I am not asserting equivalence among such modes of imitation; some are elective, some are compulsory. The point is more basic: the inescapability of fantasy. If we believe Hegel or Lacan, the self always confronts itself first as a fantastic other; thereafter, all identity passes through otherness. Constructing others will always be part of constructing the self.

To say all identity necessarily involves projections does not mean that representations cannot be criticized. The critical question should not be whether fantastic projection is involved, for such will

never be extirpated from the crooked wood of humanity. What face-to-face relationship is free from projection, desire, and reverie? Why should dynamics among groups be any different? We should eschew the project of assigning everyone a homeland in the world of representations—white males there, black females here, red transsexuals in between—and instead join the project of attacking the inequitable allocation of the opportunity to dream and follow dreams. The critique of portrayals should move from a hermeneutics of suspicion to a pragmatics of justice. A frank avowal that all social description is metaphorical, in league with power, and interminably so, clarifies our task, which is to sort out the equity of particular cases, not to call for an anthropological puritanism in which no one would romanticize themselves or others. The only antidote to insulting fantasies is the right of reply. We need a public sphere, not a smashing of images; a conflict of representations, not a purity of depictions.

For the sake of argument, I have associated two very general stances toward identity—primordial wholeness versus constructed hybridity—with exile and nomadism. Yet exile can be an attitude quite free of nostalgia, as in Scholem's point that exile can be a mission as well as a trial, just as nomadism can be a lament for the impossibility of home. These terms are enormously subtle. In both admitting the trauma that can motivate the call for a homeland and defending nomadic identity, I follow, in large part, Stuart Hall (1994), who wants to accommodate both. His term for the theoretical mediation between authenticity and wandering? Diaspora.

In conclusion, I offer a reading of diaspora as superior to either exile or nomadism. As Daniel and Jonathan Boyarin (1993, 721) argue, "Diasporic cultural identity teaches us that cultures are not preserved by being protected from 'mixing' but probably can only continue to exist as a product of such mixing." Diaspora's lesson is that "peoples and lands are not naturally and organically connected" (723). The dream of organic connection, like the dream of universal fraternity, has dangerous edges: The difficult stance the Boyarins recommend is to be in diaspora even in one's "own" land.

Neither the exilic dream of return to organic connection nor the nomadic celebration of rootless liberty, I believe, quite offers the best option for living in a world of differences. I remain suspicious of confident and proprietary talk of one's "own culture" that

ignores the strangeness of the other that stares back at you from the mirror, and sees the clasp of the hand as only a dangerous act of appropriation. Our stance should be hands on instead of hands off. The long dream of being nomads, exiles from ourselves or God or home, dispersed far away from our loved ones and beloved land, is, admittedly, not going to disappear anytime soon. These dreams speak to anyone who has lived in time and been in love with things that vanish. The task is to keep the dreams from crushing our neighbors—or ourselves. Diaspora teaches the perpetual postponement of homecoming and the necessity, in the meanwhile, of living among strange lands and peoples. Nomadism, exile, and diaspora will abide as existential options, these three: but the greatest of these is diaspora.

works cited

Abu-Lughod, Lila. 1989. "Zones of Theory in the Anthropology of the Arab World." *Annual Review of Anthropology* 18: 267–306.

Anderson, Benedict. 1991. *Imagined Communities: Reflections on the Origin and Spread of Nationalism.* Second ed. London: Verso.

Anderson, Benedict. 1994. "Exodus." *Critical Inquiry* 20, 2: 314–27.

Arnott, Peter D. 1963. *An Introduction to the Greek Theater.* Bloomington: Indiana University Press.

Band, Arnold. 1995. "Diaspora and Diglossia." Paper presented at Annenberg Scholars Conference on Public Space, University of Pennsylvania, March, 1–4 1995.

Bauman, Zygmunt. 1996. "From Pilgrim to Tourist—or a Short History of Identity," in *Questions of Cultural Identity,* ed. Stuart Hall and Paul du Gay. London: Sage. 18–36.

Benjamin, Walter. 1968. *Illuminations.* Trans. Harry Zahn. New York: Schocken.

Bhabha, Homi K. 1994. "Of Mimicry and Man: The Ambivalence of Colonial Discourse," in *The Location of Culture.* London: Routledge. 85–92.

Booth, Mark. 1983. *Camp.* London: Quartet.

Bourgeot, André. 1994. "Nomads and the Modern State," *UNESCO Courier* (Nov.): 8–11.

Boyarin, Daniel, and Jonathan Boyarin. 1993. "Diaspora: Generation and the Ground of Jewish Identity." *Critical Inquiry* 19 (summer): 693–725.

Braidotti, Rosi. 1994. *Nomadic Subjects: Embodiment and Sexual Difference in Contemporary Feminist Theory.* New York: Columbia University Press.

Brown, Peter. 1988. *The Body and Society: Men, Women, and Sexual Renunciation in Early Christianity.* New York: Columbia University Press.

Cavell, Stanley. 1988. "The Uncanniness of the Ordinary," in *In Quest of the Ordinary: Lines of Skepticism and Romanticism.* Chicago: University of Chicago Press. 153–78.

Chaliand, Gérard, and Jean-Pierre Rageau. 1995. *The Penguin Book of Diasporas.* Trans. A. M. Berrett. New York: Viking.

Clifford, James. 1994. "Diasporas." *Cultural Anthropology* 9, 3: 302–38.

Dayan, Daniel, and Elihu Katz. 1992. *Media Events: The Live Broadcasting of History.* Cambridge, Mass.: Harvard University Press.

Deleuze, Gilles, and Félix Guattari. 1986. *Nomadology: The War Machine.* Trans. Brian Massumi. New York: Semiotexte.

DuBois, W. E. B. 1953 [1903]. *The Souls of Black Folk.* Chicago: McClurg.

Eisen, Arnold M. 1986. *Galut: Modern Jewish Reflection on Homelessness and Homecoming.* Bloomington: Indiana University Press.

Emerson, Ralph Waldo. 1981. *Selected Writings of Ralph Waldo Emerson.* Ed. Donald McQuade. New York: Modern Library.

Gellner, Ernst. 1983. "Foreword." In Anatoly M. Khazanov, *Nomads and the Outside World,* second edition. Madison: University of Wisconsin Press. ix–xxv.

Goodman, Philip. 1973. *The Sukkot and Simhat Torah Anthology.* Philadelphia: Jewish Publication Society of America.

Hall, Stuart. 1994. "Cultural Identity and Diaspora." In *Colonial Discourse and Post-Colonial Theory,* ed. Patrick Williams and Laura Chrisman. New York: Columbia University Press. 392–403.

Handelman, Susan A. 1982. *The Slayers of Moses: The Emergence of Rabbinic Interpretation in Modern Literary Theory.* Albany: SUNY Press.

Honig, Bonnie. 1997. "Immigrant America?: How Foreignness 'Solves' Democracy's Problems." Paper presented at Conference on Citizenship Under Duress, Northwestern University, 11–12 April 1997.

Kant, Immanuel. 1952. Preface to the Second Edition of *Critique of Pure Reason.* Trans. J. M. D. Meiklejohn. *Great Books of the Western World,* vol. 42. Chicago: Encyclopedia Britannica 1952. First published 1787.

Laroche, E. 1949. *Histoire de la racine nem- en grec ancien.* Paris: Klincksieck.

Lavie, Smadar. 1993. "The Bedouin, the Beatniks, and the Redemptive Fool," in *Otherness and the Media: The Ethnography of the Imagined and the Imaged.* Hamid Naficy and Teshome Gabriel, eds. New York: Harwood Academic Publishing. *Quarterly Review of Film and Television* 13, 1–3: 23–44.

MacIntyre, Alasdair. 1984. *After Virtue: A Study in Moral Theory.* Notre Dame: Notre Dame University Press.

Masud, Muhammad Khalid. 1990. "The Obligation to Migrate: The Doctrine of *Hijra* in Islamic Law," in *Muslim Travelers: Pilgrimage, Migration, and the Religious Imagination,* ed. Dale F. Eickelman and James Piscatori. Berkeley: University of California Press. 29–49.

Megill, Allan. 1985. *Prophets of Extremity: Nietzsche, Heidegger, Foucault, Derrida.* Berkeley: University of California Press.

Menache, Sophia, ed. 1996. *Communication in the Jewish Diaspora: The Pre-Modern World.* Leiden: E. J. Brill.

Miller, J. Hillis. 1963. *The Disappearance of God: Five Nineteenth-Century Writers.* Cambridge, Mass.: Harvard University Press.

Naficy, Hamid. 1993. *The Making of Exile Cultures: Iranian Television in Los Angeles.* Minneapolis: University of Minnesota Press.

Nibley, Hugh. 1966. "Tenting, Toll, and Taxing." *Western Political Quarterly* 19 (Dec.): 599–630.

Novalis [Friedrich Hardenberg]. 1969. *Novalis Werke,* ed. Gerhard Schulz. Munich: Beck.

Park, Robert. 1922. *The Immigrant Press and Its Control.* New York: Harper.

Peters, John Durham. 1994. "The Gaps of Which Communication Is Made." *Critical Studies in Mass Communication* 11, 2: 117–40.

Rasmussen, Susan. 1996. "The Tent as Cultural Symbol and Field Site: Social and Symbolic Space, 'Topos,' and Authority in a Tuareg Community," *Anthropology Quarterly* (Jan.): 14–26.

Rosaldo, Renato. 1987. "From the Door of His Tent: The Fieldworker and the Inquisitor," in *Writing Culture: The Poetics and Politics of Ethnography*, ed. James Clifford and George E. Marcus. Berkeley: University of California Press. 77–97.

Rougemont, Denis de. 1956. *Love in the Western World*. Revised ed. Trans. Montgomery Belgion. New York: Pantheon.

Scholem, Gershom. 1974. *Kabbalah*. New York: Meridian.

Simpson, John. 1995. *The Oxford Book of Exile*. London: Oxford University Press.

Strassfeld, Michael. 1985. *The Jewish Holidays: A Guide and Commentary*. New York: Harper and Row.

Tölölyan, Khachig. 1996. "Rethinking *Diaspora(s)*: Stateless Power in the Transnational Moment," *Diaspora* 5, 1: 3–36.

Walzer, Michael. 1985. *Exodus and Revolution*. New York: Basic Books.

Wolff, Janet. 1995. *Resident Alien: Feminist Cultural Criticism*. Cambridge: Polity Press.

synesthetic

homing

"is

any body

home?"

embodied imagination

and visible evictions

v i v i a n s o b c h a c k

"Help! I'm trapped in a human body!"

—anonymous caption on postcard

Who of us is "at home" in our bodies? After all, we live in a still-
Enlightened culture that, despite its current post-Enlightenment
fascination with and fetishization of the body, regards the body as
an alienated object, quite separate from—if housing—the subjec-
tive consciousness that would discipline it into shape or shape it
into a discipline. Indeed, how many of us after a hard day at the
academy lecturing about the deplorable colonization and accultur-
ation of "the" body in our contemporary culture go off (often for
all the wrong reasons) to treadmills and Stairmasters and Cybex
machines to make that body hard? Indeed, how many of us walk

around in the world feeling in the eyes of others and in our own eyes, trapped not only *by* but also *in* our pigmented, gendered, aging skin, the obesity or infirmity or flaccidness of our flesh?

In this chapter I want to meditate on some variations of the shifting ways in which we necessarily and sufficiently, ontologically and epistemologically, experience our bodies as the existential ground of our being. That is, I want to consider, both metaphorically and empirically, the various ways in which we experience our bodies as our home (where we live in transparent ease and comfort), our house (in which we reside, by choice or constraint), and a prison-house (to which we are condemned). That is, on varying occasions and in certain circumstances, our bodies are *lived as* our permanent if mutable address, as our primary if self-displacing abode, as—whether Airstream or Winnebago—our quintessential mobile home. On still other occasions, our bodies are experienced as *lived in* (the "in" is important here, and to be distinguished from "lived as"). How many of us, for example, with a certain sense of satisfaction, of cheerful American pragmatism, have turned our bodies into exteriorized projects—spending our off hours getting them into shape, giving them new faces, painting and remodeling them in quite the same house proud manner in which homeowners treat their prized and objectified secondary dwelling places? On yet other occasions and in other circumstances, how many of us have experienced our bodies not as lived, or even lived in, but *endured?* In this instance, our bodies are not transparently ourselves, taking us where we want to go, enabling us access and commerce with the world of others and things, nor do we take them up as "things" we possess in the pride or despair that attaches to the ownership of a perpetual fixer-upper. In this worst instance, our bodies seem not to belong to us at all, seem neither home nor hearth of our being, but the property of another ("property," here, referring not only to one's body perceived as the real estate of another, but also—in this alienated sense—of a defining quality that has nothing to do with one's self except through the protocols of commerce). Our bodies, insofar as we endure them, seem an objective and exteriorized physical limit holding us captive from without, constraining and restraining us from doing the things we want to do and being all that we think we can be. This is the body (perhaps ours, but not *us*) experienced as a containment cell that would inhibit our intentional movement and our volition. This is

the body experienced as a prison-house of semiotically marked flesh whose cultural display of the objectively material substance of our subjective existence—pigmentation, the shape of our eyelids, the sag of a breast or belly, the size of breasts or penis, the lack of a leg—constrains us like so many iron bars that would keep us from the free play of our existential possibilities.

Thus the body can be seen as home, as house, and as prison—as, in the first instance, the place that grounds us in a felicitous condition of enablement, that provides our original and initial opening upon and access to the world, and that gives dimension and sense and value to our lives through its motility and senses and gravity; as, in the second instance, the place in which we live in a variable relationship of hermeneutic objectification, that we decorate and display for the edification of both ourselves and others, that confounds us with problems and expense but allows us still a certain familiarity, a place to hang our hats, to let it all hang out; and, in the third instance, the same but phenomenologically quite different place, that grounds us in negativity and denies us access to the world constraint and discipline, that locks us in a room everyone regards as ours but which we understand as really belonging to others.

From a phenomenological perspective, I want us here to move beyond *thinking* just about the body (that is, about bodies always posited in their objective mode, always seen from the vantage of an other) to also *feeling* what it is to be my body (lived by me uniquely from my side of it, even as it is always also simultaneously accessible to and lived by others on their side). In this regard, it is especially important that we redeem for critical thought an understanding of the body that includes our bodies—that is, bodies not merely as they are objectively seen, but also as they are subjectively and synoptically and synesthetically lived, as they enable and contain the very meaning and mattering of matter, as they give gravity to semiotic production and circulation, and suffer as its very ground. Maurice Merleau-Ponty writes: "My body is the fabric into which all objects are woven, and it is, at least in relation to the perceived world, the general instrument of my 'comprehension'" (1962, 235). Furthermore, he tells us: "I am not in front of my body, I am in it, or rather I am it" (150). Reminding ourselves that we are not in front of" our bodies and that our bodies are lived and make meaning in ways that far exceed the particular sense-making capacities

47

of vision is especially important in a culture in which vision dominates our sensory access to the world and in which a discrete emphasis on visibility and on the body as image—what it looks like in front of others and ourselves—have greatly overdetermined the more expansive possibilities of how our bodies make sense in and of the world. Our culture's increasing valorization of the visible has greatly reduced the sensual thickness of lived experience to a single and dare I say soulless dimension.

I am going to go out on a humanist limb and make some essential claims about humanly embodied existence. In general, and barring extreme neurological or psychic pathology, every human body lives its subjective and objective existence both transparently and opaquely, transcendently and immanently. Our bodies are, at once, the transparent enabling power and "zero-degree" of our agency and yet are also opaque—within our agency, yes, but certainly in excess of our volition. In the most mundane ways, our material existence both grounds and motivates us. We take it so for granted that our bodies are not lived as visible sights but more fully, as sense-making sites for constituting meaning and realizing a sensible world. I walk to the door without a thought. As I walk to the door I think thoughts without a thought of the body that transparently makes not only my walking but also my thoughts possible, providing the primary premises for their possible logics, the material grounding for their horizon of significance and their symbolic sense. But I also live my body opaquely—and not merely because, at this point in time, the companion to that humanist limb I have gone out on is, in fact, a prosthetic leg that I have almost but not yet fully (that is, transparently) incorporated as me.

Indeed (and prosthetic leg aside), some of the opacity and objectivation we experience in relation to our bodies is grounded in certain essential and necessary conditions of being human—that is, in the very material nature and consequences of being an embodied consciousness, an objective subject who has heft and weight and gravity in the world, who not only sees but also can be seen, who not only touches but also can be touched, who not only hears and smells and tastes but also can be heard and smelled and tasted. As philosopher Gary Madison summarizes: "Consciousness . . . is not a pure self-presence; the subject is present to and knows itself only through the mediation of the body, which is to say that presence is always mediated, i.e., is indirect and incomplete" (1992, 92). Thus,

every body lives as both subject and object in the world, not only for others, but also for oneself. Even as children, although we thoughtlessly, transparently, plunge our bodies/ourselves into the living of our lives, we also pick at the scabs on our knees, hermeneutically probing for the secrets beneath. Thus while it is our body that primarily grounds us in the world as a transparent capacity of action, its materiality often nonplusses us, undermines us, overruns us precisely at the moment it stops us short. Embodied, we are enabled and can realize our intentional projects in the world, but, at the same time, we can never be completely coincident with or self-disclosed to ourselves—and this despite the proliferation of imaging technologies meant to reveal our "insides" but which instead merely show them to us in all their unforthcoming mystery.

Nonetheless, alienation from our bodies—specifically in the sense expressed by the postcard caption that opens this essay—is not an essential condition of being embodied. Rather, it is a single modality among many through which embodied consciousness reflexively relates itself to itself, and as such, it is merely—if significantly—a qualification or sufficient condition that inflects the essential material nature of human embodiment in a particular way and gives it particular meaning in a particular phenomenological structure of experience. That is, from the first, the experience of the essential ontology of the lived body in all its possibilities as both a subject and an object in the world is always already modified in existence, and its possibilities reduced, by specific and diverse epistemological qualifications. Thus, while certainly grounded in the essential condition of consciousness as embodied, the current dominance of a mode of experience that foregrounds the body-object rather than the embodied subject constitutes a particular phenomeno-logic, and is a consequence of specific cultural practices that could be otherwise.

At this point, I want to explore what we phenomenologists call the "lived body" and its existence as our empirical and metaphorical home in the world through anecdotal data that interrogates this very formulation. The first narrative foregrounds a neurological disorder which evicts consciousness from its home-body through a loss of proprioception. The second foregrounds a cultural disorder which reduces the gravity and substance of the home-body and relocates consciousness to the ("colored") surface

of the skin. Finally, the third foregrounds a (personal) physical dis-
ability that, paradoxically, prompts and enables a reconciliation of
body and consciousness, and articulates the possibility of "coming
home" to our lived location (our *"corps propre,"* as Merleau-Ponty
writes of it throughout his work). These narratives are all different
from each other, although they share a common theme. It is not
my intention here to suggest that they are in any way reducible to
each other. The neurological loss of proprioception is not equiva-
lent to the surgical loss of a leg, and neither can be equated to the
social loss of the very substance of personhood that is a conse-
quence of racism. Nonetheless, although they are quite different as
to the cause, nature, and consequences of the bodily dis-ease they
demonstrate, each of these recountings of bodily experience fore-
grounds the radical rupture that can occur within the psychoso-
matic whole that is the correlation of "consciousness" and "body."
Furthermore, each provokes us to reflect upon the various and
ambiguous ways in which vision operates in this correlation or its
rupture. In sum, these anecdotal accounts dramatize the radical
eviction of consciousness from the comfortable—and generally
transparent—assumption of its material premises.

The first narrative speaks to an *ontological* dis-ease with one's
home-body, and concerns what clinician (and phenomenologist)
Oliver Sacks calls "the neurology of identity" (1987, viii). In *The Man
Who Mistook His Wife for a Hat and Other Clinical Tales*, Sacks presents the
case of a neurologically damaged patient he calls "the Disembodied
Lady." A victim of a sudden onslaught of polyneuritis, Christina
loses nearly all her proprioception—that sixth and grounding
sense we have of ourselves as positioned and embodied in worldly
space, that sense that could be said to provide us our body image
but for the fact that such an "image" emerges not from the objec-
tive sight of our bodies (or from vision), but from the invisible and
subjective *lived feel* of material being. Sacks tells us that for
Christina, "standing was impossible—unless she looked down at
her feet. She could hold nothing in her hands, and they 'wan-
dered'—unless she kept an eye on them. When she reached out for
something, or tried to feed herself, her hands would miss, or over-
shoot wildly, as if some essential control or coordination was gone.
She could scarcely even sit up—her body 'gave way.' Her face was
oddly expressionless and slack, her jaw fell open, even her vocal

posture was gone." Her voice is described as ghostly and flat as she explains: "I can't feel my body. I feel weird—disembodied" (45).

Christina never gets better, although she eventually learns to use her eyes to position or, more aptly, pose her body in the world, to operate it and move it about as an objective thing. Sacks points out that our subjectively felt and grounding "sense of the body . . . is given by three things: vision, balance organs (the vestibular system), and proprioception" (47). Under normal (that is, nonpathological) circumstances, all these modes of sense-making and simultaneous access to the world and ourselves work cooperatively. In Christina's situation, vision dominates. However, the objectifying sense of a vision dissociated from the subjective sense of proprioception, while it allows her "some-thing" of a body and thus something of a life, is not sufficient to allow her to repossess her body as home and to abide in its material premises. Recalling Merleau-Ponty, we could say that Christina is in front of her body, rather than in it, or being it. Furthermore, consonant with Merleau-Ponty's characterization of vision as a discrete form of access to the world in which "to see is to have at a distance" (1964, 166), we could say that Christina has possession of herself "only at a distance"—initially as a horrified spectator, eventually as an accomplished director. Sacks tells us: "She could at first do nothing without using her eyes, and collapsed in a helpless heap the moment she closed them. She had, at first, to monitor herself by vision, looking carefully at each part of her body as it moved, using an almost painful conscientiousness and care" (48). Initially clumsy, her every movement the result of visually calculated artifice, Christina goes on to become more proficient, her movement more modulated, and eventually, though still vision-dependent, more automatic and—here the word takes on a deep resonance— accomplished. Sacks describes her bodily posture as appearing "statuesque," artful, forced, willful, histrionic; her voice, too, emerges as stagy and theatrical, the voice of an actress.

Although she eventually returns home to her family and work, Christina's visual possession of her visible body in no way replaced her nonvisual and proprioceptive sense of her body as it was once "lived." While corporeal, she remains unable to *incorporate* her consciousness, and thus her body was never again her abode. As Sacks points out, her visual skills at objective self-direction "made life

possible—they did not make it normal" (1987, 50). Christina "continues to feel ... that her body is dead, not-real, not-hers—she cannot appropriate it to herself" (51). Furthermore, watching home movies of herself before her ontological crisis, she can't identify with the person she recognizes on the screen. She tells Sacks not only that she can't remember her, but that she can't even *imagine* her. Losing, with her sense of proprioception, "the fundamental, organic mooring of identity," Christina has lost even her bodily imagination. Living one's body from within—as subjectively "me" and "mine"—has no dimension or meaning and thus no reality for her, and she describes herself as feeling "pithed" like a frog—eviscerated. Living it from without with the aid of vision's objective vigilance, she feels evicted, thrown outside herself—feeling, to a radical extent most of us will never experience, derealized.

Let me now move to a quite different narrative of bodily eviction and alienation. This second instance speaks not to the ontological dis-ease and opacity of one's home body, but rather to epistemological and axiological dis-ease, to pathologies of knowledge and value that result in an impoverished and alienated sense of both bodies and vision. Here, unlike Christina, the protagonist has no bodily problem sensing *that* she is embodied; her problem emerges in the uncertainty she suddenly senses at *what* she is as a body. The objectifying function of vision is also consequential in this narrative, and here, too, it is used to dominate and direct the body—although from quite a different source and to quite a different end. The autobiographical scene that follows is described by Audre Lorde in her essay "Eye to Eye: Black Women, Hatred, and Anger" (1984). This, then, is also a narrative of pathology—one that emerges not from the illness and failure of one's own lived-body, but rather from the illness and failure of a social body that does not understand intimately that the body is lived.

Lorde writes: "The AA subway train to Harlem. I clutch my mother's sleeve, her arms full of shopping bags, christmas-heavy.... My mother spots an almost seat, pushes my little snow-suited body down. On one side of me a man reading a paper. On the other, a woman in a fur hat staring at me. Her mouth twitches as she stares, and then her gaze drops down, pulling mine with it.... She jerks her coat closer to her. I look. I do not see whatever terrible thing she is seeing on the seat between us—probably a roach. But she has communicated her horror to me. It must be

something very bad from the way she's looking. . . . And suddenly I realize there is nothing crawling up the seat between us: *it is me* she doesn't want her coat to touch" (147, emphasis added).[1] Like Christina, little Audre has also lost her "body image"—been robbed of her dimension, been distanced from herself by vision. But in this circumstance, she has been "pithed" and eviscerated from without—not by a failure of proprioception, but by the perceptual pathology of an other. Lorde marks the experience in terms of vision: "I don't like to remember the cancellation and hatred, heavy as my wished-for death, seen in the eyes of so many white people from the time I could see" (147). Once warm within—and as—her "little snowsuited body," she is abruptly evicted from it, placed outside of herself "in the cold," subjectively perceiving and re-cognizing what was once the wholeness of her lived body as now split in two—on one side her conscious sense of herself, on the other her body, the latter now some distanced, objective, and terrible "thing."

Telling Christina's story, Sacks evokes Wittgenstein's *On Certainty* and suggests it might as readily have been titled *On Doubt*—for Wittgenstein questions "whether there might be situations or conditions which take away the certainty of the body, which do give one grounds to doubt one's body, perhaps indeed to lose one's entire body in total doubt" (1987, 44). Certainly, Christina's ontological pathology presents such a condition, but—just as certainly—so too does Audre's suffering of a cultural pathology. In "A Phenomenology of the Black Body" (1994), philosopher Charles Johnson speaks to this problem of bodily doubt as an effect of the cultural pathology of a racial caste system. Johnson evokes the lived sense of what it means when consciousness is eviscerated and evicted from its home-body, when it has no abode, no address, no residence—when, through a look, it is thrown outside itself: "I do not see what the white other sees in my skin, but I am aware of his intentionality, and—yes—aware that I often disclose something discomfiting to him. . . . Yet it is *I* who perceive myself as 'stained,' as though I were an object for myself and no longer a subject" (126). Johnson calls this lived sense and process of being substantially eviscerated and evicted from the transparent comfort afforded by one's material premises "epidermalization" (136).[2]

At the moment little Audre experiences what Johnson describes as "the searing Sartrean 'look' of the hate-stare," the entire world is

"epidermalized" (130). As if glossing Lorde's childhood experience, Johnson tells us of his own: "[My] body in these cases comes awake, translates itself as a total physicality—it, oddly enough, feels as if it is listening with its limbs to the Other as my interiority shrivels like something burned, falls into confusion, feels threatened and, if it does not make me constitute myself as hatred (unable to change the world, I emotionally change myself), it momentarily, like a misty field, hazes over" (130). Ices over, we could say, in the context of Audre's "soul murder."[3]

Johnson describes how the epidermalizing gaze locks his consciousness out of a body that no longer is his, its sense and its meaning possessed by and devalued by another. And yet, unlike Christina's, it is a body he still can *feel* even as he *sees* it through the eyes of an other. The feeling "is intense, as though consciousness has shifted to the skin's seen surfaces." He tells us: "Our body responds totally to this abrupt epidermalization.... There are physiological reactions: the pulse and adrenaline increase, the seen skin becomes moist, as if the body is in open conspiracy with the white Other to confirm the sudden eclipse of my consciousness entirely by corporeality. I feel its sleepy awkwardness, and know myself not as subject but as slumberous, torpid matter" (129). His very comportment changes—and, in reversible and negative reciprocity—his world, as well as his body, is diminished and shrinks.

Now, these are two extreme cases of alienation and eviction from one's body—or, more aptly, from the lived body that *is* (or is supposed to be) oneself. Christina's experience is virtually singular in its extremity (Sacks knows of only one other similar case) and, indeed, it suggests the way in which the neurologically "normal" rest of us are generally at home in our bodies, live them as ourselves, as capacious and mobile sites, for the most part, transparently grounding and enabling our intentional activity in a world that is reciprocally expansive. Audre Lorde's experience, on the other hand, while extreme in its particular manifestation and effects, is hardly singular; indeed, it is unhappily familiar. And, insofar as it resonates to different degrees within our own experience (of being suddenly disclosed to ourselves as objectively "colored" or "fat" or "old" or "female" or "diseased"), her experience suggests the way in which the normative practices of culture phenomenologically estrange us from our bodies and make us strange and hateful not only to others but, in their eyes, to ourselves as

well. In a way comparable in result, little Audre will learn to "pose" her body, like Christina, from without—to operate it and act it out in and for the sight of others. She will need to keep an eye on it all the time, or run the risk of losing grounding and ground in the world in which she lives, and in which she will never feel quite so much at home again because she has lost her original premises to others. Audre's pathology, even as she will live it, is not her own, as is Christina's. It is a single instance of the epidemic and epidermalizing cultural dis-ease of and with the body described by Johnson and it is attributable not only to a history of multifarious cultural practices and relations but also—and in no small part—to our culture's increasing dependence upon the distancing and objectifying function of vision as it has become a *technology* detached from our bodies. That is, we live immersed in "the frenzy of the visible," a frenzy characterized as the "effect of the social multiplication of images" that has increased exponentially from the beginning of the nineteenth century to the present day (Comolli, 1980, 122). Indeed, given the primacy of the visible in our culture, we could say, along with Johnson, that our entire world and most of what we mean in it has been "epidermalized."[4] And, epidermalized, we have all come to see ourselves as epiphenomenal.

Now, in no way do I want to trivialize the particular forms of alienation and eviction from one's own body effected through a specifically racial caste system by suggesting that because we are all subject to the frenzy of the visible and immersed in the society of the spectacle that we all can "feel the pain." "Epidermalization," in Johnson's sense, has its own quite particular phenomeno-logic, qualified by specific historical circumstance and cultural practice and manifest in particular structures and dynamics of response. Nonetheless, I think most of us in our present culture can recognize in this phenomeno-logic what it means to be a victim of vision and subject to—not of—the visible. Given our ontological condition of objective embodiment, Johnson himself suggests that "it is reasonable to say there is neither an impenetrable 'white' or 'black' experience which is mutually exclusive, but rather that there are diverse human variations upon experience, which can always be communicated imaginatively or vicariously across racial, political, and cultural lines" (1994, 122). Which is to say, even as many of us do not suffer the particular form of epidermalization that reduces the substantial lived-body to the superficiality of a merely "black

body," we do have a sense of what it means to be alienated and evicted from our own dimension and thickness, what it means to forget our lived bodies not in the felicitous transparency of our intentional action, but in the infelicity of an objectified vision of ourselves as mere epidermis. How, in this circumstance and from this vantage point, can we not feel, as Johnson puts it, "the sudden eclipse" of our consciousness by our corporeality, our transformation into "torpid matter"?

Today, nearly every quality that gives dimension and more than superficial significance to the lived flesh we merely "see" does not count as significant cultural capital, does not compute on screens. Thus it is no simple coincidence that the public meaning of the 1995 Million Man March was debated primarily in terms of the visible; new technologies of vision were enlisted not only to display televisually the bodies of those present, but also to scan electronically these televisual images to count the bodies in them. Debate over this visible numeration received enormous attention in the public sphere (were four hundred thousand or more than a million bodies present and accounted for?), completely overshadowing those few anecdotal articulations that focused not only on what it was to *see* all those people, but also what it was to *feel* thousands of hands and bodies "in touch." This qualitative accounting of the event incorporated a merely quantifiable number in the significance and substance of mass, the force of proximity, the power of flesh as it described new forms of bodily comportment in both those who attended and those who watched. In sum, this accounting recognized dimensions and consequences to the march invisible to the technological—and technologized—eye.

While the public's eyes were directed by the media toward the "hard news" of the black body count, a more qualitative form of accountancy was marginalized as the "soft stuff" of "human interest." Nonetheless, however side-barred, this accountancy was more powerful and potentially world-changing than any mere body count based on visibility. Kristal Brent Zook, for example, writes:

> For many of us who were there, the debates ... have become almost beside the point.... October 16th was ... about resurrecting the spirits of an all but defeated people and giving them back their destinies, their rightful place in the world.... Above all else, I'll remember my first early morning prayer best: standing

> on the grass alongside the Mall with head bowed and
> my heart wide open. On my right, I held the hand of a
> shy 13-year-old boy. On my left, an elderly man in a
> wheelchair held the tips of my fingers with a con-
> torted, misshapen grasp." (1995, 7)

What is meaningful here is the substance, the gravity, the weight and press of flesh, its empirical and therefore symbolic *mass*. The bodies described here do not have the dead weight of a body count. Rather, they are living, and they dramatize their own significance in weighty ways: "They push against one another, lean on one another, push off one another, embrace one another" (Lingis, 1993, 166). What counts n Zook's description are not the numbers but the lived bodies (here epidermalized to others and themselves as "black") using their weight and gravity, their other-than-superficial dimensions, their imagination, to find a new and substantial comportment. In counterpoint to the dominant view of the march as meaningful primarily in terms of the visibility of the bodies who attended, it is telling that Zook concludes her description by focusing on a black man who is blind

> Stevie Wonder said that while he couldn't see the men,
> he could feel them. Lifting his head to the sky, Wonder
> paused and listened. Like a wave, the crowd responded
> with an amazing electromagnetic force that washed
> over us from the Lincoln Memorial to the Capitol and
> back again. (1995, 7)

However briefly, and however much against the grain of a culture that has technologically amputated visibility from the full-bodiedness of vision, this qualitative account of the Million Man March marks the press of flesh against flesh and movement of the bodily imagination of black men from a fixed regard on the visible surface of the skin to the reclamation of its grounding premises. At home not only in their bodies, but also among other bodies, the march's participants experienced—and, yes, saw—a renewed sense of the lived body's open capacity for stance and movement and the future possibility—experienced in the present—of a less inhibited and constrained comportment in the world. For a brief time, then, these bodies were significant not merely because they were numerically visible, but because they were fully realized. To foreground the feeling of the lived body (experienced both by oneself and by others) is not to sentimentalize it. Neither is it to assert a soft meta-

physics predicated on the ineffable. It is, rather, to emphasize those aspects of our home-bodies that are not completely captured in visible images although they make their mark there and can be read and understood if we acknowledge their existence. Here, Lingis is most eloquent

> Human bodies . . . move in the world . . . leaving traces, echoes, rustlings, footsteps, murmurings, coughs, sighs . . . winks, sweat, tears. Their freedom is a material freedom by which they decompose whatever nature they were given and whatever form culture put on them, leaving the lines their fingers or feet dance in the street or the fields . . . leaving their warmth in the winds, their fluids on chairs and tools and in the hands of others. (1993, 167)

My last narrative concerns the personal lesson my own body taught me about the bodily sources of material freedom—and on the limits of the merely visible. A bit more than four years ago now, my left leg was amputated at midthigh because of a recurrent cancer (merely one demonstration of how one's body can overrun one, in this case possessing my agency without my volition). This was for me a time of bodily decomposition—and recomposition. Paradoxically, the surgical alienation of part of my body put me in phenomenological touch with the rest of it—in what was for me an unprecedented intimacy. And, ironically, given that I am a scholar of film and visual media, the cultural hegemony of an impoverished sense of vision often occupied my thoughts during the rehabilitation process, in which I learned to walk again with a prosthetic limb.

I had, like Christina, to consciously operate my body. Indeed, they put me in front of a mirror so I could see myself and my visible image. It was epiphanetic as well as ironic that for me, a film scholar and phenomenologist versed in—and averse to—Lacan, the mirror was from the first a site of *méconnaissance,* misrecognition. My visibility in it taught me nothing. Indeed, its being "on the wrong side" of me was confusing, and I would get mixed up, falter, and fall. That is, in the face of my mirror-image, I may have seen both my imago and ego, but neither of them grounded me or helped me walk. Not only did my mirror image demand that I find the shape and rhythm of my steps solely from my objective outlines, but also that I perform them in reverse. Thus, in order to walk, I had to stop

looking at myself. I was forced to reject my location "there" in my exteriorized symbolic reflection and to refind myself "here" in the supposedly unspeakable space of the real that preoccupied my body. In sum, trying to properly locate and sense my gravity, balance, comportment, and capacity for movement, I found I could not stand the distanced sight of my own body if I wanted to stand the actual site of it. (Intellectually, this is no small pun; as an intellectual, regrounding myself was no small achievement.)

When I first started working with a therapist, the task at hand (or, more precisely, leg) was to realize a derealized and inanimate artificial limb, to incorporate and animate its dead weight into the proprioceptive reality and action of my bodily intentions. To do so, I needed to learn to give up possessing myself only at a distance, as a visible object. Here, I was radically different from Christina, who had lost her proprioception and could only sense her body through her eyes. What helped me walk was not the sight of my body or the artificial limb given to me outside myself, but rather my subjective imagination of the bodily arrangement or comportment informing my actions from "my side" of my body. Of course, like Christina, I too had to initially direct my body to learn to walk again. There were all sorts of physical things I had to learn to do in quick sequence or, worse, simultaneously: kick the prosthetic leg forward to ground the heel, tighten my butt, pull my residual limb back in the prosthetic socket and weight the "artificial" leg to lock the knee, take a step with my "own" leg, unweight the prosthetic leg, tighten my stomach and pull up tall to kick the leg forward, and begin again. Never naturally athletic, hardly ever at home in my body because I was female, because I'd always felt fat, because I was aging, because I had always looked at myself from the outside, I was suddenly confronted with what seemed an impossible task of bodily coordination—impossible not only because I had to think what my body had thoughtlessly accomplished before, but also because I had much less intimacy with my body than I did with its image.

Ultimately I learned to walk by locating myself and being on "my" side of my body—that is, not by *seeing* my body as an image *of* me, but by *feeling* my body image *as* me. I closed my eyes to the superficial form of my visible mirror image and imagined instead and predominantly the shape that my other modes of self-awareness and access to the world made. I *learned* my body—my substance and dimension, my balance, my gravity, my tension and

59

motility—not as an objective and visible thing, but as a subjective and synoptic ensemble of capacities for being. It was this re-cognition of my body that helped me incorporate and transform the objectivity of a prosthetic leg into the subjectivity of a leg I could stand on, into *my* leg. In sum, I could not fall back on seeing myself as I was given in my image; rather, I had to take myself up imaginatively. This bodily imagination of myself has visible effects and makes itself present not as my epidermis but in my bodily comportment, which is not a fixed identity but a mobile style of disassembling and reassembling (decomposing and recomposing) myself in relation to the world and others. It was when I fleshed out that mirror image and repudiated its reductive epidermalization of me that I reclaimed my agency and posture, felt at home *as* my body, and was able to relocate my grounding and walk in the world.

The lessons I learned from my own rehabilitation and recomposition of my body, and from the accounting of experience by Christina, Audre Lorde, Charles Johnson, and participants in the Million Man March, suggest not that we reject visual representation and images and embrace iconomachy. Rather, it is that we recognize vision as embodied and representable not only in its objective dimensions as the visible skin of things, but also in those subjective dimensions that give visual gravity to us. That is, we must remember *in our seeing* that we transcend and subtend the images we produce and allow ourselves to be produced by. At home and regrounded in our bodies, we have dimension, gravity, and the enabling power to regain our sense of balance and to comport ourselves differently—first, perhaps, *before* our images, and then, one hopes, *within* them.

notes

1. I am indebted to S. Paige Baty for bringing this passage to my attention.
2. I am indebted to Bob Myers for bringing this invaluable text to my attention. Johnson attributes the term "epidermalization" in its phenomenological sense to Thomas Slaughter's unpublished paper, "Epidermalizing the World" (Johnson 1994, 136 n. 14).
3. S. Paige Baty, glossing the Lorde passage I have quoted here in her forthcoming book, *Representative Women*, engages in significant referential punning, evoking not only Eldridge Cleaver's *Soul on Ice*, but also the particular resonances of "soul" in African-American culture: "It is snowing and her soul is now on ice. Reification: she has been caught—frozen

by the gaze. She realizes that the horror is her black self. Two strangers on a train. One soul murder for a little girl."

4. In this context, I want to thank Daniel Bernardi for pointing out that prior to the Enlightenment privileging of vision and the observable, race relations were predicated less on "epidermalization" than on blood lines.

works cited

Comolli, Jean-Luc. 1980. "Machines of the Visible," in *The Cinematic Apparatus*. Ed. Teresa de Lauretis and Stephen Heath. New York: St. Martin's Press.

Johnson, Charles. 1994. "A Phenomenology of the Black Body." *The Male Body: Features, Destinies, Exposures*. Ed. Laurance Goldstein. Ann Arbor: University of Michigan Press.

Lingis, Alphonso. 1993. "Bodies that Touch Us." *Thesis Eleven* 36: 159–67.

Lorde, Audre. 1984. "Eye to Eye: Black Women, Hatred, and Anger," in *Sister Outsider*. Trumansburg, N.Y.: The Crossing Press.

Madison, Gary Brent. 1992. "Did Merleau-Ponty Have a Theory of Perception? *Merleau-Ponty, Hermeneutics, and Postmodernism*. Ed. Thomas W. Busch and Shaun Gallagher. Albany: State University of New York Press.

Merleau-Ponty, Maurice. 1962. *Phenomenology of Perception*. Trans. Colin Smith. London: Routledge and Kegan Paul.

———. 1964. "Eye and Mind," trans. Carleton Dallery, in *The Primacy of Perception*. Ed. James M. Edie. Evanston, Ill.: Northwestern University Press.

Sacks, Oliver. 1987. *The Man Who Mistook His Wife for a Hat and Other Clinical Tales*. New York: Harper and Row.

Zook, Kristal Brent. 1995. "Multiple Images from Million Man March." *UCLA Today*, October 17: 7.

four **home**

smell, taste,

posture, gleam

margaret morse

The way you wear your hat,
The way you sip your tea...
 —Ira Gershwin, "They Can't Take That Away from Me"

Since "home" is not a real place, (though it always was once upon a time), feeling at home is, in essence, a personal and culturally specific link to the imaginary. Feelings and memories linked to home are highly charged, if not with meaning, then with sense memories that began in childhood before the mastery of language. A fortuitous and fleeting smell, a spidery touch, a motion, a bitter taste—almost beyond our conscious ability to bid or concoct or recreate—home is thus an evocation that is of this sensory world, ephemeral and potential in the least familiar. Suddenly, when I least expect it, I am enchanted. I hold my breath at the silent transposition of a melody. Thinking about "home" is like being given a

hunting license for anamnesis, or reflection on those things "which enthrall me without my knowing why" (Barthes, 3).

A wide range of contemporary discourses treat the sensorium—especially odor.[1] Dan Sperber has proposed smell as the supremely symbolic sense (1975, 118), and Roland Barthes writes, "Of what will never return, it is odor which returns for me." (1977, 135) Walter J. Freeman explains that smell stimuli have a direct link to the limbic system in the brain, thus opening a "door to consciousness" that awakens the range of previous experience (1995). Smell is developmentally the most archaic sense and one that even today lies at the boundary between nature and culture. In a museum-case-like art installation, "The History of Wishing" (1994), Gail Wight tells the story of "an archeological dig that took place in the 1960s, uncovering nine of the world's eleven known Neanderthals up to that point." Pollen around four bodies that were buried together suggests that these remains "were apparently buried carefully, and intentionally, and with a vast number of flowers."

> A hypothesis is offered, from a neurological point of view, for what might compel humans and near relatives to throw flowers into graves. (I'm still overwhelmed that this is such an *old* practice.).... Three cognitive processes—involving pollen, emotions, and thinking about the future—are followed to where they converge at a point defined as "wishing." This in turn is reduced to an algorithm and then burned into a computer chip. In this way, a human emotional trait that emerged nearly 60,000 years ago becomes available to an artificial consciousness.[2]

Pollen and flowers evoke long-vanished smells that are in any case notoriously difficult to describe. For one thing, according to Dan Sperber, odor lacks an autonomous system of categorization: Who can remember the smell of a rose without recalling the image(1975, 117)? Sigrid and Frans Plank dispute Sperber's claim, pointing to the work of Herman Aschmann on the logical organization of smells in the Totonac language of south Mexico (Plank and Plank 1985, 69) Nonetheless, at least in European languages, sense memories that escape the dominance of the visual defy being put into words. These include not only smells, but tastes, textures, ambient sounds, qualities of voice, postures and rhythmic ways of moving, colors, and even degrees of brightness that hurt or soothe the eye.

For Roland Barthes, the sense memory on the page is "a per-
fumed idea" that saturates the text around it: "It is a good thing, he
thought, that out of consideration for the reader, there should pass
through the essay's discourse, from time to time, a sensual object
(as in *Werther*, where suddenly there appear a dish of green peas
cooked in butter and a peeled orange separated into sections)."
(Barthes 1977, 135)

The invocation of an imaginary realm tied to early childhood
nourishes the capacity for emotional investment in the body and in
the world, and, culturally speaking, the management of sympathy,
the ability to identify with others. Consider, however, that
Werther's fatal love for Charlotte is ignited when he sees her in a
group of children, slicing and distributing bread. While Ira Gersh-
win dares to rhyme "The way you hold your knife" with "The way
you changed my life," Barthes resists the pull of the senses into the
imaginary, a vortex of banality, with self-cautionary warnings: "I
call *anamnesis* the action—a mixture of pleasure and effort—per-
formed by the subject in order to recover, *without magnifying or senti-
mentalizing it,* a tenuity of memory: it is the haiku itself" (1977, 109,
emphasis in original). Barthes presents his anamnesis as matte and
meaningless—even though he knows that sense memory is volup-
tuous, glowing and aromatic, acting "as a medium [that] puts me in
a relation with my body's id; it provokes me. . . . I see the fissure in
the subject (the very thing about which he can say nothing)" (151).

Ambivalence toward sense memories that influence behavior so
profoundly adds reluctance to an impoverished vocabulary. Artic-
ulating them nevertheless runs the risk of seduction into senti-
mentality and the mythologies of family romance. As far as Barthes
is concerned, the power of sense memory is best kept in check with
a desiccating reality principle. Brave strokes of the pen initiate an
escape process from the vapid sentiment of the image repertoire,
like a descent that approaches "unendurable depth." At the bottom
is a desert, hard and dry. "There occurs—fatal, lacerating—a kind
of *loss of sympathy.* I no longer feel myself to be *sympathetic* (to others,
to myself)" (137).

Proust's epiphany described in the opening passage of *Remem-
brance of Things Past* releases him from just such an emotional desert:

> And soon, mechanically, weary after a dull day with
> the prospect of a depressing morrow, I raised to my lips
> a spoonful of the tea in which I had soaked a morsel of

the cake. No sooner had the warm liquid, and the crumbs with it, touched my palate than a shudder ran through my whole body, and I stopped, intent upon the extraordinary changes taking place. An exquisite pleasure had invaded my senses, but individual, detached, with no suggestion of its origin. And at once the vicissitudes of life had become indifferent to me, its disasters innocuous, its brevity illusory—this sensation having had on me the effect which love has of filling me with a precious essence; or rather this essence was not in me, it was myself. (Proust 1981, I, 48)

Listen to any "origin story" and you will eventually find a perfumed object linked to a gestural performance close to pantomime. For Barthes, it is the sight of Gide eating a pear while reading (not writing!) (Barthes 1977, 77f) Sometimes the "Proustian moment" is dark, nor is the fruit of the garden always offered to eat; imagine the apple rotting in the monstrous Gregor Samsa's back in Kafka's *Metamorphosis*. Toward the end of the biography of the brilliant musician Quincy Jones, *Listen Up: The Many Lives of Quincy Jones* (Dir. Ellen Weisbrod, 1980), I found the coconut birthday cake Jones's mother had thrown over the back porch when he was five years old, offered retrospectively, as if it were a key to the subject's workaholism and retarded ability to inhabit his mother's or many wives' point of view. An innocuous smell can evoke memories of a nightmare, tormenting the day (Gombrowicz, cited in Busch 1995, 15), while on the other hand, an unpleasant or acrid smell can evoke a joyous sensation, if only because of its capacity to trigger sudden recollection, (for example my own relation to hot blacktop). Method acting is built upon the invocation of such moments in the actor's fund of memories, flavoring the play of words with the juices of the flesh. Just think about eating the apple and the memory of Eden rushes back.

In high school, I used to go to a duck pond some distance away as often as I could, not to feed the ducks, but just to smell the pond. Years later, I was amazed to discover that heady smell—fresh like watermelon, with funky undertones—in the sea near Athens. It wasn't until I was in bed the night before a talk on the subject of this essay that I remembered the feeling of my feet buried in extraordinarily soft and silky-feeling silt at the bottom of a lily pond in Ohio in the late 1940s. The long roots of water lilies drifted below the dark surface of the pond, brushing my legs. I couldn't

even be sure if the euphoria I felt at remembering wasn't once repulsion or fear, though I sank just so far into the silt.

I also remember this pond from a 16mm home movie that showed me in an orange life vest, part of a crowd of children and adults splashing down a metal slide in jerky fast motion; so I added the incongruous slide into the scene of my Ur-pond. Then milk-weed fluff blew by in the wind overhead—or at least it did until I recalled the opening scene of *Amarcord*, from which this moment in my Edenic scene borrowed heavily. My elaborations produced a collage of eerie textures and smells blended with the visual record produced by my father and Federico Fellini. Today, sense memories include the intrusion of sounds and images from television, and our narratives of origin incorporate an extended family from movies, television, and toys that span the globe. "Home, Where Is Home? " is the title of an installation by the artist Muntadas, in which he pits the television against the hearth, for with the advent of the mass media, home has been lifted out of material and local experience and into cyberspace.

The artificial synthesis of the human capacity to wish or desire, associated with smell, is not unlike the process by which—Busch (1995, 22) reminds us—Villiers de l'Isle-Adam in *The Future Eve* (1982), has Thomas Edison synthesize the body odors of his friend Lord Ewald's wife. These scents are to be applied like perfume to an artificial being, the ideal woman. In Patrick Süskind's novel, a per-fume is created out of the smell of murdered girls that gives the hero great power over the feelings of others. On closer examina-tion, cyberculture and artificial life of every sort has been perfumed in a contradictory or disguised way. Even someone like Hans Moravec, who professes a desire to leave the body and sensuous experience behind, imagining his consciousness downloaded into a computer, strews his text on robot creation with good meals (1988). Malamud's *Exploring the Internet* laces personal encounters at Internet nodes with restaurant reviews: "Leaving Pascal, I went to a café near my hotel and had a fine cassoulet of snails for lunch. There, over a half bottle of Beaujolais Villages, I pondered the immense difficult of spreading the Internet [into Niamey in Niger, Lomé in Tongo, and Abidjan in the Ivory Coast]" (1993, 114).

A global mass culture cannot seat itself so firmly into our emo-tions without the aid of sensual experiences such as silt around our toes or the perfume of cold air that wafts off a sweater just in from

the snow. Proust compares the sense memory to an anchor at great depth. His is a conservative image repertoire, which requires the very same substance to reawaken what is an individual and regional mirror stage, a bond, fusion, or identification with "home" as a place of birth, a house, a family, a locality, and a nation. Consider the *Oxford English Dictionary*'s definition of *home* as "a place, region or state to which one properly belongs, on which one's affections centre, or where one finds refuge, rest, or satisfaction." That "home" may be taken away or shrivel into an empty shell. However, some part of its essence can be chanced upon, cached in secret places safe from language.

where do you come from?

Homes are "origin stories" constructed as *retrospective* signposts within visual space, acoustic space, and even tactile space. They are *made for coming from*.

—Dietmar Dath

Drastic change becomes the foundation of a way of life that I recognize in my peers with similar histories: I am one in a legion of the children of relatively privileged seminomadic people—military personnel, diplomats, professionals, corporate executives, academics—plus the wanderers who have fallen from grace, the downsized and discharged, the temps and gypsy scholars. In any case, it is the children (or brats) of these drifters with discipline and cultural capital of whom I speak. Answering the question "Where did you grow up?" isn't easy for me. Unlike most refugees, exiles, and immigrants, who come from somewhere that was a home, during my childhood we moved constantly, sometimes more than once a year. The longest stretch my family lived anywhere was in a foreign country. My grandparents had homes; we had rentals furnished largely with government-issue items, spartan versions of the hotel rooms and houses outfitted for corporate executives that Manuel De Landa describes (1995, 48). (Meanwhile, our real possessions waited in a dark storeroom for someday.) As a passenger in the backseat, a child experiences mobility differently than does Dad steering the wheel.[3] Carsick at first, careening in unpredictable paths, one eventually expects to be torn away from whatever ones loves, thrust again and again into the unfamiliar.

How, then, does one manage the investment of sympathy with-

out deep anchors? Speaking for this loose cohort of childhood drifters, we do have origins and sense memories; it's just that they are a composite of shifting locations and short-term bonds. The capacity to endure sustained dissonance and lack of closure is something I recognize immediately in my fellows in this privileged cadre of the not precisely homeless. Resourceful and self-contained, some of us even prefer the weightlessness of the floating world.

Imagine a state of absolute homelessness; it might be comparable to the weightlessness of outer space. The dancer Kitsou Dubois has described her experiences in one of the three airplanes (owned by the United States, Russia, and France) designed to train astronauts in conditions of near weightlessness—albeit just for twenty-five seconds of microgravity generated thirty times successively in parabolic spurts. The desire of the dancer to levitate and hang in space becomes a disorienting loss of horizon, without ground or a way to spot. The result is space sickness that, in Dubois's experience, can best be contained by turning a spiral, recovering a *subjective* center of gravity (1985, 76)

Addicted to culture shock, after growing up I sought out moments when I knew I would feel a profound nausea, confronting a world so different that it might as well be upside down: for example landing in East Berlin in 1977, as a total stranger with a six-month visa. Gradually finding my footing, I found in U.S.-occupied Germany a world curiously laced with sense memories of "home."

I recall the grade-school illustrated textbook that offered a horrific vision of Edward Everett Hale's "The Man Without a Country": An American naval officer and traitor is condemned to suffer a curious exile. Passed from American warship to warship without ever touching land or hearing of his country growing from sea to shining sea, the ostracized officer becomes hypersensitive, deducing enough from the way his conversation and reading material are censored to produce an up-to-date map and flag that symbolize the changes taking place in his homeland. Growing up with cold war America, I experienced the sentimentality of this patriotic story as suspiciously abstract. Now I would diagnose it as devoid of the sympathetic or countervailing effects of "home."

It is hard to imagine a life capable of imagination and sympathy that is not anchored by sense memories. Luckily, our imaginaries are more promiscuous than Proust's, yielding to qualities rather than copies. A cushiony texture like a wet madeleine might be

enough to open the gate to reverie. Victor Burgin's 1993 video essay *Venise* (with Francois Landriot, Kate Midgley, and Francette Pacteau) has a title that refers to *the* city in Italo Calvino's *Invisible Cities*. *Venise* reflects on the film *Vertigo* and the novel on which it is based, invoking the implanted and personal sense memories that merge images of Marseille, Paris, and San Francisco. None of these overlapping places is *the* city. However, drifters' children have no memory of the one, the lost Venice—though we might recognize the smell of a canal in summer or remember beating wings and the resonance of a badly played piano in the colonnade.

It is when one leaves home that the imaginary as well as political contributions to the semantic range of home—homeland, native, nation, aboriginal, settler, pilgrim, colonist, pioneer, and so on—become clearer. The degree of firstness or naturalness in relation to a locale, the degree of desire or compulsion in being where one is, the degree of permanence in that place and of the acceptance of the population in it all inflect "home," as in homeless, runaway, stranger, foreigner, exile, nomad, wanderer, adventurer, conquistador, migrant, emigrant, immigrant, traveler, tourist, voyeur. In the beginning of a folktale in Propp's model, there must be a disequilibrium of some kind; the hero must leave home before anything in the story can happen. Thereafter, the point of the story is to get home again—either to one's original home or, by marrying the princess, to a new kingdom. Home is the beginning and the end, the "long" or "last" home. However, it is this oneness, firstness, and lastness that drifters' children set in question: We are but an artifact of the post-World War II phenomenon Raymond Williams called "mobile privatization" (Williams 1975) that was already eroding the tie of house to locality. "Home" as a bond or imaginary has been in trouble for a long time, dispersing on the on-ramp to the freeway and the *infobahn*. Politically, we are currently in a process of devolution and seem socially to lack a bond with and sense of responsibility for the nation as a whole. The bonds of union have frayed; less and less we offer home as "an institution providing refuge or rest for the destitute, the afflicted, the infirm, etc., or those who either have no home of their own, or are obliged by the vocation to live at a distance from the home of their family"— another sense of *home* from the *Oxford English Dictionary*.

Considering that nothing is intact from the many stations of my childhood—even millions of pinprick-like stars have been pol-

luted out of the desert sky—it is good that sense memories can be awakened by secret resemblances in totally different substances and situations. I might encounter a silhouette or someone with his or her back turned, in a characteristic posture or with a bend of the neck; when he or she turns around and proves to be a stranger, the familiarity remains.

A moment for anamnesis of gleam: As a child, I loved the mixed sparkle of the black and white crystals in granite so much that once I spent hours beating the surface of a rock to powder and eating it. Now when a city sidewalk glitters with bits of mica and crystal, magic leads me through a dirty and somewhat menacing world. Certain things also gleam in the right way, like the older and more matte kind of tinsel and the Czech and German glitter I recently learned was composed of crushed mirror. Like the spartan white glow against the blackness of Liverpool in the film *Distant Voices, Still Lives* (Dir. Terence Davies, 1988), these are powerful evocations of the make-believe experiences of childhood—like limelight must have been before electricity.

"the way you haunt my dreams"

The earliest independent viewing experience of a movie I can recall was a rocket ship landing in a green-tinted jungle of dinosaurs in a kiddy matinee in 1952. The viscosity of canned chocolate became my memorial to terror in a liminal realm of rancid butter and pandemonium. Movie-going does smell. Furthermore, the movie itself, as resonance and rhythm of light and motion, and the appearance and disappearance of visual objects in shards of narrative, takes root in us as sense memories from our shared dream palace.

Movies also invoke sense memories. In *The Skin of the Film: Intercultural Cinema, Embodiment and the Senses* (forthcoming), Laura Marks addresses a hybrid or intercultural cinema that is particularly reliant on the invocation of touch, smell, and taste. However, "in the audio-visual media of film and video, information that is tactile, olfactory, or gustatory cannot be represented as itself. Instead it tends to appear as excess, at the limits of the visual and auditory." Her richly theoretical discussion posits hybrid cinema as "a material/fetishlike recreation of its object, rather than as a representation." That is, a fetish object can be marked by contact with an experience or event as a photograph, and can be "used prosthetically to extend bodily

experience into memory." Furthermore, a camera caressing its object offers a haptic vision that is also a tactile epistemology. Sense knowledge represented in intercultural contexts can offer potentially shattering variant forms of perception. It is that nausea, that loss of balance that I most prize as an embodied knowledge that does less to comfort than to provoke. I found Barthes's "fissure in the subject" in my own experience of closed-circuit video installation art. My body image was no longer a mirror image, but a displaceable replicant of the self, ripped from the surface of my skin (Morse, 1998, chap. 6).

On the other hand, television advertising and logo sequences are replete with haptic uses of the camera that do little but graze our eyes with extreme close-ups of gigantic hamburgers and logo objects (Morse, 1998, chap. 3). Our commodity culture is already immersed in images; the kinesthetic and haptic senses have been recruited to engage us corporeally and imaginatively with products. Our sense memories are more and more likely to involve mass exposure in packaging and distribution. The drifters with cultural capital now wander in cyberspace, encountering virtual objects without the indexicality of a photograph, unmarked by the world. It is hard to say how we will manage sympathy or where we will cache the perfume of the world in the future.

Yet it is likely that as the sensual world becomes more attenuated in our lives, "home" will gather ever more importance. Marlon Riggs is best known for *Tongues Untied*, a passionate and controversial experimental documentary film espousing black men loving black men. He was far less known for being an army brat, who, according to one friend, placed extraordinary importance on creating a sense of community, meal and household rituals and in valuing his domestic partner of fifteen years. Such rootedness and the hyperbolic importance of home is one response to the drifter's childhood and something I have also noticed in myself. For the past twenty-five years I have clung to one house that, in years as a gypsy scholar and a regional or bicoastal commuter, I seldom saw. In those years, it became more like the idea of "home" in cyberspace, deterritorialized, lifted out of its locale. It was an entry point and an orientation—the home space, the home card, the home stack, the place that you come back to when you get lost. (Now consider the *Oxford English Dictionary*'s definition of *home* in relation to games: the place where one is free from attack, the point which one tries to

reach; the goal.") When I am home, I spend the vast majority of my time beyond sleep writing at the computer or in cyberspace, watching television, listening to the radio and talking on the phone. My discipline requires constant travel to keep abreast; if I am a nomad, like many scholars and artists, it is more often strenuous than glamorous. My hold on locale, beyond surrogate ties through my spouse and my friends, is chance encounters with street plums and apples that flower in February, bred entirely for color and perfume; the mix of murmuring voices, sage, and brewing coffee in the neighborhood gathering place; and the farmer's market, where I can buy the pungent, grotesquely shaped tomatoes and peppers that reek of a midwestern late-summer garden. The red, orange, and green fruit is piled on the sills in my grandmother's summer kitchen and I see it gleam in jars in the darkness of the storm cellar.

notes

1. The following are among the many contemporary works that have contributed to understanding sensuous experience in disciplines ranging from popular culture to literature, anthropology, history, and philosophy: Ackerman 1990, 1995; Süskind 1986; Stoller 1989; Berman 1989; and Abrams 1996. Thanks to Marina La Palma Bellagente for drawing my attention to the last two. Thanks to Hamid Naficy for drawing to my attention work by Laura Marks and Jacinto Lageira (1996) on film and especially haptic memory.

2. Wight on her artistic method or procedure: "This [story] provided inspiration for me to emulate my favorite process in science: conjecture based on an absurd number of facts." Citations from electronic mail to the author, by permission.

3. Back then, Mom was a passenger, too, recreating the household over and over. "Dear Abby" recently had a spate of letters from women who move a lot—having grown up under such conditions, they are unhappy if they have to stay in one place. Mobility grants a kind of buoyancy. Who knew whether a family at anchor, no longer propelled by the ideological winds and economic currents of the cold war, could stay afloat?

works cited

Abrams, David. 1996. *The Spell of the Sensuous: Perception and Language in a More-Than Human World*. New York: Pantheon.

Ackerman, Diane. 1995. *Mystery of the Senses*. [Television series of five one-hour shows] Boston, Mass.: WGBH/PBS Video.

———. 1990. *A Natural History of the Senses*. New York: Random House.

Barthes, Roland. 1977. *Roland Barthes by Roland Barthes*. Trans. Richard Howard. New York: Hill and Wang.

Berman, Morris. 1989. *Coming to Our Senses: Body and Spirit in the Hidden History of the West*. New York: Simon and Schuster.

73

Busch, Bernd. 1995. "Eine Frage des Dufts," In *Das Riechen: Von Nasen, Düften und Gestank*. Ed. Ute Brandes. Göttingen: Steidl Verlag and Die Kunst- und Ausstellungshalle der Bundesrepublik Deutschland GmbH. 10–22.

De Landa, Manuel. 1995. "Homes: Meshwork or Hierarchy?" *Mediamatic*, 8, 2/3: 47–52.

Dubois, Kitsou. 1995. "Danse et Apesanteur," in *Actes/Proceedings. 6th International Symposium on Electronic Art*. Montreal: ISEA. 74–76.

Freeman, Walter J. 1985. "Tor zum Bewußtsein: Beobachtungen zu einigen Funktionen des limbischen Systems im Gehirn," in *Das Riechen: Von Nasen, Düften und Gestank*. Ed. Ute Brandes. Göttingen: Steidl Verlag and Die Kunst- und Ausstellungshalle der Bundesrepublik Deutschland GmbH. 74–85.

Lageira, Jacinto. 1996. "Scenario of the Untouchable Body," *Public* 13: 32–47.

Malamud, Carl. 1993. *Exploring the Internet: A Technical Travelogue*. Englewood Cliffs, NJ: Prentice Hall.

Marks, Laura U. Forthcoming. *The Skin of the Film: Intercultural Cinema, Embodiment and the Senses*. Duke University Press, Purchase, N.C.

————. 1996. "The Haptic Critic," *Framework* 8,1: 18–21.

Moravec, Hans P. 1988. *Mind Children: The Future of Robot and Human Intelligence*. Cambridge, Mass.: Harvard University Press.

Morse, Margaret. 1998. *Virtualities: Television, Media Art and Cyberculture*. Bloomington: Indiana University Press.

Plank, Sigrid, and Frans, Plank. 1985. "Unsägliche Gerüche: Versuch, trotzdem vom Riechen zu sprechen," in *Das Riechen: Von Nasen, Düften und Gestank*. Ed. Ute Brandes. Göttingen: Steidl Verlag and Die Kunst- und Ausstellungshalle der Bundesrepublik Deutschland GmbH. 59–72.

Proust, Marcel. 1981. *The Remembrance of Things Past*. Trans. C. K. Scott Moncrieff and Terence Kilmartin. New York: Random House.

Sperber, Dan. 1975. *Rethinking Symbolism*. Trans. Alice L. Morton. Cambridge: Cambridge University Press. 115–19.

Stoller, Paul. 1989. *The Taste of Ethnographic Things: The Senses in Anthropology*. Philadelphia: University of Pennsylvania Press.

Süskind, Patrick. 1986. *Perfume: The Story of a Murderer*. Trans. John E. Woods. New York: Knopf.

Villiers de l'Isle-Adam, Auguste. 1982 [1885]. *Tomorrow's Eve*. Trans. Robert Martin Adams. Urbana: University of Illinois Press.

Williams, Raymond. 1975. *Television: Technology and Cultural Form*. New York: Stockholm.

the

intolerable

five

gift

residues

and traces

of a journey

teshome h. gabriel

In the church of my childhood, after Mass was said, people used to gather in churchyards where they would be treated to a one- to two-hour-long verbal visualization of "revelations" as experienced by such prophets as Ezekiel, Elijah, or Jeremiah. The telling of the visions, by the preacher/narrator, was in a way a literal attempt to make visible, through performance, what was fundamentally invisible. This was done without questioning the sanctity of the biblical stories. The visualizations were the vehicles for instruction or delight. Then, when the members of the congregation returned to their respective homes, informal discussions would take place.

One such discussion that I distinctly remember is how Ezekiel saw visions of wheels and angels appearing in the sky. It is as if technology goes back in time to meet Ezekiel, and Ezekiel comes for-

ward in time to meet the technology of cinema, and in both cases they refer to the turning of the wheels.

<div align="center">* * *</div>

I would like to begin by asking your indulgence. What I have in mind in here is not the customary academic essay, but a more personal, indeed autobiographical, narrative. I want, in other words, to tell you a story—a story that, although it is based on my own experience and my own memories, also has significance for the questions of home, exile, and representation, and for the cinema itself. In telling this story, in sharing it with you, I would like to note the extent to which cinema is itself a shared experience in Africa. This shared experience, this notion of "the gift," is one of the threads running through my main story. In telling the story, in which my own mother plays a major role, I also want to examine those things that have always, to some degree, exceeded visual representation: the lived experience, residuals, the viscera.

I am interested in forms of knowing that operate within ideas of memory and within an oracular view of history that engages with observation, intuition, and self-reflexivity. I am referring here to people who travel in realms of ideas that we do not know much about.

<div align="center">* * *</div>

My story begins with my recent visit to Ethiopia after thirty-two years of absence, a visit that affected me profoundly at a personal level, in ways that are not easily expressed in a typical academic essay. As a professor at UCLA, I have for some time written and worked on third world issues, on memory, on identity, on nomadic aesthetics, and especially third cinema and African cinema. I am supposed to be familiar with the issues of non-Western culture, and so on. I am, in fact, often considered to be a kind of non-Western subject within the academy. It was a depiction that I gladly even accepted and cherished. One of the many ironies of my story, then, is that upon returning to my place of birth, I discovered the extent to which I had actually become a reasonable facsimile of a Westernized subject, a version of the postcolonial type.

This Westernization was exemplified in my preparations for the trip. Taking stock of what I thought I would need for my visit, one of my first actions was to buy one of the most up-to-date video cameras that I could find, along with an appropriate number of

videotapes. I also purchased a compact 35mm still camera and a miniature tape recorder, all of which I believed would help me to document my return, both for myself and for my children, who were to remain in Los Angeles while I was away.

At a more emotional level, I worried that the shock of suddenly seeing me again, after so many years, might be detrimental to my mother's health. I therefore took the precaution of telephoning members of my extended family and friends who would be able to prepare my mother for my upcoming arrival. I had often lectured to my students that "happy endings only happen in the movies, not in real life." I was truly afraid that fate had set me up for something terrible upon my return, that my coming home might turn out to be not a gift but a curse.

All my plans, all my attempts to script, organize, and arrange the narrative of my return broke down when I got there. From the moment I got off the plane, nothing happened as I had imagined. Upon seeing my mother again, it was I who was overcome with emotion; it was I who began to tremble as my eyes filled with tears, while my mother was all calm and smiling. The sight of my mother immediately stripped away everything of the past thirty-two years, and I went back, not only three decades into the past, but even further than that, because I returned to a time of childhood.

I went to Ethiopia on a private journey to interact with my family and community. On a personal level, I found that the community welcomed me and opened up to receive me as their son. And on a social level, I found myself thrust into a position I did not anticipate—cast as an elder in the hierarchy of the community. Immersed in the community's experiences, I was no longer simply an individual subject. Thus, I discovered myself in a depth of field that could not be found in any camera, a depth of field that was always deferred elsewhere, where the teller is never in the place of the telling.

<p align="center">* * *</p>

As a professor of film and television studies at a major university, I was set up as the perfect film ethnographer. My recording technologies were supposed to serve as an aid to memory, as a tool or as a prosthesis. Such an idea is based on a very Westernized notion of technology—indeed, it is perhaps the very notion that allows the West to imagine itself as modern, as different from its "premodern," "nontechnological" others. In such a notion, technology is defined

as an instrument or tool that enables a human subject to know and control an objectified world. This implies, of course, a distinction between subject and object, a stance in which one stands at a distance from one's own experience and from one's own emotions.

When I was thousands of miles away in America, the camera seemed like a useful and necessary tool to capture impressions, experiences, and observations. My initial idea was that I would make a kind of home movie out of my visit. I had imagined myself to be outside my impending experiences, from where I believed I could document them with my camera. Yet when I lived the experience itself, when I came face-to-face with my emotional inheritance, I realized that the camera was superfluous.

I therefore recorded nothing with the camera. I did not need the magic of cinematic representation and scripted narrative to stand in for me; a whole different level of creating traces began to occur. It was my body that took over and became the catalyst for a different process of writing. I began to write internally.

In internalizing my own images, I am now able, when the need arises, to show snapshots or tell vignettes of my trip to Africa, to keep reshooting it, renarrativizing it; that is, I can keep retelling the story and readapting it according to prevailing circumstances and situations, as I am obviously doing here now.

To voluntarily put myself, with camera in hand, in the position of the outsider, in the position of the intrusive other, would have been incongruous with my own theoretical tendencies and writings. It was as if my *camera-stylo* had somehow flipped around and pointed its eraser end rather than its writing tip. This was precisely because a film, as a representational record, is fixed and cannot be transformed. As my own experiences showed me, the memory of a lived experience is anything but fixed.

Because recording my experiences as film was not adequate by itself, instead of shooting the film, I, in a sense, began to shoot memory. But surely memory is not cinema, in the normally recognized sense of the term, because there is not a film there—it is zero, it reaches a ridiculous point of nullity. Yet for me it represented something more than could be conveyed on film itself. In this unique condition, technology, in the Western sense, is banished but the cinema remains. Cinema then becomes more than a tool, or a means to document and represent reality. Instead, cin-

ema becomes more than the sum of its technology and its representations: it becomes a kind of transubstantiated cinema.

What is not on the screen, but falls through the gap of the splice between images, is the eminent world that is not represented. Here I am referring to what is forced out or exiled from the image by virtue of the splice. The splice, the ellipsis, reminds us that film engages us in a ritual of transubstantiation. It is what surrounds the image as the unstated.

The concern here is that cinema should not be seen solely in technological terms, dependent only on its apparatus. The concern is with the ideas and experiences of cinema: not only what cinema is technologically, but what it can be experientially. Cinema should not simply be images printed on celluloid, but what those images refer to—the memories, the lived experiences, the dreams, the unseen realm of myths and spirits that hovers beyond and between the images.

<div align="center">*　　*　　*</div>

Cinema is an intolerable gift. But, first, what is a gift? Some argue that there is no such a thing as a gift. Others say that when one gives a gift one has an expectation of getting something in return at some point. In such instances, giving is mutually grounded in the notion of exchange. If the giver in some form or other is expecting something, even some kind of acknowledgment, then the idea of a gift is impossible.

Even when there is no definite expectation of something to be returned to the person who gives, there is nonetheless, in some ways, a societal obligation that the recipient reciprocate, by giving something in return. In other words, if there is an expectation within me of somehow having to reciprocate a gift, then the gift, in that sense, is already contaminated. The contamination comes not from the supposed gift but from the context, the milieu in which the exchange is made.

Still others argue that there should be no expectation or obligation on either side. If there is any kind of obligation to reciprocate then what has taken place is an exchange in some form or other. Is there really such a thing as a gift, anyway?

Before my departure for Los Angeles, my mother gave me two gifts that serve to suggest a different and perhaps alternative idea of gift.

One of the gifts that my mother gave me is a little clay cup that I used to drink milk from when I was a baby. The little cup is a relic

of my childhood. It is dependent not only on milk, but nourishment, sustenance, nostalgia and memory. Symbolically, the clay cup is in some sense the womb and the umbilical cord that ties me to my mother. The cup is made from the same earth in which my placenta might have been buried. There is this link to the earth, and that link is through my mother. The gift that my mother gave me does not presuppose anything in return. It is an incredible gift, where one does not expect reciprocity. It is an infinite gift.

The second gift that my mother gave me is a picture. Here is Emperor Haile Selassie I of Ethiopia, standing in a high-school classroom and listening, in his regal majesty. The image is informal and unstaged. The emperor is standing next to my shoulder. I am sitting at a manual typewriter. I am about to show the emperor how I can put words on a page. Everything is in this photograph. In a way, not on was I being prepared as a typist, I was also engaged in becoming a type—a type of person. The typewriter speaks volumes. It associates the emperor with an icon of modernization. It equates the authority of the emperor with that of writing. Writing is what I do in my professional life. The picture can also be read as a father-son relationship, sharing the same national and cultural context.

Surely it is a photograph that is seemingly very clear and very direct. Look at the photo again. Why is there so much awe and reverence written all over the face of the young boy at the typewriter? The irony of this image, however, is that a mere five years after the picture was taken, I led a university students' rally against the emperor's government in support of an attempted coup d'état, which subsequently failed. Although the emperor was for technological progress, he was also keenly aware that political change has to come from within and be adapted to what was already within. He represented both tradition and change, whereas we, the students, imbued with Western intellectual traditions, were looking outward, toward Europe and America, for inspiration and models for revolutionary change. Memory is history read backward. Sometimes it makes you wish you could be old, and then grow younger, so as to understand the mistakes of our lives.

It is in fact partly due to my involvement in the attempted coup d'état at that time that I began my academic exile in America. It partially accounts for my long absence from family and country. This photo then becomes an image not only of the past but of a memory-image I have carried on, and also displaced. From my cur-

rent position, this picture reenforces the idea that it is both past and other. It is also, of course, not other and not past, because although it might be a past represented, it is a present image—the time frame, identity frame, and national frame, all rolled into one. In a way, the image disintegrates as a hierarchy, because it is only a past representation re-presented in a new context, in which the power in the frame is no longer there. Yet it is still viable, it is still there, but it is being rewritten and reread in terms of its displacement. It is both there and not there, valid and not valid simultaneously, so it makes me very much cognizant of a past identity. It is at the same time intrinsic to who I am now, in how it cannot stay fixed. It is the epitome of the crossingover, this fluidity, that I wanted to capture, but these are also things that are the most impossible to capture.

My mother's two gifts, the little clay cup and the photograph, are intolerable gifts. Though they were forgotten, static and frozen images in my memory, through her giving they set in motion the residual associations buried in the recesses of my imagination. This notion of an intolerable gift suggests something that is simultaneously overcoming and needs to be overcome. I am attempting to make the gifts meaningful and endurable by retransforming them and reactivating them as a more fluid memory beyond representation.

<center>*　　*　　*</center>

In any image there is always a picture of difference. Every image is a mask; it conceals another image. Any single image is in fact a compendium of several images that prepare the way in which each individual image is seen and read.

Let us read the image one more time. No matter what, images keep coming back—always as residues and as excess. The little clay cup, which is behind the photograph, is outside of the image-frame, and yet it keeps sneaking back into the frame of the photograph, in a disguised form, and in an invisible way.

The little clay cup acts as the mechanism that animates the photograph. We might go so far as to suggest that what is in fact missing in the photograph is actually contained in the cup, and vice versa. It is the cup, however, that captures and completes the picture. The little clay cup metaphorically serves as a lens or beacon, by means of which the photograph is understood. As a kind of lens, the cup sheds light on the photograph in order to cause it to have a kind of movement, and it also takes the stillness of the photograph

and energizes it—it makes it move and gives it a sense of narrative development.

His Imperial Majesty is the authority in the image. The patriarchal impetus in the image is basically the emperor. He represents the institutions of the nation-state, which comes from the idea of a nation, which is missing in the photograph. What is happening in the picture is the transformation of the nation into the nation-state. Part of the photograph is, therefore, a commentary on the nation, which is invisible in the image, because it is my mother who is not in the picture.

That is partially what is happening in the picture. In many narratives of nations, it is the women who are symbolically the nation—the bearers of tradition and culture and the repositories of social and historical memories and its spiritual energy. The nation is the community. What is missing, and needs restoration in the picture, are the invisible women, who in being the outsiders, have always remained the African insiders. They are the unsung that makes the song.

There are all sorts of ironies here. The irony of ironies is that I went to Africa with the intention of making a Western film of the non-West, but instead of making that film, I received a different narrative, a different story that took the form of a gift. I was soon to discover that my mother has been shooting and editing a film all along. So just as I was about to leave for America, my mother said, "Oh, here!" And she gave me a film. She did not call it a film, yet it was far better than anything I could have made. Even if I had in fact shot a film, a good film, and given it to her, it would never have come close to the film that took my mother more than thirty-two years to make. If it was purely a Western film, she would have given me only the photograph. But little did I know that my mother has been living modern in the traditional way. She combined the two gifts so that they resonate to create something that was more than the sum of their parts, something that goes beyond the categories of modern and traditional, Western and African.

This gift was intolerable because it cannot be reduced to the terms of such categories, because it comes out of the lived experience of African women. It is intolerable because it can never be fixed in a particular photographic or cinematic representation, because it cannot be made a matter of material exchange. It is an intolerable gift because it creates a sense of having been given some-

thing that can never be returned. The intolerableness is that the gift itself creates a debt that can never be repaid. It is intolerable because it reawakens the residual traces of my return journey associated with the gift.

The representation of Africa is a gift of women. It is women who gave Africa the gift of their shared experiences: stories, musings, memories, and yes, cinema also. It is this gift that has often been forgotten, as I myself forgot it, thinking that I could stand outside it, recording and analyzing it from a critical distance.

If we acknowledge the gift, will it be less of a gift? Not really. Because the gift is just like an heirloom—it is to be forwarded, to be passed on to the next generation. Or to put it metaphorically, one can join the ends of a braided rope only by overlapping its strands. The gift, then, is not a state of being; it is continually enacted, lived, and performed.

In the gifts that my mother gave me, and which I am passing on to you, there is something that is represented and something that cannot be represented. This is why I have shown you the photograph but not the little clay cup. The photo can be materially represented, but the experiential charge of the cup, that part of my story and my mother's story, must remain amorphous, shifting as it is given from one person to another.

Africa as an idea is a flexible code, where we are all invited to navigate and narrate our own journeys, as we go along. You also must find, in your own journeys, the pathways to your stories, and to your hushed memories that come from the conjunction between your indomitable image and the little cup.

Finally, it is perhaps our bubbling memories that throw into relief our visions of home, out of which emerge all those residual meanings buried in the bigger landscape of "memory-spaces," which we incessantly reconstruct. These memory-spaces then can only serve a space away—a sort of space into which one can reactivate the rewards that have been gently consigned to the intolerable gifts of the autobiographical.

note

An earlier version of this essay appeared in the catalogue of Cinéma du réel, the 18th Festival International de Films Ethnographiques et Sociologiques, Paris, March 8–17, 1996.

the key

to the

house

patricia seed

In a two page essay published in December 1993, the noted Palestin-
ian novelist Anton Shammas, who writes in Hebrew and English
(but not Arabic), recounted an event from a few months before. At
a news conference, an employee of the Palestine Liberation Organi-
zation Information Bureau in Tunis was presented to reporters by
an associate. Shammas, who does not name either the woman or
her co-worker, describes the scene. This woman, her colleague
says, is the "genuine refugee. . . . Her father keeps in his possession,
to this very day, the key to the house that his ancestors left 500
years ago in Al-Andalus, when the Muslims were driven out of
Spain after the conclusion of the Reconquista in 1492." (1993,
32–33).

Shammas (using the woman's Palestinian fellow worker to
speak for her, that is, to represent her) tries to make an Arab moral

out of this tale. Palestinians cannot be expected to hand over the keys to houses they abandoned only two generations ago when they still retain the keys to a homeland from which they were exiled at an even more distant time. (1993, 33). Invoking a poetics of loss and longing, Shammas claims that the dispossession from Palestine may be remembered by the same physical expression—the key to the house.

When I read Shammas's account, I had heard a nearly identical tale from three different sources, one quite similar to his. Three years previously, Rice University's Anthropology Department admitted a new graduate student from Morocco. She came to introduce herself to me upon hearing that I was interested in Andalusian Arabic and Islam. She presented herself first by talking about her name. "Bargash," she said it was, but added that it was really "Vargas," that is, actually a Spanish name. But since Arabic does not have the letter "V," she showed me how the first letter of her name was written—as a classic Arabic *B* but with three dots underneath. Jamila said, "Of course, three dots *underneath* do not exist in Arabic," by which she meant they do not exist in classical Arabic. Then she passed to the hard *G* in her name, a sound that also, as she said, "does not exist in Arabic." And then she showed me how to write the hard *G*—again, not in a classic Arabic script but as *ghayn* with a circumflex over it. Finally, to persuade me of her Andalusian heritage, she told me a brief story. Over the lintel of the front door of their home in Casablanca, her father kept an enormous key to the house that her family had abandoned in Granada in 1492.

But while I have heard or read this story from North African Muslim women such as Jamila Barghash and Shammas's unnamed Tunisian, I have also listened to the story from quite different sources and in very different parts of the world.

In June 1993 I first stayed for a considerable time in Brazil, a nation that has significant numbers of Arab and Jewish immigrants, many of whom arrived in this century. Searching for descendants of Iberian Jewish scientists, I began querying many of my hosts, hoping to find some who might have had ancestors who left Portugal in 1497 or shortly thereafter (Seed 1995, 100–48). But to my dismay as I began to hear from several of these families, I found myself hearing not the information I was seeking, but something quite different. Having arrived only recently in Brazil from

places they had inhabited not long ago—modern-day Greece, Turkey, and Crete—they told tales of how they and their families had recalled fifteenth-century Andalusia. Many described family homes in the Jewish quarters of small towns and big cities in distant Mediterranean zones. In these homes their parents kept above the front door, the key to the house that they had been forced to abandon in 1492. When reading Anton Shammas's account of a key safeguarded by a Muslim family for over five hundred years, I had already heard identical stories from Sephardic Jews.

Yet the idea that Muslims and Jews may have shared the same fate, experienced similar feelings in exile, and remembered their past in a common way seems to have eluded Shammas. For in his retelling of the unnamed Tunisian woman's story, he introduced a small but telling historical fiction: "The Muslims were driven out of Spain after the conclusion of the Reconquista in 1492." There was no Muslim expulsion from Granada in 1492. Ferdinand and Isabel, the reigning monarchs of Aragon and Castile, expelled only the Jews in 1492.

Moroccans and Tunisians who keep the key to the house their ancestors abandoned over five hundred years ago are identifying themselves with the fate of their Jewish compatriots. For on the Iberian peninsula, Muslims and Jews had lived in relative harmony for nearly a millennium. While not formally banished in 1492, many of the wealthy and learned Muslims from the city of Granada felt compelled to leave at the same time as the Jews. For they believed that Ferdinand and Isabel's exiling of the Jews in 1492 constituted a portent (as indeed it was) of coming religious persecution of their faith, despite obvious indications to the contrary.

When the last Muslim empire on the Iberian peninsula fell to Christian arms in 1491, Ferdinand and Isabel signed treaties nearly identical to those that Muslim victors had previously signed with defeated Iberian Christians. According to these agreements, subsequently adopted by Christian monarchs, the defeated were guaranteed religious freedom. Seemingly observing this tradition, the king of Aragon and queen of Castile guaranteed all surrendering Muslims freedom of worship and personal liberty, together with ownership of all their real and personal property.

But this memorable tradition of tolerance, embodied in this agreement and centuries of similar agreements, was not to last. For on the pretext of reclaiming apostates (actually people whose

ancestors had converted to Islam generations or centuries before), in 1498 Ferdinand and Isabel began coercing Muslims to convert. When Muslims rebelled against these conditions three years later, the Catholic monarchs unilaterally abrogated the religious toler- ance they had promised the Muslims upon their surrender in 1492, on the pretext of preventing future uprisings. Those Muslims remaining in Iberia until finally being expelled in the 1630s were often poor, frequently rural, usually laborers or artisans. Their Christian counterparts remained socially and culturally aloof from surviving Muslims, deliberately cultivating cultural styles to estab- lish their distinctiveness. The *pícaro* who lived by his wits rather than the sweat of his brow expressed the same exaggerated disdain of laboring Muslims as did the *hidalgo*'s extravagant hauteur and pride. These carefully crafted self-images appeared in anti-Semitic formulations of Miguel Cervantes—the Spaniard who did not trade like a pig of a Jew, nor work like a mongrel of a Moor (Cer- vantes's words, not mine). After 1492 Spain no longer gleamed as the beacon of enlightenment it once had been, and in its place was a different, in some ways quite novel creation.

In expelling the Jews in 1492, Ferdinand and Isabel began to cre- ate the forerunner of the modern religious fundamentalist state, unified politically by a religion. Over the next three centuries their heirs and successors never wavered from their pursuit of a com- mon religion as the basis of state formation. In later years, Spanish rulers pursued this ambition at home by expelling Muslims. And they sought identical objectives abroad by fighting a nearly total war against inhabitants of both the Netherlands and the Americas who professed different religions or who supported religious free- dom. Spanish monarchs insisted that all their subjects—in Europe, the Americas, and Asia—had to observe the state religion, Roman Catholicism. Whereas other European monarchs and ear- lier Iberian Muslim caliphs had always clamped down upon *public* expressions of religious dissent, the Catholic kings raised the pri- vate voicing of doubt to the level of political treason. To ensure that such doubts remained unexpressed, they created a modern, centralized bureaucratic apparatus, the Inquisition, to punish unbelievers and even doubters.

Some may locate a precedent for the 1492 expulsion in the actions of the infamous twelfth century Almohads. But these largely Berber ascetics forced Jews and dissident Muslims (including

two great medieval scholars, Maimonides and Averroes) to adopt their interpretation of Islam or be expelled. While showing none of their faith's usual tolerance, Almohads nonetheless failed to intrude into the private doubts of their subjects.

<div align="center">*　　*　　*</div>

The slight historical fiction at the heart of Shammas's tale—that Muslims were expelled along with the Jews—in essence turns the story on its head. For the retellers of the tale seem rather to suggest solidarity with their Jewish compatriots in the face of an implacably intolerant Christianity. Such Judeo-Arab solidarity (against Christians) appears in North Africa even among the descendants of less affluent Arab and Hebrew exiles from Andalusia. Among them are many whose families were insufficiently wealthy to own houses to which their heirs might retain the key. In a memorable account of life among poor Muslims and Jews in this century in a North African town, Joëlle Bahloul tells of how Jews and Arabs willingly resided in the same apartment complex, though neither wanted to live with Christians (Bahloul 1992). These complexes were a collection of rooms that largely served as sleeping and eating chambers, with communal cooking, washing, drying, and recreational space in the courtyard. Residing together meant living together— watching out for each other and each other's offspring. Growing up in Christian France, Bahloul was surprised to hear such positive remembrances of Judeo-Arab communities from her parents, grandparents, and their friends. Yet when she returned to the complex and tracked down Muslim families who had moved away, she found the same pattern of fond reminiscences of a Judeo-Arab community implacably averse to cohabiting with Christians.

The story of the key to the house can be told neither as a Muslim tale nor as a Jewish one. The many Muslims banished from the Mashriq (or East) over the centuries do not recall Damascus, Tehran, or Baghdad by retaining possession of a key. And in interviewing scores of Ashkenazi Jews, I have often heard of countless retraced steps and pilgrimages to former houses and towns, but I have yet to hear the tale of a key, even from those whose families fled into exile well in advance of the Nazis. Jewish life in Central and Eastern Europe, now destroyed, has not been remembered in the same fashion as exile from Spain. Iberia was a special homeland, a place where, for a while, Jews, Muslims, and Christians shared a

history, breathed the same air, ate the same or similar food, and designed and built palaces, fortresses, synagogues, mosques, and churches of extraordinary and enduring beauty. The tale of the key commemorates a life shared in what was once the heart of the Maghreb (or West)—Al-Andalus, as it was called in Arabic, or Sepharad, as it was known in Hebrew.

<center>* * *</center>

Regardless of their language or religion, exiles remember Spain in bittersweet tones, recalling the natural beauty of its landscapes, its brilliant skies, and glorious gardens redolent with the scent of orange blossoms in the spring. Al-Andalus or Sepharad conjures up a vision and a fragrance that emotionally evoke exiles' memories of a homeland.

The present-day reality of the key reminds these exiles' descendants of their losses of not just a home but a homeland. It reminds them that the home in which they now reside—in North Africa or the eastern Mediterranean—is a kind of home under erasure, a home that *is* home, but not the homeland. For the loss they have experienced went beyond the loss of home. It was an intellectual and spiritual privation as well.[1]

In addition to abandoning Iberia's natural and man-made beauty, they were leaving behind a world of extraordinary accomplishments in philosophy, theology (Averrö's, Maimonides), science (Al-Farabi, Zakkut), medicine (Avicenna), and architecture (the Alhambra). From the distance of exile, these achievements seemed to have occurred far closer to paradise than the worlds to which the exiles were banished. The places of exile—Italy, Greece, and the Ottoman Empire—often lacked libraries and printing presses, the skilled doctors and scientists, the linguistic comprehension of a rich Judeo-Arabic literature. Furthermore, exile had scattered those talented human beings—Jews and Muslims alike—across a broad expanse of the Mediterranean and the then-tolerant Netherlands. The ease of communication and exchange that had been so intellectually productive was severed, often forever. And for many, the loss was greatest on a personal level: deprivation of the intimate bonds between peoples and individuals forged over centuries. It is perhaps not surprising that the tales of banishment from al-Andalus often sound and feel like the account of Adam and Eve's expulsion from the Garden of Eden.

Yet the houses that Jews and Muslims once occupied in Iberia are frequently no longer standing, and the locks that their safely guarded keys once fit have long since been removed. For if the door and the house are no longer there, keeping the key only allows exiles to dream of return. But should they return, the society they once inhabited would no longer be there. Many of the places in which they once worshiped are shattered or altered beyond recognition. Some, like the once-stunning mosque of Seville, La Giralda, have been transformed into Christian cathedrals. Palaces such as the Alhambra have been reincarnated as tourist attractions.

The shared life and expectations have vanished as well. The common knowledges of Iberia's Jews and Muslims no longer are at the forefront of scientific knowledge and discovery. The dynamic world economy dominated by Muslim and Jewish traders has been taken over by not one but several different strands of global capitalism.

Retaining the key to a house that is likely no longer standing and a lock that has undoubtedly long since disappeared, however, is not a nostalgic gesture.[2] Nostalgia springs from capitulation, resigning oneself to the irretrievable loss of familiar objects and well-liked faces, the bonds of friendship, shared learning and languages. Retaining the key that may no longer open a door, on the other hand, reminds Sephardis and Andalusians to remember and to narrate the history of their losses.

Thus the key prompts exiles to retell their history, which is also the passing of an extraordinary moment in human life. Just as the Passover seder prompts Jews to retell their history of exile and slavery, the key, like the seder, is a device or occasion to permit retelling of the narrative of loss. All such stories refuse to forget.

Recounting their losses does not heal the grief caused by exile, but rather the reverse (Naficy 1993). Both the key and its narrative perpetuate traumatic memories: the pain of multiple losses, the lives and friendships ruined, the careers and achievements in science and medicine terminated, the exquisite places of worship smashed, the beautiful skies never to be seen again. Thus, as if by some twisted logic, the key preserves the sweet pain of exile, allowing it to be called up and relived.

Al-Andalus differs from Palestine, occupying a different place in our imaginations and our histories. Palestine contains sites sacred to Islam, Christianity, and Judaism. But it lacks the record of enduring great *human* accomplishments, shared understandings,

and personal companionship that have made the exile from Al-Andalus/Sepharad so traumatic.

The most harmful mistake in understanding this story is to link its tragedy to the history of a single religion. This blunder—in essence, mistaking the religion for the territory—is all too common in this era of Muslim, Hindu, and Christian fundamentalisms, in which politically ambitious leaders increasingly confuse religious and territorial power.

For the story of the key to the house is not about a single religion, and even less about modern Jewish-Arab conflicts. The heirs to that great civilization once called Andalusia, al-Andalus, or Sepharad speak alike of their deprivations. Their stories and keys commemorate a shared dispossession. For their keys unlock memories of a now-vanished place—a religiously tolerant, pluralistic Spain—on the threshold of undergoing a vicious, vindictive ethnic cleansing in 1492. Expelling Jews, forcing many Muslims to convert, and introducing secret police with powers to arrest and torture, the Catholic monarchs ruthlessly eliminated traces of that earlier world, which had demanded, if not mutual respect, then at least a minimum of tolerance. The trauma of its annihilation made that earlier milieu seem prelapsarian by contrast. Jewish and Muslim keys together open a door within memory to a world that was truly lost in 1492 and the years following, not by accident, but by the deliberate political extirpation of peoples whose homeland on the Iberian peninsula had endured nearly a millennium.[3]

But the tale of the key to the house safeguarded by exiles is also being retold in the present world by believers of yet another faith. Speaking in neither Ladino, nor Judeo-Arab, nor classical Arabic, nor Hebrew, but in regional Castilian accents, these modern narrators unselfconsciously recount an identical tale.

This final group of tellers was, in fact, the first to tell me this tale. In order to explain their version I must quickly sketch another historical background. In 1492, just as the last major boatload of Jews set out from the port of Cadiz in Sepharad, never to return, a slightly different group of voyagers embarked from a smaller nearby port. This other voyage was headed by a difficult man of some (but not extraordinary) navigational skills, learned largely on Portuguese Atlantic trade routes. This individual, named Christopher Columbus, had persuaded Queen Isabel that Spain could beat Portugal in the race to India by sailing to the West. Eager to gain

India in advance of the Portuguese, Isabel outfitted Columbus's ships and provided him with a translator to help in his commercial dealings with the great khan of China. (Trade in Asia during the fifteenth century was often transacted in one of two lingua francas, Arabic or Hebrew.) Hence on board Columbus's ship was the interpreter Luis de Torres, a recently converted Jew, who first addressed in Arabic and then in Hebrew the leader of the (Lucayan or Taino) natives of the Caribbean.

I first heard the story of a key to a house from Spanish inhabitants of a Caribbean island reached by Columbus. Like the keys of Andalusian Jews and Arabs, these exiles' keys also unlocked a story of a homeland abandoned because of political persecution. When I first came to Houston fourteen years ago, I met some of the leaders of the local Cuban community. One of the earliest stories a number of them told me concerned a key to a house that they had abandoned in Castro's Cuba. They kept this key, they said, over the portal of their homes here in Houston.

Seemingly different events provoke a similar way of remembering for those sharing a common history. Today, a successor place to Al-Andalus or Sepharad resides in the crystalline waters of the Caribbean, bearing the sights, smells, and sounds of yet another homeland that is now no longer home. Thus the trauma of 1492 is kept alive in a different way. For these contemporary Cuban narrators are Catholic, descendents of Spanish immigrants to the Caribbean. It seems that even those who remained in Spain—the seemingly victorious Christians—were also touched by the losses of 1492. All the heirs to Al-Andalus, Sepharad, and Spain suffer the deprivations occasioned by expelling those among them who differed from the ideal demanded by a modern religiously homogenous state. Jews and Muslims left more than a memory of their presence in Spain; they also left a way to remember separation from the homeland.

The tale of the key to the house belongs neither to one particular faith nor to a given language. Modern Christians, Muslims, and Jews all safeguard keys to houses abandoned in their homelands. Speaking in Hebrew and in Arabic, in Ladino, in Portuguese, and in Castilian they all recount their expulsion and the worlds they were forced to relinquish. All contemporary keepers of a key descend from that great civilization that was once called Andalusia, al-Andalus, or Sepharad. They are the modern heirs to both a com-

mon history and a common nightmare. The joint history consists of past greatness; the joint nightmare concerns a homeland insistent upon religious conformity and homogeneity. These keys remind those residing in exile of a homeland—one they can dream of, and yet will never return to, except perhaps to visit. For even if the houses remained standing, the world they or their forebears once inhabited is no more.

patricia seed

notes

1. I am grateful to Teshome Gabriel for having first pointed this out to me.
2. Yet Shammas described pre-1948 Palestine as "a construct of nostalgia" (Shammas 1993, 33).
3. The Muslim conquest of Iberia was complete by 709; their expulsion was not finalized until the 1630s. The Jewish population of Iberia antedated the Muslims.

works cited

Bahloul, Joëlle. 1992. *The Architecture of Memory: A Jewish-Muslim Household in Colonial Algeria, 1937–1962*. Cambridge: Cambridge University Press.

Seed, Patricia. 1995. *Ceremonies of Possession in Europe's Conquest of the New World*. Cambridge: Cambridge University Press.

Naficy, Hamid. 1993. *The Making of Exile Cultures: Iranian Television in Los Angeles*. Minneapolis: University of Minnesota Press.

Shammas, Anton. 1993. "The Art of Forgetting," *New York Times Magazine,* (December 26): 33–34.

cinematic

modes

of

production

ethnicity,

authenticity,

and exile:

a counterfeit

trade?

german filmmakers and

hollywood

t h o m a s e l s a e s s e r

Why was it that so many talented European filmmakers, actors, scriptwriters, composers, and set designers ended up in Hollywood? The question has attracted a fair amount of attention from biographers and cultural historians, but mainly to flesh out with anecdote an answer already known in advance.[1] Especially when concentrating on personnel from German-speaking countries, writers have their narrative emplotment more or less ready-made, for it makes sense to see the émigrés as political refugees, first fleeing Europe because of Fascism, then frustrated by uncouth and uncultured movie moguls, and finally persecuted and witch-hunted by paranoid anti-Communist U.S. senators. Prominently featured in this version are Fritz Lang and Bertolt Brecht, expressionism and *film noir*, Thomas Mann and Arnold Schoenberg,

Marlene Dietrich and William Dieterle. John Russell Taylor's *Strangers in Paradise* can be considered the definitive account and classic formulation of the liberal-intellectual political-émigré thesis, where the story tells itself across aptly titled chapters, such as "The Gathering Storm," "Hollywood Left and Right," "The New Weimar," "Hollywood at War," "What We Are Fighting For," and "How to Be Un-American" (Taylor 1983). This canonical version does not lack either plausibility or testimony, yet its self-evidence is nonetheless deceptive.[2] In what follows, I would like to complicate the picture slightly, at first by extending it backward in time, and then by doubling the political dimension with another one: that of trade and competition, of contracts and markets. Finally, the anti-Fascist war and the trade war have themselves a double in the cinema: the looking-glass war of competing representations of identity and origins, where what it means to have a home and to have left it receives a further turn.

immigrants or invasions, exiles or trading places?

While the cinema is undoubtedly *the* American art par excellence, it has long been recognized that migration, exile, and immigration are constitutive of what we understand by the American film industry. Hollywood—originating when the independent producers escaped the (Eastern) Motion Picture Trust to set themselves up on the West Coast—is incomprehensible without the play of ethnicity and family values as the tropes of economic-institutional bonding along with a disavowal of origins. If the disavowals in many ways reinforced the bonding, neither quite dissolved without residue into the immigrants' assiduous striving after assimilation and integration. The process left sediments of transit, habit, and defiance that, when projected into an entrepreneurial future of dynastic ambitions and cultural aspirations, defined the conformism of a self-made élite. Carl Laemmle was a German-born bookkeeper whose career began in a clothing store in Wisconsin; Samuel Goldwyn, born in Warsaw as Samuel Goldfisch, was a glove merchant from upstate New York before he married into the Lasky vaudeville family; Adolf Zukor was born in Hungary and made his first fortune as a furrier in Chicago before moving into penny arcades; William Fox was born Wilhelm Fried in Hungary and set up in New York's Lower East Side garment trade before buying up

Blackton's bankrupt arcade business; Louis B Mayer, born in Russia, moved from his father's scrap metal business in Boston to owning cinemas in New England; Joseph and Nicholas Schenck also came from Russia, owning drugstores and amusement parks in New York while keeping their sights on the high-risk motion picture business. Another Russian, Lewis Selznick, owned jewelry shops in Pittsburgh, gambled away a fortune made in movies, but fathered two famous sons that were to make the family name part of the Hollywood legend.

Yet ethnic memory or even the Jewish faith as such is perhaps not what was most remarkable about Hollywood's "founding fathers." The paradox of these first-generation Americans is that they played such a large part in transforming film production into the cartel known as the Hollywood studio system, precisely because they wielded a cultural influence over mass taste while claiming simply to be in a business. For even if they did not altogether "invent Hollywood," as argued by Gabler (1989), by repressing and disavowing their own homeland and heritage, they must have helped install at the heart of Hollywood an ambiguity regarding cultural identity that has typified the role of foreigners in Hollywood ever since: either assimilate and become 110 percent American, or be European and exotic, but also 110 percent! Such asymmetry and excess might in fact represent two hidden figurations that sum up this relation to a "center" that is itself the projection of different kinds of otherness, hinting that the questions of émigrés and ethnicity, of homeland and Hollywood have to be located also in a broader context.

The contradictory field of force is perhaps most noticeable among the German émigrés to Hollywood, arguably the largest group or, as indicated above, the one most written about. The story of Germans in Hollywood is complicated by two factors. They came from a country that, at least in the 1920s, could boast of a strong film industry; but they also came from a country that was politically a pariah—associated with war, aggression, and Prussian brutality after World War I, it became in the 1930s the country that openly persecuted the Jews. As a consequence, two master narratives compete for credibility. One is centered on the 1930s and 1940s and tells the story backwards, with the émigrés-refugees fleeing Europe to escape a Fascist dictatorship and the war, only to be humiliated in Hollywood by tyrannical, ill-read, and ill-bred movie

moguls such as Louis B Mayer, Darryl Zanuck, and Harry Cohn. This narrative gradually replaced an earlier one, also centered on a war. It described the Germans as invaders, and as a flood, terms first used when *The Cabinet of Dr. Caligari* (Robert Wiene, 1919) and *Madame Dubarry* (Ernst Lubitsch, 1919) made money for their (American) distributors, but the metaphors allude to militaristic national clichés in everyone's mind after 1918, when there was substantial resistance against the import of German films.

The trade press of the time was particularly fond of such bellicose expressions, which reached a climax when Ernst Lubitsch came to stay and brought with him his whole retinue from the German studio conglomerate Ufa. David Robinson in *Hollywood in the Twenties* echoes the mood when he writes of "Ernst Lubitsch, the most successful and enduring of the foreign invaders" (Robinson 1968, 57). John Baxter takes up the same theme: "The arrival in New York on 24 December 1921 of Paul Davidson and Ernst Lubitsch—and the more flamboyant landing a few weeks later of Pola Negri [were the] harbingers of a flood that fundamentally changed the American film industry" (Baxter 1976, 36), adding, somewhat gleefully, a few pages later, that the flood was eventually "beaten back," either because directors "returned in disgrace" or because Hollywood "ruined the brightest European talent" (Baxter 1976, 54, 65, 72).

One could argue that both Baxter's claim and his disclaimers are exaggerations, and indeed, I shall try to put forward a slightly different case. For instance, if the military vocabulary about "invaders" has any justification, it applies more to Hollywood than to Germany: throughout the 1920s, talent-raiding campaigns were masterminded and conducted by U.S. studio executives, coming to Europe for what Fritz Lang called "trophy-hunting," the objective being the defeat of a rival by buying out their best talents in order to exploit them internationally. On one of these trips Harry Warner "bought" Michael Kertesz in Berlin. Kertesz had taken refuge in Germany from Hungary, after the collapse of the Austro-Hungarian Empire, and in Hollywood transformed himself into Michael Curtiz, the most dependable and inspired of Warner's contract directors, directing for them some fifty films in twenty years, among them a German-language version of Lloyd Bacon's *Moby Dick* (*Dämon des Meeres*, 1931) and (much later) everyone's favorite émigré film, *Casablanca* (1943). And Carl Laemmle's summer vaca-

tions during the 1920s in the (now Czech) spa towns of Marienbad and Carlsbad were notorious occasions where Berlin film folk fell over themselves in the hope of garnering a contract for work at Universal (Kohner 1977, 52).

Baxter, however, makes an important point in passing: when discussing the émigrés of the film business, it can be misleading to focus on the directors alone, because the asset Hollywood wanted was the popularity (in the European market) of certain stars whom the directors were deemed to be able to deliver (apart from Pola Negri, Lubitsch also brought Emil Jannings, while Mauritz Stiller brought Greta Garbo). Hermann Weinberg, in *The Lubitsch Touch* also recognized the nature of trade:

> The foreign "invasion" had begun, though it was never a real invasion, for the European contingent had been invited one by one, nay, *lured* to come here. Thus on the heels of each other soon appeared Emil Jannings, Conrad Veidt, Erich Pommer, Alexander Korda, Paul Leni, Lothar Mendes, Lya di Putti, Karl Freund, Lajos Biro, Friedrich Murnau, E. A. Dupont, Ludwig Berger, Camilla Horn and many others—stars, directors, cameramen, and scene designers, leaving Ufa all but bereft of many of its best talents. (Weinberg 1964, 47)

Even with the lesser talents the aim was to make films destined for the penetration of the foreign national markets at the expense of indigenous producers. As Lubitsch's personal assistant, for instance, came a young man called Heinz Blanke, who would become, behind the scenes, one of the most important middlemen in the traffic between Berlin and Hollywood. From 1933 to 1962 he acted as a key producer for Warner Brothers under Hal Wallis.

The anti-Hollywood sentiment in Weinberg has been taken up by other writers, such as Siegfried Kracauer and Lotte Eisner, who speak of an exodus, a drain that left the German film industry deserted and depleted. Here the economic argument shades into the political argument, for it implies the notion of a steep decline of the German film industry in the latter years of the 1920s, leading inevitably to its artistic demise in 1933. But as George Huaco has pointed out, this narrative cannot be right, since films made in Germany in the late 1920s and early 1930s—*Menschen am Sonntag* (*People on Sunday*, Billy Wilder/Robert Siodmak, Fred Zinneman, 1929), *The Blue Angel* (Joseph von Sterberg, 1930), *Der Kongress Tanzt* (*The Congress*

Dances, Eric Charell, 1931), *M* (Fritz Lang, 1931), *Die Dreigroschenoper* (*The Threepenny Opera*, G. W. Pabst, 1931), *Vampyr* (C. Th. Dreyer, 1932), and *Kuhle Wampe* (Hans Eisler/Slatan Dudow, 1932) to name only a few—are aesthetically as important, thematically as adventurous, and stylistically as diverse as anything produced at the same time in Hollywood, quite apart from the fact that these films, among others, ensured that the German film industry was financially more stable and internationally more successful than at any other time in its history. The profits from a series of musicals produced by Ernst Pommer and directed mostly by Hanns Schwarz, Karl Hartl, and Gustav Ucicky (all of whom stayed on) were enough to keep the Ufa balance sheet positive, despite the studio's huge investments in the conversion to sound.[3] Considering how generally hostile avant-garde critics tended to be to the coming of sound, one wonders whether the political argument of the exodus after 1933 might not have found reinforcement in an aesthetic prejudice.

wave after wave?

A more historically grounded assessment of the relation between Germany and Hollywood, therefore, cannot be either solely economic or purely political. The two master narratives of the "German invasion" and the "German refugees" at once contradict and complement each other, precisely because they are held together at another level, that of the ethnic imaginary, where the dilemma of the Germans of the 1920s as well as of the 1930s matches the situation of the "founding fathers" of the 1910s. Hence the interest in tracing the peculiar cultural logic underpinning the interchanges. To start with the economic interchange: If the Germans did not make for a flood, one may compare them to waves, but these waves need to be distinguished from each other. Lubitsch in 1921 could be called the crest of the first wave, and Murnau headed the second in 1925. After the success of *The Last Laugh* (1924) Murnau was imported with the more specific brief of bringing to Hollywood the values of "cinema art" (Allen and Gomery 1985), while behind him were those whom Hollywood regarded as specialists in particular styles or niche markets, such as E. A. Dupont and Paul Leni, both, like Murnau, were known for exceptionally innovative but also esoteric films in Europe (*Waxworks* [1924], *Variety* [1925]). Dupont's and Leni's motives were primarily economic, or at the very least, professional:

Hollywood made films with higher budgets, in better equipped studios, for larger audiences.

Besides directors with some experience, such as Lothar Mendes and Ludwig Berger, this wave also brought to southern California adventurers with little previous experience, such as Fred Zinnemann, or with varied experience, such as Edgar Ulmer, who first visited as an assistant to Max Reinhardt in 1923, then came back as part of the Murnau troupe in 1925, returned to Germany in 1929, only to try his luck once more in Hollywood as an art director in 1931, until he hit his stride with *The Black Cat* (1933) and found a specialized niche as the most important director of Ukrainian and Yiddish films between 1935 and 1940.

These filmmakers, then, were neither poor immigrants fleeing their country of origin to escape hunger in search of the American dream, nor political exiles and refugees, but film artists and cinema professionals who were attracted because of the technology, resources, and rewards that Hollywood could offer. This migration is therefore first and foremost an expression of the extraordinary economic dynamism of the film industry generally during the mid- and late-1920s, and of the inescapably international character at every level of its operation, be it production, distribution, or exhibition.

Nothing demonstrates this more clearly than another wave around 1930, which brought to Hollywood William Dieterle, Hans Heinz von Twardowski, Günther von Fritsch, and several other less permanent visitors. They were hired by Warner Brothers' Berlin subsidiary, Deutsche National, in order to make foreign-language versions of Warner films, with Dieterle being chosen because he could act as well as direct, and Fritsch because he had enough Spanish to direct a Latin American version alongside a German one, saving Warner transport, board, and lodging on their imported labor. Germans thus made German films in Hollywood while still contributing to the American picture business, especially in the then-crucial overseas (European, Latin) markets. In a similar context, Dupont was able to revive his faltering international career by directing, between 1928 and 1931, a number of English-, French-, and German-language versions for the London-based British International Pictures and its German subsidiary, Südfilm (Higson 1992, 34–52).

The last example shows that fighting fierce competition and forging strategic alliances was the modus operandi not only

between Europe and Hollywood, but also between the different national industries as well as among national producers. What moved people and personnel from country to country was often the sheer power of capital needing to stay in circulation within the various sectors of the (international) film industry. This is even the case with the wave that landed after 1933, and which with more justification can be called political refugees: Fritz Lang, Joe May, and Billy Wilder, and later in the decade, Robert Siodmak, Curtis Bernhardt, John Brahm, and William Thiele. One feature shared by these émigrés is that many arrived in Los Angeles not from Berlin or Vienna, but from Paris, where all of them had also directed films, while some came via London, where they had gone in the hope of being able to return to Germany once things improved politically (which proved a false hope). None had intended to seek his fortune in Hollywood, and all had to remake themselves culturally as well as professionally in order to prosper.

The Paris stopover most clearly indicates the mixture of economics and politics in the motives for migration, because it points to the dominance of the German film industry over that of France from the late 1920s throughout the 1930s. Only the final wave of émigrés during the late 1930s and early 1940s, notably Max Ophuls, Jean Renoir, and René Clair (escaping from occupied France, or via Holland), and (from Germany) Reinhold Schünzel, Frank Wisbar, and Douglas Sirk were to leave Europe for political reasons. The last three had a difficult time once they arrived in America, not least because the émigré community regarded them with suspicion, since they were known for having made prominent and highly successful films for Ufa after the Nazi takeover, such as *Victor und Viktoria* and *Amphitrion* (both Reinhold Schünzel, 1933, 1935), *Anna und Elizabeth* and *Fährmann Maria* (both Frank Wisbar, 1933, 1934), *Schlußakkord* and *Zu Neuen Ufern* (both Douglas Sirk, 1936, 1937). The most tragic case perhaps is that of G. W. Pabst, known in the late 1920s and early 1930s for his experimental (*Secrets of a Soul*, 1926), socially committed (*The Joyless Street*, 1925), new-realist (*Diary of a Lost Girl*, 1929), liberal (*The Loves of Jeanne Ney*, 1927), and critical-pacifist films (*Kameradschaft*, 1931). He too went to the States in 1934, after making French and French-language-version films between 1930 and 1933. When *A Modern Hero* (1934, made for Henry Blanke and Hal Wallis at Warner Brothers) was not a success, he resumed directing in France from 1936 to 1939. With a ticket on the *Normandie* to New York already

booked, Pabst returned to his mansion in Austria, where he fell ill just as war was being declared, which postponed his departure indefinitely. Film historians have not forgiven him for "missing the boat" (Bock 1990, 228–30).

Pabst's example underscores more dramatically than the meandering careers of Ulmer, Bernhardt, or Dupont that to speak even of "waves" is misleading, since much of this was two-way traffic.[4] Especially in the late 1920s and early 1930s, individual trajectories were at once contingent and accident-prone before political events in Europe and Hitler's rise to power forced upon so many careers the fatal pattern of persecution, exodus, and blighted prospects. Although everyone who was in the public eye was affected by the changes in Germany after 1933, often it was actors, writers, composers, and singers who experienced Fascism and anti-Semitism more directly as a threat to their lives as well as their livelihood; they made up the hard core of the political refugees. The directors, especially those with a reputation already established, had contacts abroad as a matter of course; they were familiar with the basic techniques and technology of picture making everywhere, and many knew the working practices in other studios, quite apart from the fact that language was less of a barrier to finding work than for writers or actors. Certainly during the 1920s, improved communication and sea travel meant a continuous back-and forth between Europe and America. John Baxter points to this when he writes, "Many came to Hollywood—it is hard to find a single major European director of the period who did not make at least a token visit to Los Angeles—but only a fraction ... stayed there" (Baxter 1976, 54).

This, too, is not the whole picture: behind the directors, there are the producers. Paul Davidson's role in getting Lubitsch to Hollywood has already been mentioned, and Pabst was able to work in France because of his long-standing association with Seymour Nebenzal's Nero Film, which had connections with Warner Brothers and Pathé Nathan.[5] But the close ties that the German filmmaking community had with Paris, London, and Los Angeles were in no small measure due to the vast network of contacts and incessant travel of a single individual: Erich Pommer, the head of production at Ufa for much of the 1920s, who began as the German representative of Gaumont, worked for Eclair, had contracts with Paramount and MGM, and in the 1930s produced films for Fox in France and the United States, worked with Korda in England, shuttled

between London and Los Angeles for most of the 1940s, and returned to Germany as a U.S. officer to reorganize the West German film industry in 1947. If at one end it is the impersonal, abstract logic of capital that provides the necessity as well as the energy for competition, collaboration, and exchange, at the other end the engine that kept the revolving doors in motion was the charismatic personality of Pommer, either directly or indirectly (Hardt 1996, 141–62).

the dynamics of uneven exchanges

But what, one is obliged to ask, is finally being traded in this pattern of uneven and nonequivalent exchanges? What profit-and-loss ledger actually keeps score? Is it commodities, reputations, services, expertise, markets, know-how, patents? If one concentrates on the most tangible commodity, the films, it is obvious that very few German films from the so-called classical German cinema were commercial or even critical successes. After the flurry of excitement caused by *The Cabinet of Dr. Caligari*, not only the press became more critical. As Baxter observes:

> By the time *Passion, Deception*, Buchowetzky's *Danton* and the remaining post-war epics had been released in the U.S., Hollywood's ardour for the German film was considerably diminished. Having bought every new production of any reputation in order to keep it from competitors, the studios viewed their accumulated holdings with alarm. (1976, 54).

Baxter goes on to quote from an interview with a production head from Famous Players–Paramount who in 1922 was in charge of reediting Joe May's eight-part series *Mistress of the World* (*Die Herrin der Welt*, 1921) for the American market. Dismissing German films for their "shape that the most amateurish of American picture fans would laugh at," he finds that "the German mind cannot condense..... Editing seems a totally unknown art in the German film studio." A similar though more famous response was Randolph Bartlett's "German Film Revision Upheld as Needed Here" in the *New York Times*, March 13, 1927, a justification of the decision to reedit Lang's *Metropolis* (1926). Bartlett argued that the cut and retitled American version "brings out the real thought" of the film, which Lang had somehow failed to put across in the original. As for

the stars, not even Emil Jannings was able to sustain a career in the United States into the 1930s, while Pola Negri, more famous for her romance with Rudolph Valentino and the feuds with Gloria Swanson than for her American films, crissed-crossed between Hollywood and Germany throughout the 1930s and 1940s.

Yet what the focus on the films', stars', and directors' fortunes in the United States loses sight of is that the battle was usually not over the American market at all, but over American influence on West European, South American, or East European audiences. As suggested by the investments initially made in multilanguage versions both in Hollywood and at Paramount's Joinville studio outside Paris, the U.S. film industry was always vigilant regarding its dominant role in the export field, threatened, or so it seemed, with the advent of the talkies. Such profound technical and financial changes in the industry as the conversion to sound make it doubly difficult to construct the narrative of film emigration to Hollywood around the front-line personalities. Throughout the 1920s film industry personnel came to Hollywood, and their influence was in some ways more lasting and more profound than that of the directors or the films. One could take cameramen such as Karl Freund, Theodor Sparkuhl, or Eugen Schufftan, art directors such as Hans Dreier and Ali Huber, and composers such as Erich M. Korngold, Franz Waxmann, Max Steiner, or Dimitri Tiomkin: Each had a very individual career in Hollywood and made a contribution difficult to underestimate in his field, recognized by the industry if not always by the general public.

Karl Freund, for instance, is a figure who deserves a major study all to himself. After being responsible for the camerawork in *The Last Laugh*, *Variety*, and *Metropolis*, Freund not only became a key director of photography for Universal and MGM, and a director of eight feature films (among them such classics as *The Mummy* [1932] and *Mad Love* [1935]) but also an activist in the Society for Motion Picture and Television Engineers, and after the war worked in television as chief cameraman for Lucille Ball at the Desilu Company. He had also acquired—since the mid-1920s—important patents in sound, color, and optical instruments technology. These he exploited commercially through his own company, the Photo Research Corporation, which in turn had close ties with U.S. Defense industries working on guided weapons systems.

If Freund thus had several "visible" as well as "invisible" identi-

ties as an émigré, moving with seeming ease between his roles as film director, director of photography, inventor, patent holder, and businessman, a champion chameleon in the survival stakes of southern California, the case of Henry Blanke, already mentioned, is special, because of a career conducted almost entirely out of the public eye—inside the whale, so to speak. His longevity as line producer at Warner Brothers throws a fascinating light on the forces that controlled, or at least shaped, the fate of, many of the German émigrés. After working for Lubitsch until 1926, Blanke went to Berlin to be Lang's production manager on *Metropolis*, another sign that Ufa conceived this film right from the start with the American market in mind. He returned to Warner in 1927, only to be sent back to Berlin in 1928, when Warner opened their own production unit in Germany (Deutsche First National). There Blanke got to know William Dieterle, who made one of his biggest successes, *Der Heilige und ihr Narr* (*The Saint and Her Fool*, 1928) for First National, as well as working for the German subsidiary of another U.S. firm, Deutsche Universal, headed by Joe Pasternak. With the introduction of sound in German first-run theaters in 1929, Blanke was recalled to Hollywood to oversee German language productions, for which he hired Dieterle.

Dieterle, for his part, was only too eager to accept, having had to default on substantial debts incurred on a contract with the Silva Film company. In the files of the Bundesarchiv–Film Archiv Berlin, one can inspect a warrant issued for Dieterle's arrest, dated from about the same time in July 1930 as the *Thüringer Allgemeine Zeitung* reported on Dieterle's "Sudden flight to America." A month later, the Berlin trade journal *Film Kurier* ran a First National publicity still of Dieterle, his wife, and other German and French actors waving from the engine of a train that has just pulled into the Union Station in Los Angeles. In the Dieterle files of the Berlin Kinemathek there also exists the copy of an out-of-court settlement from January 1931, according to which Warner Brothers' New York office agreed to employ Dieterle for forty weeks, paying $400 each week to Silva Film in Berlin, while Dieterle received only $200 a week salary.

The incident neatly underlines the trade and barter between German and U.S. firms, as well as Dieterle's status as a "hired hand" when he first arrived in Hollywood. Ironically, the reason Silva Film could claim such high damages for breach of contract (2 million

RM at first, though they seemed to have settled for 80,000 RM) was Dieterle's German box office pull as both a leading actor and a director. Blanke continued to work with Dieterle on the many of the latter's more famous bio-pics (*The Story of Louis Pasteur*, 1936; *The Life of Emile Zola*, 1937), but Dieterle had to pay off his debts to Warner by directing a number of remakes of his former German colleague's films, such as Joe May's *Ihre Hoheit Liebe* (which became *Her Majesty, Love*, 1931), the Billy Wilder scripted *Ihre Majestät Befiehlt* (which became *Adorable*, 1933), and Lubitsch's *Madame Dubarry* (which became *Madame Du Barry*, 1934). At the same time, Dieterle also directed some of the fastest-paced, most action-packed and wise-cracking pre-Code Warner Brother's programmers, such as *The Last Flight* (1931), *Jewel Robbery* (1932), or *Lawyer Man* (1932). Only the arrival in Hollywood of his former teacher Max Reinhardt changed his image, when Reinhardt agreed to have him direct *A Midsummer Night's Dream* (1935). This became a prestige success for Warner Brothers and upgraded the studio's image while rescuing Dieterle from the namelessness of remaining a B-picture director, after having already been an A-picture director in Germany. Was he a refugee or an adventurer, "lured" to Hollywood or waiting desperately for that Hollywood "phone call" the Berlin press was always joking about? But although they were neither Jewish nor a prestige European import, Dieterle and his wife became the most welcoming Hollywood home for German political refugees, using all their influence to obtain entry visas, affidavits, or contracts for Germans in need.

Dieterle's initial task—the remaking of German pictures for the American market—highlights a common feature in the careers of German and German-speaking émigrés. Understandably, many tried to sell to the studios subjects or treatments with which they had already had success in Europe. A good example is the playwright and screenwriter Lajos Biro, originally from Hungary. Biro sold Lubitsch the play on which was based *Forbidden Paradise* (1924, remade as *A Royal Scandal* by Otto Preminger in 1945); he wrote *Hotel Imperial* (1927), Erich Pommer's first Hollywood production, and remade twice more, once by Billy Wilder as *Five Graves to Cairo*, 1943), and returned to London with Alexander Korda to write *The Private Life of Henry VIII* (1933, itself inspired by Lubitsch's 1920 *Anna Boleyn*).

Such networks of ethnic bonding, trading on the common culture, and cashing in on kinship contacts, became so notorious that

Alexander Korda put on his desk a sign that read "It's Not Enough to Be a Hungarian." The obverse of the close-knit community, which depended on each other but also vampirized one another, were often-bitter personal enmities and rivalries among the émigrés, especially prior to the late 1930s. The composer Kurt Weill, for instance, who became one of the most successful "assimilationists," heartily detested his occasional encounters with fellow refugees, calling the evenings spent with them "nights in the mummies' cellar" and complaining about the "execrable German" spoken there, "that awful mixture of Hungarian and Viennese," while bemoaning the fact that the subject of conversation was invariably gossip about other émigrés (Schivelbusch 1997, 34).

old world, new world

Such stories are of course only too familiar among diaspora communities everywhere and at all times. They illustrate painful dependencies, uprootedness, and the perverse need to reassert individual identity in the face of a common fate. But especially among artistic and intellectual circles, where the immigrant ethos of trying to blend with the host culture in order to give positive value to a decision forced upon one by external circumstances is blunted by resentment about the loss of prestige and nostalgia for the status enjoyed back home, a deep distrust of the American values in general and those of Hollywood in particular made integration unlikely. Personalities with such opposing views as Bert Brecht and Thomas Mann, Theodor W. Adorno and Lotte Lenya, Arnold Schoenberg and Hanns Eisler were agreed on one issue: that Hollywood represented culture at its most corrupt, venal, and hypocritical.

How could such insistence on difference amid commonality and tacit consent amid divergence manifest itself in the work the émigrés were able to realize? Did the split consciousness come up with its own imaginary coherence, or were the fault lines visible in the films the Germans produced, authored, directed, or otherwise creatively influenced? I have—in the context of the German "contribution" to Hollywood par excellence, namely, *film noir*—argued for a more cautious and thus discursive rather than determistic model of "influence" (Elsaesser 1996). Not only did the different cadres of foreign or exiled professionals affect the film industry in varying

degrees and often unexpected ways—as in the case of Karl Freund or that of William Dieterle—but the logic of this impact is such that adequate terms have yet to be found. What can be said is that here the cultural paradigm transforms and yet also instantiates the economic and political determinants. Hence my suggestion to call the resulting mindset an "imaginary," to indicate a relation between orders of being that cannot be thought of as contiguous or complementary, while nonetheless exhibiting the binding force of a mutually sustaining fantasy. I have already signaled the ambivalence among the Berlin film world of the 1920s vis-à-vis Hollywood, reflecting the ambivalence of Weimar Germany vis-à-vis America generally.

Only against this historical backdrop of a complex cultural rivalry between the first and second world's most powerful industrializing nations can some of the contradictory attitudes of the various waves of émigrés be mapped, and it thus provides the ground on which, for instance, the films themselves can be read as the figures. The process is well illustrated by a director from the first wave such as Lubitsch, who epitomizes the most salient features of the German-American film exchange. While the lure of America for Lubitsch was living in a society that had successfully entered an age of perpetual revolution and modernization—in industry, lifestyles, and technical inventions, from which emanated the glamour of speed, wit, and energy—what America wanted from Lubitsch was something quite different. Although he considered himself Germany's most American director (having made satires of Germany's "Americanitis," such as *The Oyster Princess*), Hollywood needed him to be an out-and-out European.

Once arrived in the United States, Lubitsch, along with other "name" émigrés who came to Hollywood with an international reputation, realized that for the New World, they were representative of the Old World. They found Hollywood hungering for images of a Europe fashioned out of nostalgia, class difference, and romantic fantasy. Obliged to recreate and imitate a version of the world they had left behind, directors found their previous work in Germany little help in fashioning an American career. In this context, Vienna became an important reference point, the master sign and key signifier of "Europe" to America, comparable only to the function of Paris in this regard. Lubitsch, a Berliner through and through, had to revive time and again Vienna and the Balkans, thus

reversing the historical process whereby scores of directors, producers, writers—from the Korda brothers to Michael Kertesz, from Joe May and Fritz Lang to Billy Wilder and Emeric Pressburger—had come to Berlin to get away from the decadence of Vienna and the decrepit reality of the collapsing Austro-Hungarian Empire.

The secret affinity that existed between Hollywood on one side and Vienna or Paris on the other was that they were societies of the spectacle, cities of make-believe and of the show. The decadence of the Hapsburg monarchy was in some ways the pervasive sense of impersonation, of pretending to be in possession of values and status that relied for credibility not on substance but on a convincing performance, on persuading others to take an appearance for the reality. There is a historical basis to this construction: One can think of Vienna as a "melting-pot" city, in which class conflicts and ethnic tensions are veiled by a kind of permeability between classes, a state of affairs dramatized most succinctly in operettas, where the lumpenproletariat and the aristocracy can find themselves enjoying the same places, not least because they have a common enemy: the hardworking, production-oriented, upwardly mobile bourgeois. Similarly, the Paris that attracted Hollywood was the Paris of Jacques Offenbach, the operetta composer, during the years prior to 1848, the end of the restoration period, before the revolution. The power of Vienna as a signifier haunts the émigrés well into the 1940s: Max Ophuls did not come from Vienna any more than did Lubitsch, but he too became a specialist in Viennese charm (admittedly a choice that predated his work in Hollywood, as his German and French films from the 1930s amply indicate).

Erich von Stroheim and Joseph von Sternberg are good illustrations of a more drastic reversal of signifiers: fashioning for themselves identities as European aristocrats, they made their personalities into brand names, which consisted, at least to the outside, of Sternberg's trappings of an Old World dandy. Stroheim, with his boots, his monocle, and his military "pedigree," might be said to have demonstrated the Vienna principle to dizzying perfection: son of a poor immigrant hatmaker, he lived not only the fiction of an aristocrat but also that of an Austro-Hungarian aristocrat, doubling the connotations of pretense, style, and playacting, taking it from screen roles into his biography, and choosing for his life and work a mode, in which the Prussian and Austrian impersonations are not

felt to be at all contradictory (as they were in history). Indeed, they almost cancel out the falsehood in both, to make one totally convincing persona.

Sternberg made a film with Emil Jannings which, in the admittedly somewhat different context of the Russian revolution, nonetheless very poignantly engages with this subject: *The Last Command* (1928) was scripted by none other than Lajos Biro. The film is about a tsarist general who, fleeing from the Bolsheviks and now living as political refugee in the United States, is reduced to making a living as a Hollywood extra in Los Angeles. As fate would have it, he is cast in an anticommunist epic about the heroic last stand of a White Russian batallion. Obliged to watch a Hollywood actor play a tsarist general, his distress at the fake performance makes him rush up to the director and explain to him who he "really" is. The director eventually gives in, and—dressed once more in his full military splendor—the general-turned-pauper-turned-movie-extra is able to die before the camera the heroic death on the battlefield that life so ignominiously denied him.

Other directors of European origin also promoted themselves as more or less subtle versions of national stereotypes. One thinks of Chaplin or Hitchcock, and in a lesser register also of Dieterle, who affected the wearing of immaculate white gloves on the set during the shooting of his 1930s films. The Hollywood publicity machine ensured not only that the private self could be consumed as myth, but also that it was a highly coded and thus immediately recognizable myth.

clichés in the air

The story of the German film émigrés thus presumes a twofold estrangement: from their own home, and from the view that their U.S. hosts have of this homeland. The consequence is a kind of schizophrenia, which yields a double perspective also on American society, as admiration and a hypercritical view vie for priority. The dilemma of the émigrés in this respect refigures the cultural attitude of the "pioneers" who created Hollywood: Did they repress their ethnicity, or did it give them a sharper insight into what it meant to be American?

Many of the émigrés' biofilmographies do in fact make little sense if one does not read them against the trade and barter (pro-

grammed by the film industry economics) I have tried to sketch above. But they also need to be read in light of this other movement, of miscognition and recognition, across the gap that opens up between the two kinds of imaginary, represented by Europe's view of America and America's view of Europe. For however much a biographer might be tempted to construct the linearity of a lived life around the fates of the immigrants, émigrés, adventurers, and exiles, it may be much more coherent to assume that many of them lived several lives, quite separate from each other, and yet each responding with some degree of logic to the requirements of a particular film-historical or film-economic exigency.

Two striking cases in which mutual miscognition played a crucial part are the American debuts of Joe May and E. A. Dupont. May, an unwilling émigré, came to the United States via Paris with Pommer, for whom the 1933 arrival was more critical than that in 1926, when he was wooed back to Berlin by the new Ufa management. *Music in the Air* (1934), which Pommer and May undertook for Fox (continuing his Fox-Europe connection), was very much an émigré project, with Billy Wilder as co-scenarist and Franz Waxmann writing the score. Pommer had wanted an unknown to star, but the studio insisted on Gloria Swanson. May's films, including his 1928 success *Asphalt*, were quite unknown in the States—perhaps a blessing in the light of the acid comments made about *Mistress of the World*—and he could only point to a recent work of his that had been remade by Warner Brothers, the already mentioned *Ihre Hoheit Liebe*.

The film was not a success, though it must be said that its release coincided with the deep financial crisis of Fox, in the wake of the bid for Paramount, leading ultimately to the takeover of the company by Twentieth Century and Zanuck. *Music in the Air* is interesting as a project, not only because it is calculated to cash in on a number of Pommer/Ufa films that did make waves in the States, such as *Der Kongress Tanzt, Ein blonder Traum* (*A Blond Dream*, 1932), *Liebeswalzer* (*Love Waltz*, 1930), and some of the other early sound musicals, with which Ufa, as indicated, was impressing the world and redressing its balance sheets. But *Music in the Air* had the added piquancy of being based on a Broadway hit by Jerome Kern and Oscar Hammerstein that took an Old World setting and a typical operetta plot as its subject. What was being exchanged in this film made by Europeans and adapted from an American musical were national stereotypes in the form of mutual cultural compliments,

and maybe the film should have been called "Cultural Clichés in the Air." May did not get a second chance until 1937 and, apart from a few assignments in the 1940s, had no film career to speak of in Hollywood. Even his other venture, running a restaurant, called—how could it be otherwise?-*The Blue Danube* did not rescue him and his wife from the most desperate and humiliating penury.

Ewald André Dupont, too, saw his filmmaking career fizzle out in the Hollywood of the 1940s, but in order to understand the logic of his professional life, one needs to treat it as several rather discrete "slices," happening almost to different individuals. In contrast to May's enforced exile, Dupont was more of an adventurer. He signed a three-year contract with Carl Laemmle in 1925, came to Hollywood, and directed *Love Me and the World Is Mine* in 1926. His stay proved exceedingly brief, for by July 1926 he had severed his ties with Universal and was on his way again: not to Germany, but to London. The fact that by the end of 1932 Dupont was back in Los Angeles, and once again (briefly) under contract to Universal, before moving to Paramount and beginning a tragicomic roller-coaster ride to disgrace, oblivion, and a postwar comeback as a hack director underscores one's sense that in his case, the term "émigré director," with its political overtones, is peculiarly inappropriate. And yet Dupont's diverse career moves do actually fit into some of the patterns outlined so far.

What made Dupont attractive to Laemmle was the major international success of *Variété*, a Pommer/Ufa production that was neither Dupont's first film nor his first foray into the milieu of *artistes,* circuses, and wandering players (*Alkohol*, 1919; *Der weiße Pfau/The White Peacock*, 1920; *Das Alte Gesetz/The Ancient Law*, 1923). What made *Variety* such a success was the blend of closely observed milieu—indeed, sordid naturalism—with a particularly intense, brooding psychological study of male masochism, jealousy, and murderous rage. It was also a virtuoso display of film technique, with camerawork by Karl Freund that could be either fluid and unobtrusively mobile or vertiginously drawing attention ot itself in the scenes where it substituted itself for Emil Jannings's perception and feelings. Especially modern were a number of set pieces (as in the famous scene filmed through a revolving fan) that were attributed to Freund but whose conception can also be found in earlier Dupont films, not shot by Freund (for instance, *Alkohol, Die grüne Manuela/Green Manuela*, 1923).

Yet when Dupont arrived in Hollywood, what project was he offered? *Love Me and the World Is Mine* (1928), after the novel *Hannerl and Her Lovers* and thus, as one critic commented, "another piece of Viennese schmaltz." It seems that, whatever directors had been known for at home, all that American producers could think of was Old Vienna. Furthermore, as with May, whose film was to give Gloria Swanson a comeback, and also reminiscent of Lubitsch, who, it will be remembered, was called over by Mary Pickford to give her career a different turn (with *Rosita*, 1921), the Dupont project was intended by the studio as a vehicle for Mary Philbin, whose career had been in decline since *The Phantom of the Opera* (1925) and *The Man Who Laughs* (1926). The April 12, 1926 issue of the trade journal *Film Kurier* announces the completion of Dupont's first "Super Jewel Film," *Hannerl and Her Lovers* (that is, *Love Me and the World Is Mine*), which was to be followed by *Romeo and Juliet*, also with Mary Philbin, and with sets designed by Paul Leni. On the same front page, the *Film Kurier* also carries the notice that *Variety* was being screened to the Paramount renters' convention in Atlantic City, on the first day in its Berlin version and once more at the end the week in a version reedited for the American market, "to give the 400 representatives a chance to decide for themselves." Clearly, in the world of a film industry trade journal, the two items are not linked by the name of Dupont, indicating once more the subordinate status of the director.

sound strategy?

Traditional wisdom has it that it was the coming of sound that most damaged the "international" dimension of the cinema. In *The Shattered Silents*, a study of the American cinema on the eve of the transition to sound, Alexander Walker recalls the films to be seen in New York during August 1926, when the Warner Theatre on Broadway showed its first Vitaphone sound program:

> Next door or just down the street, were Rex Ingram's *Mare Nostrum*; Rudolph Valentino's *The Son of the Sheik*; King Vidor's *The Big Parade*; Sjostrom's *The Scarlet Letter*; MGM's *Ben Hur*; E. A. Dupont's *Variety*; *The Waltz Dream*, another Ufa film; and a whole repertory season of Emil Jannings' pictures. Sophisticated in their narrative-telling, international in understanding, without speech, yet intelligible in all languages, each one bear-

ing the individual signature of a director, star or studio:
such movies as these presented some of the silent cin-
ema's finest flowering. (1979, 198).

Although it therefore makes sense to say that with the coming of
sound, movies became not only more realistic but also more nation-
ally specific, my argument would be that the introduction of sound
was not an especial barrier to, for instance, German directors mov-
ing between different countries in Europe, or between Europe and
America. Neither did it displace the peculiar trade-offs, just noted
for Lubitsch or Sternberg, between an outsider's view on America
and the American public's desire to see on their screens a particular
view of Europe, which the émigrés were not averse to providing. On
the contrary, the films of Lang, Preminger, Wilder, and Siodmak as
far as urban America is concerned (*Woman in the Window* [Fritz Lang,
1944], *Laura* [Otto Preminger, 1944], *Double Indemnity* [Billy Wilder, 1944],
Phantom Lady [Robert Siodmak, 1944]), and those of Ophuls (*The Reck-
less Moment*, 1949) and Sirk (*All that Heaven Allows*, 1956) with respect to
suburban America, shaped and fixed the (U.S.) national mythology
in very important respects. The "Germanic" touch detected so often
in the psychological thriller, in *film noir,* and melodrama seems thus
more convincingly argued once one takes into account these mutu-
ally sustaining "national imaginaries" I've been outlining, rather
than any direct, linear descent from "expressionism."

The complementary counterexample is Dupont. If *Variety*, or
rather its quasi-unanimous success with an international public as
well as the critics, was to haunt the director throughout his life,
earning him the somewhat sadistic sobriquet of the "one-time
genius," Dupont figures by rights once more in the history of the
cinema, with a film rarely recalled because of its aesthetic merits or
its mythical resonances, and rather remembered for its technical
novelty. In 1929, working by then for British International Pictures
in London, Dupont was responsible for the first European talking
picture, an adaptation of a play about the sinking of the Titanic,
which became *Atlantic* (1929) and was filmed in three versions, with
Dupont directing the English and the German ones but not the
French.[6] More multilanguage films followed: *Two Worlds* (a story
reminiscent of the already mentioned *Hotel Imperial*, with Charles
Rosher as cameraman) and *Cape Forlorn* (1931; the German version,
Menschen im Käfig, has an all-star cast of Conrad Veidt, Fritz Kortner,
and Heinrich George) completed his deal with BIP, and Dupont

returned to Germany.[7] What intrigues me is just what kind of link might exist between such distinctly disparate moments focused on the same name, beyond the pure accident of someone called Dupont having directed, among many other films, these two landmarks of film history. On Dupont's side, however, there is no mystery. Insofar as European filmmakers have always, at least in principle, been recognized as artists, that is as independently creative individuals. Dupont can be seen to have tried throughout his career to achieve a work that resembles his persona and is consistent with itself, rather like a writer or a painter. But since being an *auteur* in the cinema also implies having to survive and remain close to the technological-economic means of production, this "staying in the game" represents a director's true working capital, his currency within the industry and for the critics, who in the case of Dupont never stopped playing his previous success against his later flops. For work in Hollywood, *Variety* was both Dupont's launch pad and his meal ticket. But it also was the cage from which he tried to escape—though often enough by a sort of compulsion to repeat. His motto seemed to be "repetition by variation," for every time Dupont found himself at the crossroads in his career, he seemed tempted by yet another variation on the motifs of *Variety*: show people entangled in the eternal triangle. After his arrival in Britain, the first films are *Moulin Rouge* (1928) and *Piccadilly* (1929, also set in the milieu of dancers, gigolos, and show people), and his first film after returning to Germany is called *Salto Mortale* (a triangular love story of trapeze artistes). The question that poses itself, however, is not what personal obsession or existential themes might Dupont the *auteur* have wanted to articulate across the themes of the circus, vaudeville, or the world of the spectacle, but rather why, when arriving in Hollywood in 1926 at the height of his reputation, did he *not* make a film featuring a circus ring or a *ménage à trois* (that is, a remake of *Variety*), and instead adapt a popular Austrian novel (*Hannerl and Her Lovers*), the sentimental story (with a happy ending) of a young woman who has to choose between a paternal professorial type and a young lieutenant departing for a war from which he may not return? The second question concerns *Atlantic*, that is, how was it that Dupont found himself in the vanguard of sound film and the multilanguage versions when little in his previous work indicated this turn? The answer has to be sought in the dynamics of European production companies finding themselves with too small a national

market to remain competitive. British International Pictures intended to break into the European and American market, and so it was looking for an "international" director, with experience in its largest rival markets, the United States and Germany. *Piccadilly* was the biggest production BIP had so far undertaken, the first of a series of "prestige" films, which not only explains the presence of a German director, but also of American stars (Anna May Wong and Gilda Gray, inventor of the "shimmy"). Dupont in effect found himself in a situation similar to that of Lubitsch when hired by Hollywood: the Trojan horse smuggled into enemy teritory. The dynamics thus bear signs of a comedy of errors and mistaken identities, not without tragic potential, making history at times seem like a prankster. Comparable in this to Pabst's missed boat, some of Dupont's career moves are the result of awesome accidents, though in a direction opposite to Pabst's bad timing: a Dupont project called *Der Läufer von Marathon* (*The Marathon Man*, 1932) involved location work in Los Angeles during the Summer Olympics of 1932. When the film opened in February 1933 in Berlin, Dupont had already seized the opportunity to stay on in the States, for by May of 1933, he was back under contract with Universal, never to return to Germany, having suddenly become, after years as an international adventurer, a political refugee with the Nazis' seizure of power.

cultural contraband

It is in fact around the anti-Nazi films in particular that the German émigrés once more became an important force, but also a source of controversy with the Production Code. While Fritz Lang was praised by the Motion Picture Association for the delicate handling of difficult domestic subjects such as lynching and blacks in *Fury*, when Pabst wanted to propose as his second Hollywood venture a film about a mad radio operator (Peter Lorre) starting a proxy (European) war on board an ocean liner, the project was promptly vetoed by the Hays Office as unsuitable for overseas markets and thus as diplomatically tricky. Dieterle, on the other hand, did get himself involved in a number of politically sensitive films: over *Juarez* (1939) there were endless squabbles with ambassadors from both Spain and Mexico; over *Dr. Ehrlich's Magic Bullet* (1940, about the inventor of a cure for syphilis) there was an issue regarding the Jewish origin of the hero; and *Blockade* (1938, about the Span-

ish Civil War) gave rise to trouble with the American Catholic Church (Vasey 1996).

The émigrés' brush with the Production Code over the anti-Nazi films highlights a number of additional ironies that only the exiles—the Jews, the refugees from Europe—could fully appreciate. In the anti-Nazi films, it was often Jews who had fled from Hitler's Germany who ended up playing SS men or high-ranking Nazis, these being often the only roles they could get because of their accents (Reinhold Schünzel, Alexander Granach, Gustav von Wangenheim, Hans Heinz von Twardowski, Conrad Veidt, Fritz Kortner, in films such as Litvak's *Confessions of a Nazi Spy* [1939], Douglas Sirk's *Hitler's Madman* [1943], Fritz Lang's *Hangmen Also Die* [1943], or *The Hitler Gang*). Otto Preminger, blacklisted by Daryl Zanuck, was only allowed back to Twentieth Century Fox after his Broadway success as an actor playing the Nazi in *Margin for Error* (1943). But it is Lubitsch, underscoring the theatricality of the Hitler regime in his *To Be or Not to Be* (1942), who fully exploits the supreme irony of the émigrés cultural camouflage. *To Be or Not To Be* brings back that imaginary dimension I briefly alluded to in the beginning, when I argued that in the traffic between Europe and America images are being traded, images of America, but also images of Europe: after the "Viennese pastry" and "schmaltz" of the 1920s and 1930s, it is a European political tragedy—a dictatorship practicing genocide— that is caught in the mirror of a double reflection that seems to date back to the early 1920s. The extent and kind of involvement the émigrés had with the political realities of their time were thus refracted via the politics of make-believe, so that the stylization of *film noir*, the double entendres or sight gags of sophisticated comedy, and the "imitations of life" of melodrama might turn out to be just as politically engaged as the anti-Nazi films.

By contrast, Dieterle's and Dupont's stories help to focus on the way in which some directors found it difficult to shape, out of dozens of films, a coherent work. Their individual films do not seem to be more than the sum of the the circumstances under which they were made, which may not add up to a reason why they were made. Useful for the historian, because they become symptomatic of the forces at work in the film business, the films end up being more interesting for their incoherences, gaps, and fissures, as I have tried to show in a case study of Dieterle's Warner Brothers biopics, notably *The Story of Louis Pasteur* (Elsaesser 1986). Secondly,

Dieterle's and Dupont's films, for all their qualities—and for all Dieteerle's political intentions—never seem to engage with the awareness of this historical situation of the double reflection, as I tried to argue was also the case with other directors who found themselves caught by the overdetermined signifiers "Austria," "Viennese decadence," "Germany," and "America." For what some émigrés achieved was to make out of make-believe a morality; only by piling up the falsehoods could they get closer to a truth. Highly self-conscious and self-referential, their films play with appearance and the many levels of irony involved in make-believe. This has always been recognized about the American films of Lubitsch, and Lang, but it is equally the case for Wilder, Ophuls, and even Preminger. If the spectacle is false, it can nonetheless be judged only by another spectacle. And while it is the combination of economics and inter(natio)nal politics that must be seen as the driving force for the conversion to sound, the workings of the Production Code, and the cultural camouflage adopted by Europeans in Hollywood, there is a dimension to this counterfeit trade in images and imaginaries that is as politically delicate in its way as the issue of America's isolationism in the late 1930s, and as morally disturbing as the depiction of its gangsters in the early 1930s. When it comes to finally assessing the question of influence that the German émigrés, among others, had on Hollywood, it may not be so much this *auteur* or that film style, but rather something altogether politically more acute and yet intangible: Is it not the immigrants, the "invaders," émigrés, and refugees who helped to make for all of the world, including the United States, out of Hollywood a country of the mind: the supreme fiction of displacement, transport and virtual realities? If the dream factory was thus partly "made in Europe," the worlds of make-believe, disavowal, deception, and self-deception have their own share of historical reality, fashioned from the contradictory triangulations of migration, national or ethnic stereotyping and exile.

121

notes

1. Among the extensive literature, one can best consult the following titles: Baxter, *The Hollywood Exiles*, 1976; Mike Davis, *City of Quartz*, 1990; Friedrich, *City of Nets*, 1997; Freyermuth, *Reise in die Verlorengegangenheit*, 1990; Heilbut, *Exiled in Paradise*, 1983; Hilchenbach, *Kino im Exil. Die Emigration deutscher Filmkünstler 1933–1945*, 1982; Horak, *Fluchtpunkt Hollywood*, 1984; Jay, *Permanent Exiles*, 1985; Kohner, *The Magician of Sunset Boulevard*, 1977;

Koebner, *Exilforschung Band 2*, 1984; Palmier, *Weimar en Exil* (2 vols.), 1988; Schnauber, *One Way Ticket to Hollywood. Film Artists of Austrian and German Origin in Los Angeles, 1884–1945*, n.d.

2. The outlines of this story are strangely congruent with another inter-American migration — that of the 1940s and 1950s, when East-Coast or Midwest artists, show people and writers moved to Hollywood, often to leave again, disenchanted, or with careers blighted and lives destroyed. Heading the list are Orson Welles and Joseph Losey, but especially after the McCarthy witch hunts, it includes countless New York writers, Broadway actors, theater producers, and choreographers.

3. The most comprehensive accounts can be found in Bock and Töteberg 1992 and in Kreimeier 1992.

4. It is well known that Louise Brooks became a star after being imported from Hollywood to work for Pabst on *Pandora's Box* and *Diary of a Lost Girl*. See Brooks 1982. What is perhaps less well known is that it was Emil Jannings who, anxious to restart his career in Germany, brought with him Josef von Sternberg to direct *The Blue Angel*.

5. Paul Davidson remained in Germany. After the formation of Ufa, his once brilliant career began to falter, and in the wake of a few false starts, he died in 1926, probably suicide. See Bock 1984.

6. Jean Kemm directed the actors in the French version, but judging from the version I was able to see at the National Film Archive in London, he utilized almost all of the nontalking scenes shot by Dupont.

7. In Germany, Dupont once more became a name "author," judging by his different studio affiliations. He took on the post of production head at Emelka (a Munich company) in February 1930, but his first film after returning to Germany was actually made for Harmonie Film Berlin (*Salto Mortale*, 1931) before directing a major hit for Emelka in 1932 (*Peter Voss der Millionendieb/Peter Voss, Gentleman Thief*).

works cited and consulted

Allen, Robert C., and Douglas Gomery. 1985. *Film History: Theory and Practice*. New York: Random House.

Baxter, John. 1976. *The Hollywood Exiles*. New York: Taplinger.

Bock, Hans Michael. 1990. "Documenting a Life and a Career," in *The Films of G. W. Pabst*, ed. Rick Rentschler. New Brunswick: Rutgers University Press,. 228–30.

———, ed. 1984. *CineGraph—Lexikon zum deutschsprachigen Film*. Munich: text + kritik.

——— and Michael Töteberg, eds. 1992. *Das Ufa Buch*. Frankfurt: Zweitausendeins.

Brooks, Louise. 1992. *Lulu in Hollywood*. New York: Knopf.

Davis, Mike. 1990. *City of Quartz: Excavating the Future in Los Angeles*. New York: Verso.

Elsaesser, Thomas. 1996. "A German Ancestry to Film Noir?" *Iris* 12 (spring): 129–44.

———. 1986. "Film History as Social History: The Story of Louis Pasteur," *Wide Angle* 8, 2: 15–32.

Freyermuth, Gundolf S. 1990. *Reise in die Verlorengegangenheit*. Hamburg: Rasch und Röhring.

Friedrich, Otto. 1997. *City of Nets: A Portrait of Hollywood in the 1940s*. Berkeley: University of California Press.

Gabler, Neal. 1989. *An Empire of their Own: How the Jews Invented Hollywood*. New York: Doubleday.

Hardt, Ursula. 1996. *From Caligari to California: Eric Pommer's Life in the International Film Wars*. Providence/Oxford: Berghahn.

Heilbut, Anthony. 1983. *Exiled in Paradise*. New York: Viking.

Higson, Andrew. 1992. "Film Europa: Dupont und die britische Filmindustrie" in *Ewald Andre Dupont: Autor und Regisseur*, ed. J.Bretschneider. Munich: text + kritik. 89–100.

Hilchenbach, Maria. 1982. *Kino im Exil. Die Emigration deutscher Filmkünstler 1933–1945*. Munich: Saur.

Horak, Jan Christopher. 1984. *Fluchtpunkt Hollywood*. Muenster: Maks.

Jay, Martin. 1985. *Permanent Exiles*. New York: Columbia University Press.

Koebner, Thomas, ed. 1984. *Exilforschung Band 2*. Munich: text + kritik.

Kohner, Frederick. 1977. *The Magician of Sunset Boulevard*. Palos Verdes, Calif.: Morgan.

Kreimeier, Klaus. 1992. *Die Ufa Story*. Munich: Hanser.

Palmier, Jean Michel. 1988. *Weimar en Exil*. (2 vols). Paris: L'Harmattan.

Robinson, David. 1968. *Hollywood in the Twenties*. New York: A.S. Barnes.

Schivelbusch, Wolfgang. 1997. "Turnip into Asparagus," *London Review of Books* (June 5): 34.

Schnauber, Cornelius, ed. n.d. *One Way Ticket to Hollywood: Film Artists of Austrian and German Origin in Los Angeles 1884–1945*. Los Angeles.

Taylor, John Russell. 1983. *Strangers in Paradise: The Hollywood Emigres, 1933–1950*. London: Faber and Faber.

Vasey, Ruth. 1996. *The World According to Hollywood, 1918–1939*. Madison: University of Wisconsin Press.

Walker, Alexander. 1979. *The Shattered Silents: How the Talkies Came to Stay*. New York: Morrow.

Weinberg, Herman. 1964. *The Lubitsch Touch*. New York: Doubleday.

between

rocks

and

hard places

the interstitial mode

of production

in exilic cinema

hamid naficy

A defining characteristic of what I have called the "accented style" of exilic and diasporic cinema is the mode of production, distribution, and consumption of this cinema (referred to as "mode of production" for convenience). This mode of film production takes a number of forms; chief among them the interstitial and collective types. In this chapter I will deal with the interstitial category alone.

Cinema's mode of production is influenced by and modeled after the reigning mode of production in society, and like that mode, it specifies a relationship between forces of production and social relations of production. The product of cinema is film, a commodity that in capitalist regimes must return a profit to its investors at the box office, video stores, television outlets, and cash registers (for tie-in products). Thus mode of production also specifies a social rela-

tion of consumption. The industrial mode of production, exemplified by Classic Hollywood cinema and the studio system in its heyday (1920s–1960s), was characterized by centralized control of production, distribution, and exhibition; division and hierarchy of labor; mass production of standardized products and their continual variation; and creation, attraction, and manipulation of mass publics and taste cultures.[1] These characteristics have tended to situate the filmmakers as manufacturers and the spectators as consumers who complete the industrial cycle of [re]production.

The studio system's industrial mode of production as we know it has faded away, gradually giving way since the mid-1970s to what has become known as the new Hollywood cinema and its postindustrial mode, which is less involved in production than in the global acquisition, distribution, and marketing of films and related merchandises and services. As Tom Schatz notes:

> In one sense the mid-1970s ascent of the New Hollywood marks the studios' eventual coming-to-terms with an increasingly fragmented entertainment industry— with its demographics and large audiences, its diversified "multimedia" conglomerates, its global(ized) markets and new delivery systems. And equally fragmented, perhaps, are the movies themselves, especially the high-cost, high-tech, high-stakes blockbusters, those multipurpose entertainment machines that breed music videos and soundtrack albums, TV series and videocassettes, video games and theme park rides, novelizations and comic books. (1993, 9–10)

This new postindustrial system is made possible thanks to both vertical integration and a widening horizontal integration, once outlawed by the U.S. Supreme Court in its 1948 *Paramount* decision, which has come back since the 1980s in a vastly increased and globalized proportion, driven partly by corporate mergers of an unprecedented scale. The merger of Walt Disney and Capital Cities/ABC, and Time Warner's acquisition of the Turner Broadcasting System in the mid-1990s, provide examples of this accelerating vertical and horizontal integration of media, entertainment, and merchandising companies at the global level. This has brought together, under one roof, movie production and distribution, music production and distribution, broadcast television, cable television, foreign television, satellite television, video distribution,

radio broadcasting, film library acquisition, book and periodical publishing, theme parks, sports teams, and merchandising and retailing.[2]

Undergirded by the privatization, diversification, and deregulation of media ownership worldwide, this post-cold-war trend has led to the formation of nearly a dozen globalized "colossal conglomerates," primarily in the United States and Europe—including the media empires of Leo Kirch in Germany, Silvio Berlusconi in Italy, Johann Rupert in South Africa, and Rupert Murdoch in Australia, Britain, and the United States—which act like cartels to preserve themselves and each other and to maintain their dominance of world cultural agendas and markets (Stille 1995). To these so-called synergistic trends must be added the technological convergence that promises to standardize and digitize all forms of communications, on one hand, and to fuse telephone, cable television, and computer technologies and services, on the other.[3]

In these media environments, movies are no longer what they used to be: films shown to a group of people in a theater according to a schedule. Instead, they have become the "intertextual products," "franchises," or "software" that nourish this integrated postindustrial system of cultural production and consumer services. This development has, likewise, deeply influenced the films' choice of stories and their manner of storytelling, as Schatz astutely observes, "The vertical integration of classical Hollywood, which ensured a closed industrial system and coherent narrative, has given way to 'horizontal integration' of the New Hollywood's tightly diversified media conglomerates, which favors texts strategically 'open' to multiple readings and multimedia reiteration" (1993, 34).

The key words summarizing this postindustrial system—globalization, privatization, diversification, deregulation, digitization, convergence, and consolidation—are all associated with centralization of the global economic and media powers in fewer and more powerful hands. However, this market-driven centralization masks a fundamental opposing trend at social and political levels, that is, the fragmentation of nation-states and other social formations, and the scattering, often violent and involuntary, of an increasingly larger number of people from their homelands and places of residence—all of which are driven by divergence not convergence. The exilic mode of production is the product of the con-

fluence of these twin centripetal and centrifugal developments. It is being applied here to the work of exile, émigré, refugee, and displaced filmmakers working in the West since the 1960s.

exilic and diasporic films as alternative practice

The postindustrial mode of production is dominant not because it is homogeneous or because it obliterates all opposition, but because—despite shifts, cracks, tensions, and contradictions within it and its products (such as the films themselves)—it acts hegemonically by incorporating, domesticating, marginalizing, or exoticizing not only those very tensions and contradictions but also all the alternative film practices. Yet there will always emerge pockets of alternative film practice that escape the panoptic lights, the voracious gaze, and the alluring temptation of the dominant cinema—even though they too may ultimately be absorbed, leaving behind new offspring. In his thought-provoking book *Allegories of Cinema*, David James formulated the "alternative" mode of production that emerged during the 1960s in the United States as a counterpractice to the capitalist and industrial mode of production (1989). In a later work, he quoted Karl Marx on the dominant mode of production:

> In all forms of society there is one specific kind of production which predominates over the rest, whose relations thus assign rank and influence to the others. It is a general illumination which bathes all the other colours and modifies their particularity. It is a particular ether which determines the specific gravity of every being which has materialized within it. (quoted in James 1996, 12)

The dominant mode of cultural production exists side by side with the alternative and emergent modes, which serve other functions and can mobilize other values. Although it may circumscribe, color, and modify those modes, it does not obliterate their particularity or eradicate their alterity, for it needs both the alternatives and the alterity in order to survive, flourish, and remain dominant.

The exilic and diaspora cinema's mode of production is an alternative film practice that stands in relation to the postindustrial cinema in a way similar to how James's alternative practice stood in relation to the industrial mode. It is a cinema of alterity that lurks

among the dark shadows cast by the bright illumination of the postindustrial cinema. Its mode of production may variously be characterized as independent, personal, artisanal, interstitial, third cinema, collective, ethnic, immigrant, or exilic—although no single characterization encompasses it fully. Even though it is not strongly motivated by money, alternative cinema, even, in a mode as marginalized as exilic or "accented" film, is nevertheless enabled by capital—in a peculiar mixed economy consisting of market forces within media industries; personal, private, public, and philanthropic funding sources; and ethnic and exilic economies. As a result, the alternatives are never entirely free from capital, nor should they be reduced to it. In terms of distribution, marketing, exhibition, and consumption of their films, alternative exilic filmmakers rely heavily upon a number of interlinking independent, nonprofit, political, ethnic, arts, and boutique microdistributors; specialty film festivals, film series and film package tours; broadcasting, cablecasting, and narrowcasting channels that specialize in arts, culture, ethnicity, and access; and a myriad of site-specific mediating cultural institutions, such as museums, art-cinema houses, repertory theaters, labor unions, grassroots and socially active venues, religious and ethnic establishments, émigré and exile cultural formations, and universities and colleges. Significantly, the small-scale, viewer-oriented technologies of production and consumption, such as Hi-8 video cameras, VCRs, CD-ROMS, computers, and cable TV, have become the linchpins that link the products of the most advanced postindustrial mode to those of the most artisanal and alternative mode. These technologies have made possible the kind of low-tech, personal, impulsive, and contingent filmmaking and film viewing—demanded by exilic cinema—that was difficult to realize before.

Because of the availability and diversity of these intermediary structures of funding, distribution, exhibition, and consumption exilic cinema is relatively autonomous. This autonomy is derived fundamentally from its interstitiality within social and economic formations and its marginality within the dominant film and media industries. The totality of this organism is called the exilic mode of film production. As such, this mode is born out of only "moments of autonomy" that are ephemeral but sufficiently real, such as the liminality of exile, and it serves to not only renew the dominant mode of production but also to enrich the plurality of

what is collectively called "cinema." Dependence and autonomy, therefore, are the dual, differentially torqued engines of the alternative mode. That is why this discussion of the exilic mode is driven not only by the limitations and constraints that dependence poses but also by the freedom and enablement that interstitial autonomy promises.

The alternative mode is different from what is popularly but erroneously labeled "independent" cinema, for the latter cinema, in the late 1990s, consists of films marketed by "mini-majors"—a half-dozen companies that control the majority of independent releases and have the greatest acccess to A-list screens. Even though a few of them began independently, unaffiliated with the Hollywood majors, and some of them continue to handle low-budget unconventional films, all of them are currently owned by the majors. The mini-majors include Miramax (owned by Disney), Fine Line (owned by Ted Turner), Gramercy (co-owned by Universal and Polygram), Searchlight (owned by News Corporation's 20th Century Fox), and Sony Pictures Classics (formerly Orion Pictures). It is important to bear in mind, however, that the majors and their stepchild—whether it is called new independent cinema, commercial independent cinema, Hollywood's semi-independent cinema, or mini-majors—have not been transhistorical, monolithic, or stable.[4]

Likewise, the alternative mode of production is not autonomous, unified, or homogeneous. It may encompass, in addition to exilic and diaspora cinema, the avant-garde, underground, personal, diary, experimental, Third, ethnic, nonindustrial, and radical cinemas. While alternative filmmakers frequently evolve, and some even move into (post)industrial practice, the alternative mode itself remains emergent, for it is essential to the continual rejuvenation and luster of the hegemonic cinema. The output of the exilic mode is a cinema of alterity whose films, in James's words, are "(un)popular" in that they are "contradictory, unstable, and usually short-lived," made by displaced and minority persons in liminal circumstances under "their own volition, rather than by corporations" (1996, 18). These films are also fundamentally oppositional, or "critical," in Scott MacDonald's term, for they are sometimes semicommercial, often noncommercial, and usually artisanal. They either refuse to use, or use, in order to critique and undermine, the conventions of funding, production, storytelling,

and spectator positioning so naturalized by mainstream cinema (MacDonald 1988, 2). Moreover, exilic filmmaking tends to critique the dominant cinema by using its own critical methodologies and aesthetics, condensed into what I have termed "accented style" (Naficy 1999, 1997).

The alternative mode of production, exemplified by exilic or accented cinema, is not only "alternative" and "critical" but also "minor," in the sense that Deleuze and Guattari have formulated. They ascribe three characteristics to "minor literature": "the deterritorialization of language, the connection of the individual to a political immediacy, and the collective assemblage of enunciation" (1986, 18). The exilic mode of production encourages the development of an accented and deterritorialized style that is driven by its own limitations, that is, its smallness, imperfection, amateurishness, and lack of cinematic gloss (many of the films are low-tech shorts that have an extremely low budget and a small crew and cast). It is also driven by the style's textual richness and narrative inventiveness, that is, its critical juxtaposition of audiovisual and narrative elements, discontinuity and fragmentation, multifocality and multilinguality, self-reflexivity and autobiographical inscription, historicity, epistolarity, claustrophobic textuality and spatiality, and resistance to closure (deterritorialized language).

The expected imbrication of exile and politics in this cinema goes beyond the inscription of political content or of mimetic, autobiographical, and theoretical criticism within the films themselves (as MacDonald would have it). Because it involves inserting politics at the point of the film's origination, as well as of its reception, the exilic mode of production offers, by the fact of its existence, a powerful criticism of dominant film practices (political immediacy). Inserting politics at the point of origination may take the form of collective production. This can mean collaboration among a group of filmmakers, or a kind of "collective enunciation" that is aware that filmmakers and audiences are always already conjoined by their membership in collective communities of address consisting of émigrés, exiles, disporized, ethnicized, and otherwise otherized subjects (collective assemblage of enunciation). If the capitalist industrial mode tends to situate directors as manufacturers and spectators as consumers, the alternative mode's collective enunciation and reception potentially blur the line that separates producers from consumers. Significantly in the case of

exilic cinema, the filmmakers' enunciating work is not only collective but also integrated, for it does not end at producing the work (as is generally the case with independent and mainstream cinemas); rather, it must extend to actively facilitating its marketing to and consumption by situated collectivities. As a result, the exilic mode continually grapples with the politicized immediacy of the films and their collective enunciation and reception, that is, with the manner in which politics infuses all aspects of its existence.

Exile filmmakers are multiply positioned to act critically and to make (un)popular films, thereby becoming minor: ontologically, by living at a tangent to the world and to the industry they inhabit; structurally, by opting for an alternative and interstitial mode of production; and thematically and narratologically, by ignoring or critiquing dominant cinema's conventions and cultural values and by experimenting with new ones. As such, making films in exile is, in the words of Deleuze and Guattari, like "setting up a minor practice of major language"—a practice that defines the major (1986, 18). It is the minor practice of alternative filmmaking that supplies the sculpting lights that help define the major cinema's glowing visage. As such, any definition of the dominant cinema must necessarily and centrally involve consideration of its alternatives.

Formulated as a subcultural practice by situated filmmakers working at a specific historical juncture and organized around unorthodox modes of production and distribution, alternative film practices generate both situated minor filmmakers and filmic forms, exemplified by the accented style of exilic cinema. As James argues, "A given stylistic vocabulary is never merely itself; rather, it is the trace of the social process that constitutes a practice" (1989, 23). The stylistic vocabulary of the accented style inscribes the social processes of exile and diaspora that have their roots in the decolonization, radicalization, deterritorialization, and restructurations since the 1960s that situate the filmmakers and affect their authorial vision and their mode of production. By thus internalizing the conditions of its own production and the location and vision of its makers, exilic cinema becomes an allegory of exilic conditions, locations, and visions. Indeed, every exilic film is at once an allegory of both exile and cinema. However, every exile filmmaker is not locked permanently into exilism, exilic authorship, and alternative practice. In the same way that exiles can metamorphose from liminal beings into ethnic subjects and consuming citizens,

exilic filmmakers can transform from being a minor or minority *filmmaker* to becoming a mainstream film *director*. Gregory Nava and Mira Nair are two examples of people who began as more or less "ethnic" filmmakers with their first fiction features, *El Norte* (1982) and *Salaam Bombay!* (1988), respectively, and gradually moved into making mainstream films under the New Hollywood regime with their latest films, *Selena* (1997) and *Kama Sutra: A Tale of Love* (1997), respectively. Such a social and professional mobility in the new land by means of cinema was a characteristic of the first generation of immigrants in the early twentieth century, who created the Hollywood film industry and the studio system and with them shaped their own identity and that of their new country. Filmmaking is once again proving to be a powerfully alluring mechanism for self-fashioning by a newer generation of émigré filmmakers, many of whom struggle to move out of minoritarian cinema into the mainstream by making popular films and some of whom strive to become minor by making (un)popular films. By means of the alternative mode of production, exilic filmmakers can move out of their disempowered minority status, conferred upon them by the majority, into becoming minor, a self-designated, self-actualizing category of empowerment.

If since World War II the alternative mode of production in the United States (especially in avant-garde and art-cinema circles) was peopled primarily by European-Americans, the current crop of emergent exilic, émigré, and diaspora filmmakers is largely from non-Western and postcolonial third world origins. And if the first group worked independently and individually, the new group has found ways of working artisanally, collectively, and transnationally. In the remaining pages I will focus on the artisanal, or interstitial, mode.

interstitial or artisanal mode

Transnational exilic filmmakers inhabit the interstitial spaces of not only the host society but also the mainstream film industry. It would be inaccurate to characterize them as marginal, as scholars are prone to do, for they do not live and work on the borders, margins, or peripheries of society or the film and media industries. They are situated inside and work in the interstices of both society and media industries. As Homi Bhabha has noted, it is "theoreti-

cally innovative and politically necessary" to think beyond singular categories and dominant designations, to focus on "those *interstitial* moments or processes that are produced in the articulation of 'differences'" (1994, 269). It is in these interstitial spaces that "minorities translate their dominant designations of difference—gender, ethnicity, class—into a solidarity that refuses both the binary politics of polarity, or the necessity of a homogeneous, unitary oppositional 'bloc'" (270). To be interstitial, therefore, is to operate both within and astride the cracks and fissures of the system, benefiting from its contradictions, anomalies, and heterogeneity. It also means being located at the intersection of the local and the global, mediating between the two contrary categories which in syllogism are called subalternity and superalternity. As a result, exilic filmmakers are not so much marginal or subaltern as they are interstitial, partial, and multiple. And they are interstitial, partial, and multiple not only in terms of their identity and subjectivity but also in terms of the various roles they are forced to play, or choose to play, in every aspect of their films—from inception to consumption.

One of the characteristics of the interstitial mode of production is the financial provisions under which it operates. Filmmakers often have to either invest in their own films or work in technical or routine capacities in the media and entertainment industries.[5] Such forced crossovers tend to blur the boundaries that traditionally separated film, television, and video and the levels of professionalism in each area. Exilic filmmakers are involved in a range of cinematic practices, from professional to amateur and a range of television, from broadcast to narrowcast TV, and from art video to lowcast video to pointcast video (via the Internet). Both the intertextuality and the hybridity promoted by such crossovers are commensurate with and constitutive of the filmmakers' own postcolonial and postmodern exilism and hybridized identities. However, since working in these fields usually does not generate sufficient funds, filmmakers must seek additional financing and cofinancing from a range of public and private sources. Perhaps the lion's share of their time is spent on financial and producerly functions. Amir Naderi's film *Manhattan by Numbers* (1993), provides an allegorical, if dystopic, inscription of the arduousness of the fundraising that many exilic filmmakers must perform. In doing this, the film becomes an allegory also of the conditions of exile itself. It focuses on the fruitless efforts of a laid-off journalist to find

one of his friends, who has money and from whom the journalist wants to borrow cash to forestall certain eviction from his apartment. Like a filmmaker who is trying to tap into every resource and connection to generate funds, the journalist searches Manhattan from one end to the other and places numerous phone calls to mutual friends. But his moneyed friend appears to have vanished, like scarce filmmaking resources. The film's drama centers on the journalist's growing despondency about his inability to locate his friend and the imminence of his homelessness on the heels of his joblessness—a prospect not unfamiliar to exiles and refugees and many exilic filmmakers.

The general low budget of the films, however, does not necessarily translate into unpolished products. For example, the overall high production values of Atom Egoyan's films belie the extremely low budgets within which he has operated. *Next of Kin* (1984) was made for $37,000, *Family Viewing* (1987) for $160,000, and *Calendar* (1993) for $100,000; *Exotica* (1994) was budgeted at $2 million, the highest ever for Egoyan (Naficy 1997). The budget for *Speaking Parts* (1989) was pegged at £600,000, £75,000 of which (or 13 percent) was supplied by Channel 4 (Pym 1992). Such low budgets were made possible in part by the multiple functions that Egoyan, like most independent transnational filmmakers, has performed in his films.

The increased means of production and channels of transmission since the 1960s have magnified manyfold the need for new sources of progamming, leading to an unprecedented diversification of financial and programming sources and contents. Broadcast and cable television, especially Channel 4 (in UK), ZDF (in Germany), Canal Plus (in France), Arté (in Germany and France), and PBS, Bravo (including its Independent Film Channel), Sundance Independent Channel, and Arts and Entertainment (in USA), became major sources for financing and broadcasting of independent films and alternative cinemas, including those made by émigrés and exiles. In the United States, cable TV, with its provisions for public access and leased access, opened the airwaves to transnational, ethnic, and exilic media producers who could not gain entry to the big medium of broadcast TV (Naficy 1993, 1996). These narrowcast, even lowcast, forms of TV, especially in the United States, Canada, and Europe, became instrumental in helping displaced populations form and maintain cultural identities from a distance and across national and geographic borders. Some postcolonial and

postmodern diaspora filmmakers and videographers have aired their products on or have worked for these minority television outlets at one time or another in their careers. The emergence of video since the 1970s as a readily available and inexpensive medium expanded the local, national, and global markets for alternative films, helping to consolidate the work of narrowcast television in maintaining long-distance nationalism, ethnicitys, and exilism.[6]

In the careers of exilic filmmakers in particular, there are long periods of distressing and dispiriting downtimes spent on waiting for financing to come through. Sohrab Shahid Saless, a filmmaker of Iranian origin who has been making celebrated but difficult films in Germany since the mid-1970s, captures this state of mind and describes the political economy of such periods of waiting as a form of censoring of unpopular films:

> You feel badly frustrated when you stay at home for months looking out through the window and wishing you could film your ideas; but everybody else is trying to block your way or stop your project from being fulfilled. Let me tell you this: unlike what many people may think, censorship is not only in the third world countries. But it also exists in countries such as Germany, France or Britain. The difference is that here they are more experienced in this regard. They stop it [the project] before it is begun, saying there is not enough budget or this film will fail (1993, 65).

A second characteristic of the interstitial mode is the multiplication or accumulation of labor (especially on behalf of the director) instead of division of labor—which characterizes the postindustrial mode of production. Like many independent and auteur cinéastes, exilic filmmakers often take up multiple functions in their films. They act in principal roles in their films in order to control the project, keep the cost down, or make up for a lack of appropriate, bilingual actors.[7] For example, Fernando Solanas appears in a small role in his film *Tangos: Exile of Gardel* (1985); Parviz Sayyad stars in his films *The Mission* (1983) and *Checkpoint* (1987); Chantal Akerman stars in many of her films, including *Je Tu Il Elle* (1974); Elia Suleiman stars in *Homage by Assassination* (1991); Jonas Mekas and his brother Adolfas are prominent presences in almost all of Jonas's films, including *Lost, Lost, Lost* (1949–1976); Miguel Littín appears in *Acta General de Chile* (1988); Nina Menkes's sister, Tina

Menkes, is the star of this director's films, including *The Great Sadness of Zohara* (1983). The voices of Mona Hatoum and Akerman are the sole voices heard in their respective films *Measures of Distance* (1988) and *News from Home* (1977). Both Mahnaz Saeed Vafa, the director, and her mother appear in *A Tajik Woman* (1995).

Sometimes such self-inscriptions are not for financial reasons or for a tighter control over the film. In these cases, self-inscription is often autobiographical (as is the case with the films of Mekas, Hatoum, and Saeed Vafa). Whatever the motivation, self-inscription tends to implicate the author as the actor, thus collectivizing the film's enunciation.

Exilic filmmakers not only act in their own films but also perform multiple other functions. The Jewish-American filmmaker Nina Menkes is the director, cinematographer, art director, coeditor (with her sister), and fund-raiser for her own films. Unlike many diasporic and avant-garde filmmakers, she does not consider performing multiple functions to be a form of victimization and poverty. On the contrary, similar to other exilic and avant-garde filmmakers, she considers multifunctionality a proactive strategy:

> Doing all these functions is an active choice because my work is intensely personal. I would never have anyone else shoot my movies or be the art director. If I would get more help on my future projects I would get more help on the production manager level and have more production assistants.... I feel like I am the enemy of Hollywood. I am in direct opposition to everything Hollywood stands for politically, socially, emotionally. (Oswald 1991, 27)

Perhaps for similar reasons, the Iranian-American filmmaker Marva Nabili directed, wrote, and photographed *Nightsongs* (1984) and her husband, Thomas Fucci, produced the film. Caveh Zahedi wrote, codirected, and starred in *A Little Stiff* (1992) and he also wrote, directed, and starred in *I Don't Hate Las Vegas Anymore* (1994)— a film in which his father and brother act in prominent roles. Amir Naderi, another Iranian-American filmmaker, wrote, directed, and edited *Manhattan by Numbers*. The Ethiopian-American filmmaker Haile Gerima produced, directed, wrote, and edited his latest film, *Sankofa* (1993). The Pakistani-British filmmaker Jamil Dehlavi was producer, director, writer, editor, cinematographer, and a key actor in his avant-garde film *Towers of Silence* (1975). The Kurdish film-

maker Nizamettin Ariç directed, cowrote the screenplay for, starred in, composed and performed the music for, and supervised the make-up and costuming in his German production *A Cry for Beko* (*Klamek ji bo Beko/Ein lied für Beko,* 1992). The Egyptian-born Armenian-Canadian filmmaker Atom Egoyan has written and directed all of his features, edited several of them (*Next of Kin, Family Viewing,* and *Calendar*), functioned as executive producer in one (*Speaking Parts*), and acted in one (*Calendar*). His wife, Arsinée Khanjian, has starred in all his feature films, and several other actors have appeared in a number of his films.

By performing multiple functions in their films, a filmmaker can not only save money but also shape the film's vision and aesthetics and become truly its author. Authorship, therefore, is to be found not only in the economic and aesthetic but also in the total control of the film. Laws and regulations, however, define authorship differently in each country, and this may also influence the filmmakers' decision to serve multiple functions. The 1957 intellectual property law in France, for example, confers authorship on the film's director, not on the producing, funding, or institutional agency. In other countries where authorship is not so clearly ascribed to the director, performing multiple functions helps to settle the question of who is the film's author. However, multiple involvement in all phases and aspects of films is not an ideal that is universally desired; it is often a condition forced by exile that is very taxing.[8]

Multilinguality is a third characteristic of the interstitial mode. It is driven by the multilinguality and cosmopolitanness of the filmmakers and their crew, the stories they make films about, and the audiences they address. Multilinguality complexifies the films' intelligibility and contributes to their accented style. It is important to note that, in these films language is almost never taken for granted. In fact, it is often a theme and the self-reflexive agent of narration and identity. Raúl Ruiz's *On Top of the Whale* (*Het Dak Van de Walvis*, 1981) is about an anthropologist traveling to Tierra del Fuego, at the southernmost tip of Chile, to study the language of two remaining members of a Patagonian tribe. As the French anthropologist, in a situation typical of ethnographic fieldwork, points to everyday objects and asks the Patagonians to name them, he discovers to his dismay that their language consists of only one phrase, *yamas gutan.* By varying the pattern of stress on the syllables,

the Patagonians imply different meanings. Even more distressing for him, the meanings derived are not stable as they change almost daily. This disturbing and droll use of language in the film invokes multiple meanings. The invention of a shifting language can be read as the Patagonians' resistance against their colonizers. By rendering themselves unintelligible, they become a moving target that cannot be comprehended and apprehended. The reduction of a tribe to only two surviving members bespeaks of the massacre of indigenous peoples at the hands of their European invaders. Anthropologists' methodology and their complicity with colonial powers are also ridiculed and criticized. Finally, and more important, the film points to the constructedness of all languages—a fact that becomes more apparent in exile and displacement, where the "natural" context for language is removed.

Most exile films are bilingual, but many are multilingual, necessitating elaborate and varied dubbing, translation, and subtitling strategies. Marilu Mallet's *Unfinished Diary (Journal inachevé,* 1986) is spoken in three languages, French, Spanish, and English, which are subtitled. *On Top of the Whale* is spoken in English, Spanish, French, Dutch, German, and a Ruiz-invented "Patagonian" language, all of which are subtitled in English. Atom Egoyan's *Calendar* contains telephonic confessions of love and lust in more than half a dozen languages, none of which is either translated or subtitled. Likewise, Elia Suleiman's *Homage by Assassination* contains Arabic proverbs and text on the screen that are neither translated nor subtitled. The lion's share of the dialog in Ann Hui's *Song of the Exile* (1990) is in English, but the portions spoken in Chinese and Japanese are subtitled. The bilingual sound track of Mona Hatoum's *Measures of Distance* consists of two competing voices, the daughter's voice reading her mother's letters in English and the mother-daughter conversation in Arabic that is neither translated nor subtitled. Multilinguality, like politics, interpenetrates all aspects of transnational and exilic film practices, not only those aspects that appear on the screen, such as character speech and dialogue and subtitles, but also those, like the multinational composition of the production crew, that are behind the cameras. It also involves the films' reception, as multiple languages serve multiple communities of address, often privileging one over another.

The production process of exilic and diasporic films is convoluted: funding sources, languages used on the set and on the screen,

nationalities of crew and cast, and the functions that filmmakers perform are all multiples. This complexity includes the artisanal conditions and the temporal and political constraints under which the films are shot—forming a fourth characteristic. The Kurdish filmmaker Nezamettin Ariç who lives in Germany, filmed most of his *A Cry for Beko* in Armenia in the early 1990s near the Armenian-Turkish border. As an exile from Turkey, condemned by its government, he could not film his Kurdish nationalist saga in his country of origin. However, filming in Armenia presented other difficulties. As there were no processing labs nearby in Armenia, he had to ship the exposed footage to Leningrad. For various reasons, the lab did not deliver the footage in time, forcing Ariç, who was operating under a tight temporal and financial budget, to film without seeing any of the dailies until long after the cast and crew had left the location—all this during his directorial debut. The telltale signs of these production difficulties are the traces they sometimes leave on the films' imagery, sound quality, and editing—signs that give the films that certain look and feel of "imperfection" that signifys exile and exilic production.

A fifth characteristic of the interstitial mode is the length of time that it may take to distribute and exhibit films. For example, it took Jocelyne Saab of Lebanon four years to make *The Razor's Edge* (*Ghazal al-bant*, 1985) and three years of court battle to get it released commercially (Rosen 1989, 35). Chantal Akerman's great film *Jeanne Dielman, 23 Quai de Commerce, 1080 Bruxelles* (1975) did not open commercially in New York for eight years, but it was discussed widely by feminists and film critics (Rosenbaum 1983, 31). An analysis of Akerman's career makes clear that the disparity between generous press coverage, (especially in France where she has made many of her films, and small audiences is not limited to this demanding film but is a characteristic of the bifurcated responses to her films in general (McRobbie 1993, 200). This split reception—motivated by a combination of political and commercial forms of censorship—applies to the works of many independent exilic filmmakers especially those from the the third world. It can be said to be a characteristic of the accented style in which exilic politics contaminates the entire film process—whether it is the politics of nations and nationality, patriarchy, gender, class, ethnicity, race, or religiosity.

Interstitial filmmakers must in general be satisfied with a limited distribution and exhibition of their films, and must make extra

efforts to promote them. Spectators for their films are not a given; they must be sought. This is accomplished by creating and catering to specialized film tours, festivals, and distribution companies and by relying on video as the most viable vehicle for entering college and university courses and academic conferences.

One major consequence of the difficulties of making and exhibiting films under exilic and artisanal conditions—the sixth characteristic—is the very meager output of many of the filmmakers. In tabulating the output of Middle Eastern filmmakers working in exile and diaspora in the West, I discovered that some three hundred cinéastes had made a little over eight hundred films (features and shorts), with an average of 2.3 films per filmmaker—not a high output. Although certain individuals are more prolific than others, for filmmakers sometimes years pass without making a new film. The Argentinean filmmaker Fernando Solanas made his second film in exile (*Tangos: Exile of Gardel*, 1986) eight years after his first (*The Sons of Fierro*, 1975–78). The Iranian filmmaker Parviz Sayyad made his second film in America (*Checkpoint*, 1987) only four years after his first (*The Mission*, 1983). However, now, over a decade later, he has yet to make his third film. Amir Naderi emigrated to the United States in 1986 to make films, but it took him seven years to produce his first English language film (*Manhattan by Numbers*, 1993) and another four years for his second film (*Avenue A B C, Manhattan*, 1997). Likewise, despite her efforts, Marva Nabili has directed only one feature (*Night-songs*, 1984) in the past dozen years in her adopted land, the United States. The Egyptian filmmaker Tewfik Saleh, who went into exile in Syria in the late 1960s, was able to make only seven films in over twenty years of exile. The Palestinian filmmaker Michel Khleifi working in Belgium made his first film, *The Fertile Memory* (*Surat min mudhakkirat khusbah*) in 1981. It took him six years of making films for Belgian TV to be able to produce his own celebrated second feature, *Wedding in Galilée* (1987). The well-known Algerian writer Assia Djebar made her first film, *La Nouba des femmes du Mont Chenoua*, in 1978, followed four years later by her second film, *La Zerda et les chants de l'oubli* (1982). Since then, however, she has made no other film and appears to have abandoned filmmaking altogether. Sometimes it takes years to film a single project: The Mauritanian exile filmmaker Abid Med Hondo, working in France, relates how it took him a year and half to film *Soleil O* (*Sun Oh*) and three and a half years to film *Les Bicots-Nègres: Vos Voisins* (*The Nigger-Arabs: Your Neighbors*) (Hondo 1987, 75).

Low output may be a function not only of economic forces and the filmmakers' interstitial location, but also the antagonistic state-artist relations. The Armenian filmmaker Sergei Paradjanov provides an example of this relation in the context of internal exile. Born in Georgia, Paradjanov made his early brilliant films in Ukraine during the Soviet era under the centralized state-sponsored mode of production (*Shadows of Our Forgotten Ancestors* [1964], and *The Color of Pomegranates* [1969]). However, despite such support, he was accused of homosexuality, currency fraud, Ukrainian nationalism, and incitement to suicide, and was forced to spend six years of the 1970s in labor camps. Because of an international campaign on his behalf, Paradjanov was released in 1978, but was blacklisted, blocked from cinema, and rearrested for a time for attempted bribery (the real reason may have been his interviews with foreign journalists). He began making films again only on the eve of Mikhail Gorbachev's presidency and reforms. This activity resulted in only two more features (*The Legend of the Suram Fortress* [1984] and *Ashik Kerib* [1988]). All in all, his meager life's output was four feature films and a number of documentaries, made in two working periods separated by fifteen years (Alekseychuk 1990–91, Hoberman 1991).

For exilic filmmakers, the dream of transcendence and transformation that their liminality and interstitiality promises must constantly be checked against the realities of state encroachment and free-market competition. Some of their output is entertaining, even though ironically and parodically critical of both the host and home societies. But as artists who often make distressing and dystopian films, exilic filmmakers inhabit a realm of incredible tension and agony, as Shahid Saless has sarcastically noted:

> People like us who make somber and hardly entertaining films are not fortunate. They write letters, come up with treatments, put together scripts that are never filmed and once in a while a good soul appears, gestures to them and says—just like in Kafka—: it's your turn now. You too can have a chance. (1988, 56)

Straddling more than one culture, diasporic filmmakers are occasionally in a position to play funding agencies from different countries against each other to receive financing. Sometimes they attempt to get ahead by cashing in on the newsworthiness of their country of origin. Such efforts pay off more when newsworthiness is based on positive attributes, but they can backfire badly if

negative connotations are involved. The case of *Veiled Threat* (1989), made by the Iranian-American filmmaker Cyrus Nowrasteh, is an instance. The Los Angeles International Film Festival canceled the film's premiere in April 1989 at the last minute on account of a bomb threat—an action that caused controversy about the festival's responsibility for public safety and First Amendment rights protection. However, it was difficult to sort out definitively the real reasons behind the bomb threat or the cancellation of the screening. The festival director claimed that the producers had brought the threat on themselves as a publicity stunt by publicly linking their film and its anti-Islamic content to the Ayatollah Khomeini's *fatwa* against Salman Rushdie. The producers responded by saying that the threat was real enough for the Federal Bureau of Investigation to have taken it seriously. This low-budget, low-velocity, lowbrow thriller finally opened in Los Angeles theaters to dismal reviews and attendance. Trying to recoup their losses by downplaying its Islamic connotations, the producers dropped the "veil" from the title. The ploy did not apparently help the film's box office.

The Kafkaesque situation that Shahid Saless speaks about is certainly real. It becomes more personally painful when national representation in festivals is involved, raising anew for transnational filmmakers such vexing questions as which "nation" they belong to and which "national cinema" they represent. In the dozen years after the 1973 military coup, Chilean exile filmmakers made over 250 feature films and documentaries—far more than were produced in Chile itself up to 1973 (Peña 1987, 137). Much of this work constituted a Chilean cinema of resistance. However, this classification excluded certain exile films—for example, Raúl Ruiz's works after *Dialogue of Exiles* (*Dialogue d'éxilés*, 1974), which had critiqued the exiles (Pick 1987, 41). The politics of exilic filmmakers, who are usually against their home government, often forces them into painful positions. This highlights the liminality of their status as exiles, the problematic of their national identity as interstitial artists, the problem of their attempt to represent anybody but themselves, and the minor status of their films. For example, the Turkish government revoked Yilmaz Güney's citizenship after he escaped to Europe to complete his film *Yol* (*The Way*, 1982), which powerfully critiqued Turkish society under military rule. Thus the most famous Turkish filmmaker, who was also a very popular actor, could not represent his own country abroad. Parviz Sayyad could

not enter in the Cannes International Film Festival as an Iranian product, his film *The Mission* (1983), a sharply anti-Islamic Republic film made in the United States. Unwillingly, he entered it as a U.S. production. By doing so, he was forced in effect to admit that he represented neither Iranian cinema nor Iranians. Unable to represent his own country and unwilling to represent the host country, he was in essence made "homeless." This kind of homelessness, of course, is not limited to third world or non-Western films or to their makers in the West. It is not a new phenomenon, as an increasing number of transnationally financed films and filmmakers (including such international luminaries as Luis Buñuel) have found it difficult to land a home, so to speak. But theirs is a different story, to be told elsewhere.

Exilic and diasporic filmmakers and videomakers and their distributors and exhibitors are working at the intersection and in the interstices of culture industries; transnational, national, federal, state, local, private, ethnic, commercial, and noncommercial funding agencies; and myriad institutions of reception and consumption. All of them grapple with the exigencies and reverse magic of interstitiality which sometimes turns the promised freedom and flexibility of this mode into constraint and limitation. As one film reviewer noted:

> Although far from the mainstream, outfits like Women Make Movies and the films they distribute travel a tenuous line between radical aspiration and brute reality. At every curve, from issues of funding to those of form, the ability to retain both independence and integrity is increasingly difficult. (Dargis 1992: 66)

Because of this and other challenges of interstitiality, most exilic films I have mentioned here are sad, nostalgic, and dystopic. On the other hand, there are exuberant, parodic, and playful films, such as Toronto-based Srinivas Krishna's *Masala* (1991), United States–based Vivek Renjen Bald's *Taxi-Vala/Autobiography* (1994), and United Kingdom–based Gurinder Chadha's *Bhaji on the Beach* (1994). These three filmmakers of South Asian descent take advantage of the social and aesthetic freedoms of interstitiality and point out both the perils and pleasures of hybridity. It is important to bear in mind, however, that even dystopic exilic and diaspora films are empowering because of their potential to reterritorialize both their makers and their audiences. The reterritorialization takes the form not only of

discursively emplacing the displaced filmmakers and their communities of address but also, if their films are successful at the box office, of making the filmmakers both attractive and desireable to the mainstream postindustrial cinema. This is particularly true of the European filmmakers in the United States, whose civilizational familiarity with Western cultures and the Hollywood system, as well as the absence of racism and xenophobia against them, facilitates their ready acceptance and assimilation. This is borne out by the spate of big-budget and independent Hollywood films that foreign-born European and Asian directors have released in the United States in just one year, 1997.[9] It is thus that the dynamic relationship of the intersitial and postindustrial cinemas continues to nourish both and enrich the latter.

notes

1. On the classical industrial mode of production, see Bordwell, Staiger, and Thompson 1985, Gomery 1986, and Schatz 1988.

2. The "merger mania" in 1995 was in anticipation of the 1996 United States telecommunication law that fundamentally restructured the communications industries.

3. In September 1995, major makers of rival video disks agreed to a digital format that would standardize all future products (Pollack 1995).

4. On new independent cinema, see Schatz 1993; on commercial independent cinema, see Bordwell, Staiger, and Thompson 1985:317; on Hollywood's semi-independent cinema, see Bernstein 1993; on mini-majors, see Pribram 1993.

5. Until *Exotica*, Armenian filmmaker Atom Egoyan invested in his own films. Iranians Marva Nabili and Amir Naderi worked as film editors to raise money for their films. Chilean Raúl Ruiz and Iranian Parviz Kimiavi worked for French television, Palestinian Michel Khleifi made films for Belgian TV, and Armenians Nigol Bezgian and Ara Madzounian produced ethnic TV shows.

6. On video, narrowcasting, and collective identity, see Burnett 1995.

7. For example, the Iranian director Said Assadi who made his first exile film, *Fata Morgana* (*Sarab* 1991) in Sweden, had to act in it because he could not find a Persian-Swedish bilingual actor (*Majalleh Sinemai-ye Film* 132 [November 1992]: 84).

8. Said Assadi, who produced, directed, acted in, photographed, and wrote the narration for *Fata Morgana*, says: "I would like to one day make a film for which I am only the director. Unfortunately, however, because of lack of financial resources I am forced to do all the work myself" (see *Majalleh Sinemai-ye Film*, ibid.).

9. Among these are Hong Kong director John Woo's *Face/Off* (1997), Taiwanese director Ang Lee's *The Ice Storm* (1997), German director Wolfgang Petersen's *Airforce One* (1997), Polish director Agnieszka Holland's *Washington Square* (1997), Australian director Jocelyn Moorhouse's *A Thousand Acres* (1997), and German director Wim Wenders's *The End of Violence* (1997).

145

works cited

Alekseychuk, Leonid. 1990–91. "A Warrior in the Field," *Sight and Sound* 60, 1 (winter): 22–26.

Bernstein, Mathew. 1993. "Hollywood's Semi-Independent Production," *Cinema Journal* 32, 3 (spring): 41–54.

Bhabha, Homi K. 1994. "Frontlines/Borderposts," in *Displacements: Cultural Identities in Question.* ed. Angelika Bammer. Bloomington: Indiana University Press. 269–72.

Bordwell, David, Janet Staiger, and Kristin Thompson. 1985. *The Classical Hollywood Cinema: Film Style and Mode of Production to 1960.* New York: Columbia University Press.

Burnett, Ron. 1995. *Cultures of Vision: Images, Media and the Imaginary.* Bloomington: Indiana University Press.

Dargis, Manohla. 1992. "Girls on Film," *The Village Voice* 37:19 (May 12): 66, 69.

Deleuze, Gilles, and Félix Guattari. 1986. *Kafka: Toward a Minor Literature.* Trans. Dana Polan. Minneapolis: University of Minnesota Press.

Gomery, Douglas. 1986. *The Hollywood Studio System.* New York: St. Martin's.

Hoberman, J. 1991. "Paradjanov and Protegé," *Premiere* (September): 36–37.

Hondo, Abid Med. 1978. "The Cinema of Exile," in *Film and Politics in the Third World*, ed. John D. H. Downing. New York: Praeger. 69–76.

James, David E. 1996. "Introduction: Socialist Questions in a Rented World," in *Power Misses: Essays Across (un)Popular Culture.* London: Verso. 1–23.

———. 1989. *Allegories of Cinema: American Film in the Sixties.* Princeton: Princeton University Press.

MacDonald, Scott. 1988. *A Critical Cinema 1: Interviews with Independent Filmmakers.* Berkeley: University of California Press.

McRobbie, Angela. 1993. "Chantal Akerman and Feminist Film-Making," in *Women and Film: A Sight and Sound Reader*, ed. Pam Cook and Philip Dodd. Philadelphia: Temple University Press. 198–203.

Naficy, Hamid. 1999. *Making Films with an Accent: Exilic and Diaspora Cinema.* Princeton: Princeton University Press.

———. 1997. "The Accented Style of the Independent Transnational Cinema: A Conversation with Atom Egoyan," in *Cultural Producers in Perilous States: Editing Events, Documenting Change*, ed. George E. Marcus. Chicago: University of Chicago Press. 179–231.

———. 1996. "Narrowcasting in Diaspora: Middle Eastern Television in Los Angeles," in *Living Color: Race, Gender, and the U.S. Television*, ed. Sasha Torres. Durham: Duke University Press.

———. 1993. *The Making of Exile Cultures: Iranian Television in Los Angeles.* Minneapolis: University of Minnesota Press.

Oswald, Helga. 1991. "The Dark Realities of Nina Menkes," *Montage Magazine* (summer): 26–29, 34.

Peña, Richard. 1987. "Images of Exile: Two Films by Raoul Ruiz," in *Reviewing Histories: Selections from New Latin American Cinema*, ed. Coco Fusco. Buffalo, N.Y.: Hallwalls. 136–45.

Pick, Zuzana. 1987. "Chilean Cinema in Exile (1973–1986)," *Framework* 34 (1987): 39–57.

Pollack, Andrew. 1995. "After the Digital Videodisk War." *The New York Times* (September 18): C4.

Pribram, Deidre E. 1993. "Straight Outta Money: Institutional Power and Independent Film Funding," *Afterimage* 21, 1 (summer), 3–5.

Pym, John. 1992. *Film on Four, 1982/1991, A Survey*. London: BFI Publishing.

Rosen, Miriam. 1989. "The Uprooted Cinema: Arab Filmmakers Abroad," *Middle East Report* (July-August): 34–37.

Rosenbaum, Jonathan. 1983. "Chantal Anne Akerman," in *Film: The Front Line 1983*. Denver, Colo.: Arden Press. 30–36.

Schatz, Thomas. 1993. "The New Hollywood," in *Film Theory Goes to The Movies*. Jim Collins, Hilary Radner, and Ava Preacher Collins, eds. New York: Routledge. 9–36.

———. 1988. *The Genius of the System: Hollywood Filmmaking in the Studio Era*. New York: Pantheon.

Shahid Saless, Sohrab. 1993. "Sohrab Shahid Saless and A Private Agony," *Film International* [Tehran] 1, 4 (autumn): 60–65.

———. 1988. "Culture as Hard Currency or: Hollywood in Germany (1983)," in *West German Filmmakers on Film: Visions and Voices*, ed. Eric Rentschler. New York: Holmes and Meir.

Stille, Alexander. 1995. "Media Moguls, United," *The New York Times* (August 28): A13.

part four

mediated

collective

formations

bounded

realms

household, family,

community,

and nation

d a v i d m o r l e y

Home, in the literal sense *Heim*, chez moi, is essentially private.
Home in the wider sense *Heimat*, is essentially public... Heim
belongs to me and mine and nobody else... *Heimat* is by defini-
tion collective. It cannot belong to us as individuals

—Eric Hobsbawm

My aim in this chapter is to try to bring together a set of debates
concerning concepts of home and *Heimat* that have, thus far, largely
been conducted in isolation from each other, across a range of dif-
ferent disciplines. My premise is that only a truly interdisciplinary
approach, one that can synthesize the various potential insights
generated in these artificially separated analyses, can supply us
with an effective understanding of the central issues at stake in
what I take to be one of the most central political issues con-
fronting us, as we attempt to construct a viable cartography of the
postmodern world.

In part, the question also concerns the need to articulate different levels of abstraction in these debates. In particular, I advocate a "grounded theory" approach, which places particular emphasis on the integration of micro and macro levels of analysis. My main focus in this respect is to offer an approach to the analysis of microstructures of the home, the family, and the domestic realm that can be effectively integrated with contemporary macro debates about the nation, community, and cultural identities. The key concepts deployed in this analysis are those of boundary maintenance and boundary transgression. My focus is thus on the mutually dependent processes of exclusion and identity construction, at both micro and macro levels of analysis.

In the attempt to develop this analysis I draw on work in media studies (including some of my own) on the role of various communications technologies in the maintenance and disruption of the symbolic boundaries around both home and *Heimat*. However, in explicating these issues, I am concerned to broaden their theoretical frame. I draw on insights from contemporary work in the field of cultural geography which insists on the necessity of rethinking our sense of place in the context of the transformations and destabilizations wrought by the new communications technologies of the global media industries. I am also concerned, however, to articulate these issues of virtual geography to some older debates, largely within anthropology, concerning the conceptualisation of the "foreign" (the unfamiliar, or *Fremde*, which is the negative image of *Heimat*), by reference to its significance in the rituals of (domestic and national) exclusion, by means of which the sacred space of the home or *Heimat* is "purified."

In this connection I then address recent debates about the need for "roots" and the deeply problematic reemergence, on the contemporary political scene, of various regressive forms of cultural fundamentalism and nostalgia. In conclusion, I offer a critical perspective on poststructuralist approaches to the "politics of difference," which have, in my view, come close to abandoning any idea of the possibility of community—a possibility that I take to be a necessary prerequisite of any effective politics. My ambition is to offer a progressive notion of home, *Heimat*, and community, which does not necessarily depend on the exclusion of all forms of otherness, as inherently threatening to its own internally coherent self-identity.

the mediated home

I take as my premise here the notion that "home" (some conception of a protected, stable space; Douglas 1991) simply cannot be understood except in relation to its outside(s). In the work that Roger Silverstone and I did (see Morley and Silverstone 1990) based at Brunel University, researching the household uses of information and communication technology among a range of British households, our principal interest lay in the analysis of the role of various communications media in the articulation of the private and public spheres. The key issues in that research project concerned the role of these technologies in disrupting boundaries of various sorts at both domestic and national levels, and in rearticulating the private and public spheres in new ways. My point here is that the kind of abstract arguments about the creation of new kinds of image spaces or cultural identities—much debated in postmodern cultural theory—need to be better grounded in analysis of the everyday practices and domestic rituals through which electronic communities of various sorts are daily constructed and reconstituted. These macro patterns can only be adequately understood by analyzing the microprocesses through which they are both reproduced and over time, transformed (Knorr-Cetina 1989).

Ithiel de Sola Pool (1977) talks of the telephone as a technology with a "double life"—it both connects us to elsewhere and interrupts or invades our private spaces. This is to begin to think of communications technologies as having the simultaneous capacity to articulate together that which is separate (to bring the outside world into the home via TV, or to connect family members via the phone to friends or relatives elsewhere) but, by the same token, to transgress the (always, of course, potentially sacred) boundary which protects the privacy and solidarity of the home from the flux and threat of the outside world. Margaret Morse (1990) speaks of the liminal place occupied by the TV set, at the junction of the inside and outside, the channel through which the news of the public world enters the domestic realm. As Don Delillo puts it, in his novel *White Noise* (1985), there are, for most people in the world, only two places: where they live and their TV set. In the same spirit as DeLillo, Morse speaks of "our idyll, our self-sufficient and bounded place ... the space in front of the TV set" (1990, 205). The question is one of how TV (and other media) connect the place of

that "idyll" to other, geographically distant but communication-ally present places (Soja 1996).

the national family: integration and regulation

In their historical analysis of the development of British broadcast-ing, Cardiff and Scannell (1987) focus on broadcasting's crucial role in forging a link between the dispersed and disparate listeners and the symbolic heartland of national life, and on its role in promoting a sense of communal identity within its audience, at both regional and national levels (see Lofgren 1993 and 1995 for comparative material). They argue that, historically, the BBC can be seen to have been centrally concerned to supply its isolated listeners with a sense of the community they had lost, translated from a local to a national and even global level. Here we see precisely the concern identified above to articulate the private and public, as Scannell notes:

> It was no coincidence that Reith [the then Director-General of the BBC-DM] had worked hard for years to persuade the king to speak, from his home and as head of his family, to the nation and empire of families, lis-tening in their homes on [Christmas] day.... It set a crowning deal on the role of broadcasting in bringing the nation together... the family audience, the Royal family, the nation as family. (Scannell 1988, 19)

However, this is to consider only the positive dimension of articula-tion and connection of the family home to the wider world (and this one-sided emphasis has regretably become the tendency of Scannell's more recent phenomenological work, to the neglect of questions of power; see Scannell 1996). As broadcasting and other technologies connect the private home to the public world they also, simultaneously and inevitably transgress the boundaries of the household; thus they are felt to stand in need of some form of regulation.

All households regulate these matters in some way or another: in the Brunel project referred to earlier, our interest was in the vari-ety of ways in which households of different types enacted their reg-ulatory strategies. Elsewhere (see Morley, 1992 chap. 11, pp. 239 ff.), I have offered a detailed account of these modalities of regulation. That essay explores one particularly revealing case, where seem-

ingly simple economic family rules about controlling expenditure on the telephone rapidly turned out to have crucial noneconomic, symbolic functions in protecting "family time" from the intrusions of others. The parents in this family (and the husband in particular) were also deeply concerned by the prospect of deregulated television broadcasting bringing pornographic or violent programming within their children's grasp. As the father expresses his anxiety about their children's viewing habits: "[They] have sets in their rooms and [we] can't know what they are watching all the time." Thus, deregulation is not only a formal concern for the state at the macrolevel, in terms of the possible disruption of national boundaries by transnational broadcasters; for this family at least, it is also a question of fear of the family's (boundaries being transgressed directly), by unwanted "foreign" elements, bringing "matter out of place" into the home, and more particularly in this case, into the private space of the childrens' bedrooms. Here we readily see the connection between concerns about "boundaries" at both micro (or family) and (or national) macro levels. The concern displayed by the father of the household interviewed in the Brunel research project (who was anxious about the ways in which communications media transgressed and thus potentially destabilized the boundaries of his household) can be readily seen to have parallels at other levels of social scale. Thus Diane Umble (1992) offers an illuminating account of the ways in which the Amish community in Pennsylvania has developed an elaborate set of rules to regulate the impact of the telephone on the "sacred space" of their community life (rules concerning both the location of the machine and when it can be used, for incoming and outgoing calls). The Amish case may lie at one end of the spectrum of control, but my argument here is that these matters will always be regulated in one way or another.

Evidently, it is not just families or religious communities who make regulations of this sort: so do national governments. In recent years, many national governments have attempted to ban (or at least control) the consumption of "foreign" media material, by outlawing (or requiring the licensing of) satellite dishes. Thus, in an uncannily exact mirror image of the other's policies, while the Iranian government has attempted to ban satellite dishes, on the grounds that foreign programs were part of a Western cultural offensive against Islam, bringing a cultural danger of "Occidentosis" (an infection from the West; see Al-i Ahmad 1984), the mayor

of Courcoronnes (a poor, mainly North African immigrant area south of Paris) banned such dishes at the instigation of the French political party. the National Front, in whose eyes the dishes represented "the threat of a population that lives physically in France, but inhabits (via satellite) a world of Virtual Islam" (DeJevsky 1995).

postmodern geographies: space, place, and nostalgia

david morley

In her recent work, Doreen Massey has made a series of criticisms of the orthodoxies of the new postmodern geography. In essence, her argument is that this current orthodoxy offers too stark a binary contrast, in which an overly static model of the past is unhelpfully set against an overly frantic model of the present. In this orthodoxy, as she puts it, "an (idealised) notion of an era when places were (supposedly) inhabited by coherent and homogenous communities" (1991, 24) is crudely counterposed to an image of destabilizing, postmodern fragmentation and disruption. Her point is that the "place called home was never an unmediated experience" (1992, 8) and that, moreover, the "past was no more static than the present" (1992, 13). This is so, she argues, not least because "it has for long been the exception rather than the rule that place could simply be equated with community, and by that means provide a stable basis for identity," and because, certainly so far as Britain goes, "places have for centuries been. . . complex locations, where numerous different and frequently conflicting communities intersected" (1992, 8). So much for the (back-projected) settled, homogeneous communities of postmodern theory's romantic and nostalgic image of the past.

As Massey notes, the destabilizations of the postmodern period have certainly given rise to a variety of defensive and reactionary responses—witness the rise of various forms of born-again nationalism, accompanied both by sentimentalized reconstructions of a variety of "authentic" localized "heritages" and by xenophobia directed at newcomers or outsiders. Certainly, as Massey notes, in the face of these developments it has come to seem to many critics that any search for a "sense of place" must of necessity be reactionary. Massey's argument is that this is not necessarily the case and that it is in fact possible, if we approach the question differently, "for a sense of place to be progressive; not self-enclosing and defensive, but outward-looking" (Massey 1991, 24; compare Wheeler,

1994). This approach rejects the notion that a "sense of place" must necessarily be constructed (a la Heritage Industry) out of "an introverted, inward-looking history, based on delving into the past for internalized origins" (Massey 1991, 27).

That way of thinking about space and identity is premised on the association of spatial penetration with impurity, whereby incoming elements ("foreign" immigrants, commodities, or TV programs), represent "matter out of place," as the anthropologist Mary Douglas classically defined "dirt." Against any inward-looking definition of place and identity, Massey argues for "a sense of place which is extroverted, which includes a consciousness of its links to the wider world" (1991, 28), where what gives a place its identity is not its separate or "pure" internalized history, but rather its uniqueness as a point of intersection in a wider network of relations. This is then not simply a bounded, self-contained sense of place, constructed in antagonism to all that is outside (the threatening otherness of externality), but "an understanding of its "character" which can be constructed by linking that place to places beyond" (1991, 29) and where it is the "particularity of linkage to that 'outside' which is . . . part of what constitutes the place" (1991, 29).

Among other things, Massey takes issue with the high level of abstraction at which analysts of postmodernity consider the issue of time-space compression. The question Massey poses is a simple one: "Who is it that experiences it and how? Do we all benefit and suffer from it in the same way?" (1991, 24). This exposes the ethnocentricity of theories of time-space compression that regard this phenomenon as new. To fail to note this, as Massey argues, is also to fail to see that, from the point of view of the colonized periphery (for whom "the security of the boundaries of the place one called home must have dissolved long ago" in the wake of imperialism's conquests of other people's homes), it is perhaps "centuries since time and distance provided much protective insulation from the outside" (1991, 10).

For Massey, the politics of mobility and access certainly concern what she calls the "power-geometry" of these issues, insofar as different groups and individuals are placed very differently within the overall field of "mobility." The question is who moves and who doesn't; who has control of their movements and who doesn't (compare Hannerz's [1991] distinction between "voluntary" and "involuntary" cosmopolitans). If we consider (voluntary) access to

both physical mobility (transport) and information (via communications systems) as social "goods" (forms of cultural capital, as Bourdieu [1984] put it), then the question is that of the social distribution of access to these goods. As soon as we pose that question, we see that, whether in terms of access to physical transport (possession of a car, for instance) or to communications systems (the ability to pay for a cable TV subscription or to pay for time on the Internet), access is heavily structured by class, by gender, by ethnicity, and a whole range of other social factors. The idea that somehow "we" *all* experience some new form of postmodern "nomadology," then appears little more than a cruel nonsense. There are, in Massey's view many different "conditions of postmodernity," insofar as groups and individuals are "located in many different ways in the new organisation of relations over time-space" (1992, 9).

virtual geographies

A whole series of critics have supplied us with images of our (supposedly) new disembedded status within the virtual geography of postmodernity. Arnheim (1933), McLuhan (1964), Meyrowitz (1985), Rath (1985), Virilio (1986), Morse (1990) and most recently Wark (1994) have all alerted us to the transformations of time and space brought about by electronic technologies. In his version of this argument, Wark announces that nowadays, in the emerging virtual communities, unanchored in locality, which are made possible by the "ever more flexible matrix of media vectors crossing the globe ... we no longer have roots, we have aerials" and "we no longer have origins, we have terminals" (1994, x, xiv). We live in a "new virtual geography—the terrain created by the TV, the telephone, the telecommunications networks criss-crossing the globe." This offers a new kind of experience, which Wark defines as that of "telesthesia"—perception at a distance (for another approach to these issues, see Naficy 1993).

158

However, it may be a good idea to exercise some caution here. Marjorie Ferguson (1990), in her critique of the overblown claims of McLuhan, Meyrowitz, and others, argues that while it must be acknowledged that satellite media technologies are producing new definitions of time, space and community, these are not necessarily erasing but are rather overlaying our old understandings of dis-

tance and duration (compare Morley and Silverstone 1990 on the incorporation of new technologies into older communication patterns). Neither is it a matter of physical geography somehow ceasing to exist or ceasing to matter. It is rather a question of how physical and symbolic networks become entwined and come to exercise mutual determination on each other (compare Robins 1997 for a demolition of the "politics of optimism" in relation to current fantasies about the necessarily "empowering" effects of new communications technologies in transcending what Michael Ondaatje [1992] has called "the sadness of geography").

mobile privatization

Sean Moores (1993a) follows Raymond Williams (1974) in focusing on the role of television (and other mass media) as forms of "mobile privatization," that supply an experience of "simultaneously staying home and imaginatively . . . going places." However, "if broadcasting is able to 'transport' viewers and listeners to previously distant or unknown sites, mediating between private and public domains, then we need to specify the kind of "journeys" that are made. Who chooses to go where, with whom and why?" (Moores 1993a, 366). Or, as he puts it elsewhere, we must investigate the kinds of mobility that television offers its viewers, asking "to what new destinations is it providing transport" and "who chooses to make the journey" (Moores 1993b, 623).

Moores returns to these issues from a different angle in his study of viewers of satellite television (1996). In this connection, what has to be understood, for example, is precisely why, for particular types of people, in particular situations in the United Kingdom, satellite television comes to symbolize and represent a form of desirable freedom of viewing—precisely in contradistinction to the old national broadcasting institutions such as the BBC. The question is to understand why for a particular kind of white lower-middle-class man, it is what Moore calls the "larger feel" of satellite TV (as a form of broadcasting that transcends the boundaries of narrowly British culture) that is seen to be so desirable. "Foreignness" can sometimes be a matter of nationality, but in other cases also a matter of class, of gender, of race, or ethnicity. Certainly Gillespie (1995) found that, in Britain, the migrant Asian community she studied had a particular interest in video, cable, and satellite media

precisely to the extent that they felt ill-served by the existing British national broadcast media, whose failures to cater to their interests could then be made good via these new technologies.

the boundaries of cyberspace

More recently, with the development of computing technologies and the Internet, debates that were previously conducted with reference to traditional broadcasting media have been transposed into cyberspace, even if much of this debate has been perhaps overly optimistic (compare Robins 1997). Against tendencies to take a utopian view of the possibilities of transcending social division in cyberspace, I would argue that the Net can still reasonably be described as a "Whitezone," principally a "Boyzone" and certainly as a "Yanquinet." There are some categories of people who are completely missing from cyberspace, and it displays little diversity—its citizens include few old people, poor people, or anyone from poor countries (except a small minority of rich third world elites). In this connection, what is true of geographical mobility in physical space is also true of the structure of access to cyberspace. As Neil Smith put it, "It is not just that the rich express their freedom by their ability to overcome space, while the poor are more likely to be trapped in space" (1993, 106). Differential access to (physical or symbolic/electronic) mobility is itself also a cause of inequality in other respects.

As always, we need to pay attention to the differential experience of people who are members of different social and cultural groups, with access to different forms and quantities of economic and cultural capital. The point, simply put, is that we are not all nomadic, fragmented subjectivities living in the same postmodern universe. For some categories of people (differentiated by gender, race and ethnicity as much as by class), the new technologies of symbolic and physical communications and transport (from airplanes to faxes) offer significant opportunities for interconnectedness. For those people, there may well be a new sense of postmodern opportunities. However, at the same time, for other categories of people, without access to such forms of communication and transport, horizons may simultaneously be narrowing. As the provision of information, education, and entertainment passes into regimes of value determined by the cash nexus, societies are increasingly

divided, between the information-rich and the information-poor. The much-heralded wider choices offered by these new technologies are available only to those who can afford to pay for them. To the extent that access to public information and cultural resources comes to depend on the capacity of citizens to pay, so their capacity to participate effectively in the public realm will be correspondingly differentiated (Golding 1989).

geographies of exclusion and the purification of space

There is a long history of the production of imaginary geographies, in which the members of a society locate themselves at the center of the universe, at the spatial periphery of which there is a world of threatening monsters and grotesques. In these matters, the question of boundary maintenance, between inside and outside, between the world of the familiar (*Heimat*) and that of the strange (*Fremde*) is crucial. In this respect, we could usefully follow Sibley (1995), who argues that "the determination of a border between the inside and the outside [proceeds] according to 'the simple logic of excluding filth,' as Kristeva puts it, or the imperative of distancing from disgust" (Sibley 1995, 14). This process operates both on a societal or national level and, of course, at the level of everyday familiar experience.

In his analysis of the dynamics of what he calls the "purification of space," Sibley, drawing on the work of Mary Douglas (1966) and Basil Bernstein (1970), is centrally concerned with what he calls the "geography of exclusion," as enacted through the creation and policing of boundaries of various sorts. The dynamics of all this, he argues, are provided by the (socially produced) desire for the "purification" of social space. This applies at both micro and macro levels. The home may be profaned by the presence of "dirt" in the form of dust or mud (or a particular space within it profaned by the presence of an object properly belonging to another space). Similarly, the homeland may be profaned by the presence of strangers, or the national culture profaned by the presence of foreign cultural products. In either case, the "unclean" element, which brings the danger of profanity and thus must be "cleansed," represents "dirt"—that is, "matter out of place."

In an earlier article Sibley (1988) argues that far from being particular to so called primitive societies, purification rituals are a per-

vasive feature of contemporary cultural life. Thus, he continues, "residential space in the modern city can be seen as one area where purification rituals are enacted, where group antagonisms are manifested in the erection of territorial boundaries which accentuate difference or otherness" (Sibley 1988, 414).

This argument provides a close parallel to Davis's 1990 analysis of the processes of social segregation involved in the retreat of affluent whites into gated communities in Los Angeles, a process in which developments in that city seem, unhappily, to portend a similar process elsewhere. Sibley observes that patterns of residence are frequently based on social divisions such as those of class and ethnicity. As he notes, in these circumstances social difference is seen as implicitly threatening. While "with the social sorting involved in the creation of residential submarkets, the likelihood of [physically] encountering difference and otherness is minimised," by the same token "when such encounters do occur, the greater [is] the likelihood that a moral panic will ensue" (Sibley 1988, 416).

Threatening encounters with those defined as alien—those responsible for "cultural miscegenation" can take place not only in physical space but also in virtual or symbolic space. Here we return to the question of the role of the media. As the television set is placed within the symbolic center of the (family) home, thus transgressing its outer boundaries, it can serve either to enhance or to disturb viewers' symbolic sense of community (for a particularly disturbing account of the potential role of video technology in subdividing communities of viewers, see Kolar-Panov 1997). In some cases television can serve to bring unwanted strangers into our homes. Thus, in her article "Is This What You Mean by Color TV?" Bodroghkozy (1992) quotes from viewers" letters written to the producers of the black sitcom *Julia*. Among those responses, she finds one from a white viewer, pleased with his continuing success in keeping Black people out of the physical neighborhood in which he lives, who is outraged at their symbolic invasion of his territory via television: "I believe I can speak for millions of real Americans. . . . I am tired of niggers in my living room" (156). Conversely, in other situations (such as contemporary multicultural Britain), the television set can also offer the solace of symbolic immersion in a lost world of settled homogeneity. Thus, Bruce Gyngell (former head of TV-AM in Britain, now returned to work in TV in his native Australia) has claimed that Australian soap operas such as

Neighbours and *Home and Away* (which receive far higher ratings when they are shown in Britain than they do in Australia), appeal to many within the British audience precisely because they are, in effect, "racial programs," depicting an all-white society for which, he claims, some Britons still pine. As Gyngell went on to put it : "*Neighbours* and *Home and Away* ... represent a society which existed in Britain ... before people began arriving from the Caribbean and Africa. The Poms delve into it to get their quiet little racism fix" (quoted in Culf 1993).

cultural fundamentalism: nostalgia, belonging, and fear

Today, the equation of the desire for roots or belonging with a politically regressive form of reactionary nostalgia is widespread. Against this, Wendy Wheeler (1994) argues that it is politically crucial for us to come to terms with this desire, rather than simply to dismiss it as reactionary. Wheeler argues that we badly need to develop a better political response to this nostalgic desire for community by "articulating a politics capable of constituting a "we" which is not essentialist, fixed, separatist, derisive, defensive or exclusive" (108).

Verena Stolcke (1995) has observed that in Europe populist anti-immigrant feeling has been fueled by right-wing politicians' rhetoric of exclusion, extolling the virtues of a form of national identity predicated on cultural exclusiveness. Stolcke notes that advocates of immigration control justify their arguments by reference to what ethnologists call the natural territorial imperative— the idea that populations of animals (and thus, by extension, humans) will automatically defend their territory against intruders when these later increase above a certain maximum level. As Stolcke notes, "The demand to exclude immigrants by virtue of their being culturally different "aliens" is ratified through appeals to basic human instincts ... in terms of a pseudobiological theory" (4). The presumption of this approach is that people naturally prefer to dwell among their own kind (rather than in a multicultural society, for example) and this preference is assumed to be part of an "instinctive" negative response to the presence of people with a different "culture" (as signified, it often seems, by their skin color). Thus "miscegenation" (in physical or symbolic form) is defined as the key issue in the struggle of a community to preserve its own

163

original, pure biocultural identity. This form of contemporary cultural fundamentalism emphasizes difference of cultural heritage and the incommensurability of different cultural identities. As Stolcke points out, cultural fundamentalism "legitimates the exclusion of foreigners [or] strangers ... [on] the assumption that relations between different cultures are, by 'nature,' hostile and mutually destructive, because it is in human nature to be ethnocentric." Different cultures ought therefore to be kept apart for their own good" (5). The presumption is that people have a natural propensity to distrust, fear and reject "strangers" or "outsiders," simply because they are different, and to be hostile to all that is "foreign" precisely because it is "strange" to them.

Thus, culture is territorialized (Bhabha 1994) and the "problem" of immigration is construed as a political threat to national identity and integrity, on account of immigrants" cultural diversity, "because the nation-state is conceived as founded on a bounded and distinct community, which mobilises a shared sense of belonging and loyalty predicated on a common language, cultural traditions and beliefs. In [this] respect, nationalism is not all that different from the kinship principles that operated in so-called primitive societies to define group membership" (Stolcke 1995, 8).

postmodernism, poststructuralism, and the politics of difference

In recent years, the predominant approach to these issues has been that provided by various forms of postmodern and poststructuralist theory, which have given rise to what is often referred to as a new politics of difference. One key text in the construction of this discourse has been Iris Young's (1986) critique of what she terms the metaphysics of presence implicit in the very idea of community. In this section, I shall be principally concerned to offer a critique of Young's arguments, based on the work of Homi Fern Haber (1994).

Haber argues that the conventional postmodern/poststructuralist position follows Lyotard (1988) in equating any form of unity with terror. Thus totalization—or any assertion of structure or identity is equated with totalitarianism and viewed as an instrument of repression. On this model, all forms of closure (or unity, consensus, or community) are similarly reduced to forms of terrorism. The central problem with this, for Haber, is that it then pre-

cludes the identity formations necessary for political action of any kind. Haber is happy to recognize that all structures are temporary (and socially produced) and thus always open to redescription (to argue otherwise would be to reify the concept of structure). However, she insists that the repression of differences, which is logically entailed by *any* imposition of structure, is not (contra Lyotard et al.) necessarily terroristic, as long as we abandon the idea of structures (or identities) as timeless or unchanging and recognize that these things are inherently plural, provisional, and subject to deconstruction/redescription. Thus we can recognize that, in any particular formulation of an identity structure, "something will always be excluded [for that] is simply how language operates" (Haber 1994, 117), but this is quite different from the claim that such (necessary) exclusion or delimitation is, in itself, "terroristic."

In particular, Haber focuses her critique on Young's influential analysis of community and difference, arguing that Young proposes a false dichotomy—either similarity or difference—in which her commitment to the politics of difference leads her in effect, to repudiate (wrongly, in Haber's view) *any* possible notion of community. As Haber notes, according to Young the ideal of community is premised on a "metaphysics of presence" that denies difference between subjects, so that "the desire for community relies on the same desire for social wholeness and identification that underlies racism ... ethnic chauvinism ... and political sectarianism" (Young 1986, 1–2). For Haber, Young's model "assumes that members of a community see themselves as a non-conflicted, monadic unit and that identification with others in the community can work only by erasing ... differences." This is premised on a "model of empathetic understanding which forces the silencing of experiences different from one's own" (Haber 1994, 126). Haber argues that, in fact, there is little reason to presume that "community understanding" (or the recognition of sufficient similarity to allow identification) should preclude the simultaneous recognition of (other forms of) difference. She notes that "unity (the requirement that a thing be at least minimally coherent enough to be identified and redescribed) does not necessitate "unicity" (the demand that we speak with one voice)" (120). Haber's point is that while we must recognize, as Young does, that "any definition or category creates an inside/outside distinction" (Young 1986, 3), our response should not be to

abandon definitions, but simply to recognize their necessary artificiality and not to reify what is contingent as if it were absolute.

Of course, these questions cannot be entirely resolved at a theoretical level. In conclusion, it is perhaps worth noting the findings of Nora Rathzel's (1994) empirical study of attitudes about *Heimat* and *Ausländer* in Germany. Rathzel investigated the relationship between these two terms with particular reference to the question of whether people holding particular concepts of homeland were more inclined to perceive outsiders as threatening. Her empirical material, while based on a small sample, goes some way to demonstrating that people who hold a reified, "harmonious" image of *Heimat*, as something necessarily stable and unchanging are particularly likely to be hostile to newcomers, who are then held to be the cause of all manner of disorienting forms of change.

As we have seen, Haber argues, in her critique of Young that, rather than abandon the idea of community altogether, what we need to abandon is the reification of any particular idea of it. Rathzel's study shows that not only are images of *Heimat* and *Ausländer* structurally paired, as two parts of a binary opposition, in an abstract sense, but more specifically, that what makes images of Ausländer threatening is precisely that they "make our taken-for-granted identities visible as specific identities and deprive them of their assumed [or reified] naturalness," so that "once we start thinking about them, becoming aware of them, we cannot feel 'at home' anymore" (Rathzel 1994, 91).

As Marc Augé puts it: "Perhaps the reason why immigrants worry settled people so much is that they expose the relative nature of certainties inscribed in the soil" (1995, 119).

It does seem that there can be, for us, "no place like *Heimat*," or at least that the traditional, backward-looking concept of *Heimat* as a sacred and secure space from which all threatening forms of otherness have been excluded can be only a recipe for disaster. The virtual geography in which we live is in many ways quite new: The new communications technologies have had profound transforming effects, disarticulating and disaggregating communities from any necessary foundation in physical contiguity. However, as we travel the new electronic highways of cyberspace, we should beware of the duplication, if in new forms, of some of the very oldest and most regressive structures of purification and exclusion.

works cited

Al-i Ahmad, J. 1984. *Occidentosis: A Plague from the West*. Berkeley: Mizan Press.

Arnheim, R. 1933. *Film as Art*. London: Faber and Faber.

Augé, M. 1995. *Non-places: Introduction to An Anthropology of Supermodernity*. London: Verso

Bernstein, B. 1970. "On the Classification and Framing of Educational Knowledge," paper presented to the British Sociological Association conference "Sociology of Education," London.

Bhabha, H. 1994. *The Location of Culture*. London: Routledge.

Bodroghkozy, A. 1992. "Is This What You Mean by Colour TV?" in *Private Screenings*, ed. L. Spigel and D. Mann. Minneapolis: University of Minnesota Press.

Bourdieu, P. 1984. *Distinction*. London: Routledge

Cardiff, D., and P. Scannell. 1987. "Broadcasting and National Unity" in *Impacts and Influences*, ed. J. Curran et al. London: Methuen.

Culf, A. 1993. "Popularity of Australian Soaps Based on British Racism Fix?" *The Guardian* (November 21).

Davis, M. 1990. *City of Quartz*, London: Verso.

DeLillo, D. 1985. *White Noise*. New York: Vintage.

DeJevsky, M. 1995. "Ban on Islam by Satellite." *The Independent* (August 13), np.

Douglas, M. 1991. "The Idea of a Home: A Kind of Space," *Social Research*, 58, 1 (spring).

———. 1966. *Purity and Danger*. London: Routledge and Kegan Paul.

Ferguson, M. 1989. "Electronic Media and the Redefining of Time and Space," in *Public Communication*, ed. M. Ferguson. London: Sage.

Gillespie, M. 1995. *Television, Ethnicity and Cultural Change*, London: Routledge.

Golding, P. 1989. "Political Communication and Citizenship," in *Public Communication*, ed. M. Ferguson. London: Sage

Haber, H. F. 1994. *Beyond Postmodern Politics*. New York and London: Routledge.

Hannerz, U. 1991. "Cosmopolitans and Locals in World Culture," in *Global Culture*, ed. M. Featherstone. London: Sage.

Hobsbawm, E. 1991. "Exile," *Social Research*, 58, 1 (spring).

Knorr-Cetina, K. 1989. "The Micro-social Order," in *Actions and Structures*, ed. N. Fielding. Lonodon: Sage.

Kolar-Panov, D. 1997. *Video, War, and the Diasporic Imagination*. London: Routledge. 8, 3–4.

Lofgren, O. 1995. "The Nation as Home or Motel: Metaphors and Media of Belonging," Department of European Ethnology, University of Lund.

———. 1993. "Materialising the Nation in Sweden and America" *Ethnos*, 5.

Lyotard, J.-F. 1988. *The Differend*. Minneapolis: University of Minnesota Press.

Massey, D. 1992. "A Place Called Home," *New Formations*, 17.

———. 1991. "A Global Sense of Place," *Marxism Today* (June).

McLuhan, M. 1964. *Understanding Media*. London: Routledge and Kegan Paul.

Meyrowitz, J. 1985. *No Sense of Place*. New York: Oxford University Press.

Moores, S. 1996. *Satellite Television and Everyday Life*, Luton: University of Luton Press.

———. 1993a. "Television, Geography, and Mobile Privatisation," *European Journal of Communication*, 8.

————. 1993b. "Satellite TV as Cultural Sign," *Media, Culture and Society*, 15.

Morley, D. 1992. *Television Audiences and Cultural Studies*. London: Routledge.

————. and R. Silverstone. 1990. "Domestic Communications," *Media, Culture and Society*, 12, 1.

Morse, M. 1990. "An Ontology of Everyday Distraction: The Freeway, the Mall, and Television," in *Logics of Television*, ed. P. Mellencamp. Bloomington: Indiana University Press.

Naficy, H. 1993. *The Making of Exile Cultures: Iranian Television in Los Angeles*. Minneapolis: University of Minnesota Press.

Ondaatje, M. 1992. *The English Patient*. London: Picador.

Pool, I. de Sola. 1977. *The Social Impact of the Telephone*. Cambridge: MIT Press.

Rath, C. D. 1985. "The Invisible Network," in ed. *Television in Transition*, ed. P. Drummond and R. Paterson. London: British Film Institute.

Rathzel, N. 1994. "Harmonious 'Heimat' and Disturbing 'Ausländer,'" in *Shifting Identities and Shifting Racisms*, ed. K. K. Bhavani and A. Phoenix. London: Sage.

Robins, K. 1997. "The New Communications Geography and the Politics of Optimism," *Soundings*, 5.

Scannell, P. 1996. *Radio Television and Modern Life*. Oxford: Blackwell.

————. 1988. "Radio Times," in *Television and its Audiences*, ed. P. Drummond and R. Paterson. London: British Film Institute.

Sibley, D. 1995. *Geographies of Exclusion*. London: Routledge.

————. 1988. "Purification of space," *Environment and Planning*, Series D: *Society and Space*, 6, 4.

Smith, N. 1993. "Homeless/Global: Scaling Places," in *Mapping the Futures*, ed. J. Bird et al. London: Routledge.

Soja, E. 1996. *Thirdspace*. Oxford: Blackwell

Stolcke, V. 1995. "Talking Culture: New Boundaries, New Rhetorics of Exclusion in Europe," *Current Anthropology*, 36, 1.

Umble, D. 1992. "The Amish and the Telephone," in *Consuming Technologies*, ed. R. Silverstone and E. Hirsch. London: Routledge.

Vitilio, P. 1986. *Speed and Politics*. New York: Semiotexte.

Wark, M. 1994. *Virtual Geography*. Bloomington: Indiana University Press.

Wheeler, W. 1994. "Nostalgia Isn't Nasty" in *Altered States*, ed. M. Perryman. London: Lawrence and Wishart.

Williams, R. 1974. *Television, Technology and Cultural Form*. London: Fontana.

Young, I. 1986. "The Ideal of Community and the Politics of Difference," *Social Theory and Practice*, 12.

david morley

recycling

colonialist

fantasies

on the texas

borderlands

rosa linda fregoso

We live in urgent times, particularly so for those living on the Mex-
ico border. It is like a rerun of earlier epochs: the nineteenth-cen-
tury laws barring Mexican (native and immigrant) miners during
the California gold rush; the massive deportation of immigrant and
native-born Mexicans during the Great Depression; the moral
panic about border-crossers featured in an episode of Edward R.
Murrow's TV documentary series of the 1950s, *See It Now*. The back-
lash against brown residents (constructed as "foreigners" or "immi-
grants") comes in cycles. But this time it is even more frightening.
As regimes of capital accumulation deepen global asymmetries, cre-
ating massive dispersals and displacements of entire communities,
nation-states police their borders with greater aggression. In the
post-cold-war era, battles are waged against civilian populations.

Capital may be borderless in the globalized economy, yet the nativist social order of the United States responds to economic uncertainties by reinforcing the boundaries of national belonging through racial, ethnic, and sexual exclusion. Without a Communist threat to contain, the state deploys its military apparatus internally, exorcising "foreigners" from within its own borders.

For a law-and-order society, the border is a boundary line between nations that are meant to be different. It is in the commonsense discourse of border guardians such as Muriel Watson, founder of the Light Up the Border campaign, that this idea of the border is fully mobilized: "I still ask the question, 'Why are they coming the way they are?' That has to be resolved. And there's no reason that between two reasonably civilized nations, that the border can't be respected" (Quoted in Gutierrez, 1996, 259). Commonsense discourse on the border criminalizes and demonizes border-crossers insofar as they transgress the nation's sanctity and integrity. Border-crossers are denied human rights, persecuted, imprisoned, and beaten, as in a 1995 incident in southern California filmed by a helicopter news camera and broadcast nationally.[1]

Along with a media-fueled hysteria about an "out of control" border, anti-immigrant racism has recently culminated in state-sponsored measures aimed at noncitizens, such as Proposition 187 in California, the national welfare reform bill and the new immigration bills, as well as an increase in state surveillance through greater budgets for border patrols and the Immigration and Naturalization Service (INS). These are acts that serve to demonize further the bodies of border-crossers and to militarize the border. Although in the U.S. imaginary the figure of the border and images of border-crossers reinscribe the racialized boundary of citizenship and the nation-state, in theoretical discourse the terms are used to theorize cultural processes in the late twentieth century.

As a conceptual paradigm, the border traces the cultural effects of global and national transformations in the so-called postmodern, post-Fordist age, typified by the rapid circulation of capital, technology, and media, and by shifts in power relations and displacements of entire communities. Cultural theorists deploy the term *border* as a paradigm for intercultural exchanges, transcultural crossings, and mixings. In critiques of the absolutism of pure and authentic culture, the border figures as a space of in-betweenness, a third space, a *transfrontera* (transborder) contact zone. Within the

conceptual paradigm of the border, border-crossers manufacture and negotiate new social and cultural relations through processes of transculturation, syncretism, intercultural and linguistic exchanges, plurinationality, multiplicity, and heterogeneity. Yet despite offering an illuminating view of cultural processes in the late twentieth century, the proliferation of the border paradigm has led to inexact and uncircumspect applications this limit its theoretical usefulness. The concept can be brought up to explain each and every boundary/encounter phenomenon, including the intra- or interpsychic, the intra- or interpersonal, the intra- or intercultural, the intra- or international, and so forth.[2] In efforts to counter potentially unproductive and vacuous abstractions based on the term *border*, or the co-optation and the temptation to fetishize the concept, Chicana/o cultural theorists demand the specific localization of the border paradigm (Yarbro-Bejarano 1994, 9).

For Chicana/o border discourse, the explanatory power of the border is constituted through its spatial and temporal links to the U.S.-Mexico border, as is evident in the work of Américo Paredes and Gloria Anzaldúa. Their formulations of the border are concrete and historical, serving to remind us "that the military conquest of Mexican-held territories transformed the Rio Grande region from a place of peaceful co-existence into a barbed line of demarcation" (Fregoso 1993, 66).[3] Thus the concept of the border is a way of locating cultural analysis historically, in the context of imperialism and colonization in the Americas. In these elaborations, the U.S.-Mexico border serves as a paradigm for unlocking the histories of conquest, genocide, slavery and racism.[4] By situating cultural analysis within the legacies of conquest and colonization, "the borderlands make history present [and expose]—the tensions, contradictions, hatred and violence as well as the resistance and affirmation of the self in the face of that violence" (Pérez-Torres 1995, 12). Thus, in Chicana/o border discourse, the two-thousand-mile border is neither American nor Mexican but a third country, "an intercultural world unto itself," representing "a social space of subaltern encounters ... in which people geopolitically forced to separate themselves now negotiate with one another and manufacture new relations, hybrid cultures and multiple-voiced aesthetics" (José Saldívar, forthcoming). Whether deployed in the service of cultural analysis or historical revisionism, or for understanding the international gendered division of

labor (the *maquiladoras*), the border paradigm provides an analysis of asymmetrical power relations, cultures of displacement and diaspora (forced border crossings), and human suffering (environmental racism, labor exploitation), created by uneven global and hemispheric developments and political instabilities. And while the U.S.-Mexico border may very well be a site of cultural encounters—a space of in-betweenness, a third space, or a *transfrontera* contact zone—the concept names much more than an encounter between equal partners. Rather, in Chicana/o border discourse, the border paradigm identifies the forms of culture produced in nonegalitarian power relations by border subjects and helps to account for the persistence of racial, sexual, gender, and class intolerences in the borderlands. It is within the framework of a critical border discourse that I situate my own intervention in this essay.

The Media Studies Symposium on Exile profoundly altered the style and substance of my contribution to this volume. I initially wrote a conference paper about representation of Chicanas/Mexicanas in silent cinema. This article examined how nineteenth-century colonial discourse marked the bodies of Chicanas racially and sexually and narrated the nation through the disavowal of Mexicanness on the borderlands. However, during the symposium I was deeply moved by several of the conference speakers—whose interventions exemplified Cherríe Moraga's notion of theory in the flesh (1983: xviii). Inspired by these embodied theoreticians, I started to reflect on my own relation to Tejas/Texas as homeland, on the reasons for my self-imposed exile from Tejas, and on the memories giving life to vivid emotions about the homeland. I decided to write a different kind of paper, one that grappled with the metonymic relation of concrete and symbolic bodies, memory, history, and visual texts to fantasies, desires, and longings. This chapter tracks the multiple and variable ways that the border, as discourse, space, and social relations, is reconfigured in visual representations on the Mexico-U.S. borderline. I will examine the trajectory of border representations spanning several decades, from the total binarism of early cinema (*Martyrs of the Alamo*, 1915) to the sympathetic but patronizing naturalism of post World War II documentary photography (the Russell Lee project) to the nuanced yet highly problematic ambiguity of a film set in the contemporary era of multiculturalism (*Lone Star*, 1996). I situate my own intervention within the framework of critical border discourse, deploying autoethnography

to historicize the border, to bring to light a third space of Tejana (Texas-Mexican) subjectivity distinguished by its profound ambivalence toward relations of power and resistance. In this volume dedicated to imaginings of home and identities and in the context of a new and renewed racism against "dark" border-crossers, I will explore what kinds of power relations are reaffirmed and dismantled by border-crossers on the Tejas borderlands.

tejanas on the borderlands

In the final moments of the film *Lone Star*, after learning from her lover that he is also her half-brother, Pilar Cruz (Elizabeth Peña) responds with the phrase, "Forget the Alamo." The scene offers the key to the film's innermost meanings. With these words, the heroine refuses knowledge of her past and rejects the impossibility of an incestuous love affair as well as the classic tragic ending to the forbidden-love story. This refusal of the trope of impossible love goes beyond the particularities of the dramatic subtext. Turning tragedy into an individual act of defiance, Pilar disregards the borders constructed by kinship laws of alliance and the racial order, namely, the social prohibition against sibling romance and taboos around interracial love. Her shrewd response unifies the public and the private and combines personal family history with political social history. Her words indelibly rekindle a counterdiscourse to the official versions of history. As a teacher of Texas history, Pilar is well aware of the symbolic power of "Remember the Alamo," which she alters, subverting the primal myth of Texas. If bodies are marked by the history and specificity of their existence, then the body of this Tejana becomes the terrain on which social prohibitions, racial history, and myth are rewritten. Although in the context of the scene, "Forget the Alamo" mirrors Pilar's volition, these words also opened a psychic fissure in my own personal history, uncovering a submerged wound of Texas racism, which led me to inject cultural discourse with my own countermemory of Tejas. This closing scene, like Pilar's body, is layered with meaning, staging an allegory for the entwining of Tejana/os and Texans, Mexicans and Anglos. For along with its linguistic and mythic subversion, Pilar's voice resuscitates the painful legacy of disavowal on the borderlands.

173

* * *

I first heard the phrase "Forget the Alamo" thirty years ago. It was my father's antidote to the official versions of Texas history taught in the public schools of Corpus Christi. Although we confronted prejudice on a daily basis, it was in those required eighth-grade Texas history courses that Chicana/os received the officially sanctioned lesson in Anglo racism and contempt for Mexicans. Sitting in Oakland's Grand Lake Theater in 1996 next to my thirteen-year-old son, who is disturbed by *Lone Star*'s incest theme and critical of its "too many plot lines," I found myself transported back to my own childhood in Texas, sitting in Mrs. Joy's history classroom, which was adorned with the sixflags over Texas and the haunting legacy of the battle of the Alamo.

For weeks I was captivated by Mrs. Joy's petite hourglass shape, her crimson hair, and those tan-dots speckling her flesh and framing her marble-blue eyes. Mrs. Joy gave interminable, heart-wrenching lectures, reenacting with melodramatic detail Anglo-Mexican struggles for Texas's independence. A devotee of the historian Walter Prescott Webb, Mrs. Joy passionately perpetrated his views about the "cruel streak in the Mexican nature." She had mastered the skill of counterpoint pedagogy, detailing history in terms of binary opposition: the noble letter-writing campaign of Stephen F. Austin versus the "bloody dictator" Santa Anna's wrath; the memorable deeds and bravery of Travis, Crockett, and Bowie versus the atrocities of the "treacherous" Mexicans; the high-powered artillery, rifles, and cannons of the "villainous" Mexicans versus the handful of muskets, revolvers, and bowie knives of the heroic Anglos. I can still see her there pacing excitably before us, diligently pointing at maps of Texas, images of its flags, and charts. She gazed at me, the only Tejana in the class, and I felt her whiteness overpowering me each time she mentioned "the cruel streak in the Mexican nature."

Thirty years later, the shame I felt back then would turn to anger as I screened the 1915 film *Martyrs of the Alamo* during a research trip to the Library of Congress film and video collection. Directed by W. Christy Cabanne, *Martyrs of the Alamo* was supervised by D. W. Griffith, whose unmistakable imprint is etched in the narrative. The five-reel feature is shot in 35mm and replicates Griffith's system of narrative integration, especially in its liberal use of "stylistic techniques—from composition to editing—to articulate an ideology of race that positions 'whites' as superior and 'non-whites'

as deviant and inferior" (Bernardi 1996, 104). As the intertitle makes evident, Mexicans, under the command of Santa Anna, figure as the invaders in a world of "liberty loving Texans who had built the Texas colony."

The articulation of style and race in the story is reinforced through characterization and cinematic techniques such as mise-en-scène, editing and shot composition, to the extent that cross-cutting and parallel action render racial differences between Anglos and Mexicans. Mexicans are caricatured as dark, ominous, and physically aggressive. Medium and close shots depict the psychological depth of Anglo characters, whereas the camera remains distant from the Mexican characters. Filmed mostly outdoors and framed through distant and long shots, Mexicans are portrayed as a mass of bodies with faces that are indistinguishable from each other. And Mexican females fare no better, playing folkloric "cantina girls" whose sole purpose in the narrative is to dance for Mexican men. Yet the most disturbing aspect of *Martyrs of the Alamo* is the way filmmakers reroute the historical conflicts in Texas through the discourse of sexual degeneracy.

The intertitle keeps looping through my head: "Under the dictator's rule, the honor and life of American women was held in contempt." The film is informed by an offensive yet predictable racial narrative, namely, the colonialist fantasy of white womanhood under siege. *Martyrs* is, as Herman Gray writes of *Birth of a Nation*, a "scandalous representation" of non-white masculinity, embodying white anxieties about miscegenation (Gray 1997, 87–88). Following in the tradition of Griffith's racialized family drama, *Martyrs of the Alamo* recasts late-nineteenth-century pseudoscientific theories of degeneracy and miscegenation. The film positions Mexicans as sexually hungry subaltern men, predators devouring the angelic female with their looks, teasing a white mother with baby, touching white women's blond locks. The film thus draws from a repertoire of racial and imperial metaphors to construct the view of Mexican sexual degeneracy as a threat to the virtue of white femininity and racial purity. Santa Anna epitomizes Mexican degeneracy as the final segment of the film creates a myth about his out-of-control libido. The intertitle: "An inveterate drug fiend, the Dictator of Mexico also famous for his shameful orgies," is followed by a scene depicting Santa Anna, in a drunken stupor, surrounded by four Mexican women dressed exotically in dark mantillas, vests

and skirts, dancing before him. The narrative resolution around Santa Anna's capture rewrites the political struggle over Texas as a defense of white femininity and by extension the white nation, thereby rationalizing the Anglo take-over of Texas. At the end of this film I am furious because, even though *Martyrs of the Alamo* is the most extremist, xenophobic account of the Texas conflict I have ever seen, its discursive effects lingered on fifty years later, haunting me in that Texas history class.

I return to earlier memories and place myself in the body of a thirteen-year-old girl listening anxiously in that classroom. It is 1967. I imagine the harshness in the looks of my Anglo classmates, burning my flesh. By the time Mrs. Joy delivered her final soliloquy, reciting the climactic battle for Texas's independence, the primal scene that has so obsessed the Anglo-racist imaginary and that is reenacted in countless colonialist films, including *Martyrs of the Alamo*, I was interpellated into her historically distorted, chromatically tainted universe, inside the walls of the Alamo, on what Anglo-Texans reconfigure as a purely Anglo side of the line. I would later buy a "bowie knife" from a mail-order catalog. In the eighth grade, I had internalized the elision of Tejanos and the racist-colonialist gaze—a self-hatred equal to the hatred Anglo teachers of Texas history felt for Mexican-Texans.

I still own that copy of Rafael Trujillo Herrera's book, *Olvídate de "el Alamo"* (Forget the Alamo), published in 1965 and given to me by my father in 1967 to temper my fulmination against the Mexican oppressors of Anglo freedom fighters. As the title makes evident, *Olvídate de "el Alamo"* is a diametrically opposed version of the battle for Texas. Told from a Mexican point of view, it renders the struggle in Texas less in terms of liberation and more from the perspective of conquest. Like Mrs. Joy's history lessons, Trujillo's text failed to account for the political intricacies of nineteenth-century Tejas, including the important fact that Tejano landowners joined Anglos in the fight against the centralist government of Santa Anna, or that some Tejanos died alongside the Anglos inside the Alamo. Even so, I read *Olvídate de "el Alamo"* understanding only bits and pieces. The book ignited a lifelong passion for oppositional discourse and counter knowledges. Besides this introduction to Mexican nationalist discourse, in his customary wisdom, my father would further dis-order Mrs. Joy's teachings: Just imagine that one day you invite guests into your home. They can live in your home

on the condition that they follow certain rules. Then one day, your house guests decide that they don't agree with your rules and so they decide to take your house and kick you out. That's how it happened in Tejas.

Thus, while racist powers produced and marked my body as a historically specific, racial, and gendered subject of Texas, an oppositional force, metaphorized in the phrase "Olvidate de el Alamo," reoriented the terms of my inscription. This is the countermemory of Tejas that Pilar Cruz's final words enable, putting me in touch with a long tradition of opposition to racist discourse, popular forms of knowledge, transgressive tales of resistance, and subaltern practices of suspicion for official versions of history. In contrast to Mrs. Joy's account of Mexican and Chicano nationalist accounts, Pilar Cruz represents a new breed of Texas history teachers, a Tejana on the borderlands, committed to a revisionist historiography. Refusing the absolutism of binaries, the counter-discourses of Tejanas on the borderlands recount the stories of Tejas in terms of their profound ambivalence, in tales of complicity, resistance, and domination. And it is precisely this ambivalence that finds an expression in this borderlands film by John Sayles.

other border-crossers: 1996

Although John Sayles's account of multiracial Texas is framed by the discourse of white masculinity, Lone Star[5] has been praised by mainstream film critics and to some extent by the Tejana/o intelligentsia for its enlightened multiculturalism and alternative perspective on race relations.[6] Lone Star is John Sayles's tenth and most ambitious film, following a series of films tackling sensitive subjects such as labor unions in Matewan (1987), lesbianism in Lianna (1983), race relations in Brother from Another Planet (1984), and corruption in a working-class city in City of Hope (1990). Also a novelist and a script doctor who rewrote Apollo 13, Sayles perfects his storytelling techniques with Lone Star, rendering a richly layered and complex narrative with multiple story lines and the shifting points of view of at least ten substantial characters.

The film is set in Frontera (literally, "Border"), Texas, and details the story of Sheriff Sam Deeds's (Chris Cooper) investigation after the discovery of skeletal remains on the outskirts of town. The remains are believed to belong to Charley Wade (Kris Kristoffer-

son), a racist and corrupt sheriff who mysteriously disappeared in 1957 after waging a campaign of bigotry and terror against the local Tejano and black communities. Sam Deeds's late father, the legendary sheriff Buddy Deeds, Charley Wade's former deputy, becomes Sam's prime suspect. In the course of his investigation, Sam rekindles an interracial romance with his teenage sweetheart, Pilar. Shot in Eagle Pass, Texas, Sayles captures the look of Texas, filming in super 35mm. While the murder mystery provides the major plot line, Sayles portrays a multigenerational drama, rendered through the life histories of an Anglo sheriff, a Chicana teacher, and an African-American army officer. *Lone Star* can best be characterized as a blurred genre, combining elements from the western, mystery, thriller, and romance. The film is also the latest in a long line of border films; the figure of the border is iconic on the screen.[7]

Since the early days of silent cinema, U.S. filmmakers have made hundreds of films about the Mexico-U.S. border.[8] An obsession with borderlands is not the sole purview of U.S. cinema; beginning in the 1930s, the border has also captured the imagination of Mexico's film industry, which in one decade alone released over 147 films in the border genre.[9] In the cultural imaginary of both the United States and Mexico, the border figures as the trope for absolute alterity. It symbolizes eroticized underdevelopment—an untamed breeding ground for otherness and the site of unrepressed libidinal energies. Its inhabitants are coded as outcasts, degenerates, sexually hungry subalterns and outlaws. In both Mexican and U.S. cinemas, the representation of the border as otherized territory is symptomatic of a colonialist and racist imaginary. The product of a Western gaze, this representation of frontier territories as abject serves both to define the U.S. and metropolitan Mexico and to shape their national identities.

In contrast, Sayles's portrait of the borderlands captures the complexity, nuances, and multidimensionality of the terrain. In fact, at first glance, *Lone Star* reads like an application of Chicana/o borderlands theory—which may explain our initial enthusiasm. Sayles invokes the Mexico-U.S. border as a paradigm for his own analysis of U.S. social relations: "There's a kind of racial and ethnic war that has continued. That continuing conflict comes into the clearest focus around the border between Texas and Mexico." For John Sayles, Lone Star is a "film about borders" and the border

operates as the signifier for the borders of everyday life: "In a personal sense ... a border is where you draw a line and say 'This is where I end and someone else begins.' In a metaphorical sense, it can be any of the symbols that we erect between one another—sex, class, race, age" (West and West 1996a, 14) .

Sayles did his homework on Chicana/o studies cultural critiques and border theories, reading Americo Paredes's *With a Pistol in His Hand*, screening Robert Young's filmic adaptation, *The Ballad of Gregorio Cortez*, and listening to border *corridos* and studying their lyrics closely.[10] Furthermore, like much Chicana/o border writing, *Lone Star* is set in the borderlands region—the two-thousand mile strip of land, roughly twenty miles wide, separating Mexico from the U.S. And following Chicana/o border theories, the film portrays the region as a transborder contact zone, a third country that is neither Anglo nor Mexican but rather multilingual, intercultural, and multiracial. The film thematizes literal and figurative border crossings—cultural and social relations of accommodation and negotiation within and between the inhabitants on the borderlands. Exploring the racial, cultural, economic and familial conflicts in the borderland, *Lone Star* candidly depicts tensions between Texans and Tejana/os, Anglos and blacks, and Mexicanos on this side of the border and on the other side, as well as the relations of complicity between the Texan-Anglo and the Tejano-Mexicano power elite. For example, Mercedes Cruz (Miriam Colon) is a successful restaurant owner who calls the border patrol on seeing desperate Mexican immigrants run across her yard and tells her immigrant employee, "In English, Enrique. This is the United States. We speak English." Jorge is a member of the Frontera elite, and Ray is portrayed as a Tejano deputy who plans to run for sheriff in the next election with the support of the local power structure. Thus, throughout the film, relations of power and privilege are nuanced, figuring centrally in both individual and group transactions. In this respect, *Lone Star* renders, as do borderland critics, the experiences of continuity and discontinuity that mark daily life, namely, ongoing as well as incoherent encounters between various social groups, reference codes, beliefs, and linguistic and cultural systems.

The film, in fact, reads like an alternative lesson in Texas history. The resemblance of Sayles's text to Chicana/o border theory is most evident in his attempts to situate the figures of the border and borderlands as central elements of a historical revisionist project, as

well as in efforts to reclaim an alternative racial memory of the borderlands. The filmmaker challenges the prevailing historical amnesia and ideology of "presentism" of society in his efforts to illuminate how past histories weigh incessantly on present circumstances and how the mythic legacy of the past clouds the present's truths. Sayles underscores the political project of showing the bearing of the past on the individual's present through an effective use of seamless editing in the flashback sequences.

Contesting exclusionary formulations of a monocultural Texas history, *Lone Star*'s racial memory differs from two extremes: the Anglo colonialist erasure of Tejana/o subjects in Texas history (as in *Martyrs of the Alamo*) and also the Chicano protonationalist reversal of that exclusion, namely, Tejanos as the victims of conquest, the "good guys" in a them-versus-us binary revision of Texas history. Sayles portrays race relations in terms of an exercise of race and class power, in particular configurations and connections as well as in terms of singularities. Anglos and Mexicanos, Tejanos and Texans figure as both agents and subjects of domination and complicity. The film's revision of Texas history goes beyond its documentation of Anglo-Mexicano relations of negotiation and accommodation, for *Lone Star* also reflects the filmmaker's "need to document" the history of multiculturalism in this country.[11] This is what he has to say:

> As I said, [the U.S. is] not increasingly multicultural, its always been so. If you go back and turn over a rock you find out, for example, that maybe a third or more of African Americans are also Native Americans and a much higher percentage of African Americans are also white Americans. (West and West 1996a, 15).

Sayles celebrates a new social order, painting a tapestry of an interracial, postcolonial Texas, reviving a textured story of racial entwinement and complexity on the borderlands—a pluricultural transborder contact zone comprised of Native Americans, blacks, Tejanos, and Anglos. The Mexico-U.S. borderlands in Sayles's universe is hybrid and multilingual; his is a tutored and refined view that destabilizes traditional formulations of U.S. race relations (the black/white paradigm). Yet despite its overture to multiculturalism, the film's narrative is, on closer inspection, driven by a deeply colonialist and phallocentric project.

Genuine multiculturalism, that is to say, the redefinition of the

nation and a reconfiguration of center-margin power relations, insists upon the interplay of multiple and plural identities, truly questioning the border demands as well the interrogation of the boundary markers of race, class, gender, and sexuality. For in reconfiguring the nation in terms of multiculturalism, the center is no longer defined by purity, sameness, and singularity, but rather by hybridity, difference, and plural identifications. If Sayles's multi-culturalist project is to truly represent a new social order, to make a dent in the predominant monocultural, ethnocentric vision of society, it must decenter whiteness and masculinity. Even though multiculturalism always involves relations of power, neither whiteness nor maleness nor heterosexuality nor Europeanness function as universals in a multicultural world.

However, as Sayles's words make evident, maleness is the key, privileged signifier of the narrative: "For me, very often the best metaphor for history is fathers and sons. Inheriting your cultural history, your hatreds and your alliances and all that kind of stuff, is what you're supposed to get from your father in a patriarchal soci-ety" (West and West 1996a, 15) Thus a liberal confusion permeates the film. While the border figures as the symbol for multicultural-ism, crossings, intercultural exchanges, and hybridity, history is metaphorized as a patriarchal patrimony. On the surface, *Lone Star* attempts to rewrite the social order to encompass difference for a multicultural nation; the white-father-white-son structure of the story, however, keeps the center intact and multiplicity at the mar-gins of the story world. By reinscribing the centrality of the Oedipal narrative and the voice of white racial privilege, the film reaffirms the masculinist borders of whiteness, containing difference and regulating the disruptive aspect of otherness.

Whereas the plot is driven by Sheriff Sam Deed's own search for truth, his son, Sam, is motivated by a repressed hatred for his father, the legendary benevolent patriarch of Rio County, Sheriff Buddy Deeds. Like Westerns and border genre films, *Lone Star* literal-izes the symbolic structure of the Law, rendering the father and son as the embodiments of "civic law," since both are county sheriffs. Patrimony guarantees the cinematic reproduction of the symbolic oedipal structure, insofar as the son, Sam, assumes the place of the father, Buddy, literally as the sheriff of Rio County, but also sym-bolically, in the order of the phallus, the law of the father. The usual oedipal scenario is further reinforced textually by the father-

son conflict generated within the film. Namely, the son is driven by a desire to kill the father—not literally, since Buddy is already dead, but figuratively, for he is the prime suspect in the murder investigation. Instead of honoring his father's name, the son's investigation camouflages an obsessive desire to prove his father's culpability, to taint his father's reputation, thus destroying his name. As in the best mystery thriller, the plot twists and suspense of *Lone Star* yield an unexpected resolution to the murder investigation. Whereas all the evidence pointed to the father as the prime suspect, Sam discovers that the murder was in fact committed by Hollis Pogue, the current mayor of Frontera, who was not only the fledging deputy of the notorious Wade, but also the horrified witness to Wade's racist atrocities. Narrated in a seamlessly edited flashback, the murder of Charley Wade is the central motif in the film's revisionist project. Wade is murdered by the young deputy, Hollis, to prevent the murder of Otis Payne, the owner of Big O's Roadhouse and mayor of Darktown. Emblematic of a white benevolence on the Texas frontier, the murder of one white man by another white man to save a black man's life rewrites race relations in Texas, resituating the history of black-white cooperation, resistance, and collusion against white racism. Despite this revisionist endeavor, narrative closure around the son's discovery of the father's innocence further reinforces and consolidates whiteness as well as the patriarchal structure of the film. In the end, the oedipal conflict is resolved for masculinity. Clearing the father's name allows the son to assume his rightful place, the place of the father in the symbolic order, thus guaranteeing the reproduction of patriarchy.

It is precisely this patriarchal structure of the oedipal narrative that contains Tejana and Tejano subjectivities and points of view but also enables them to emerge. The structuring of information within the film positions Sam Deeds as the center of consciousness and the filter for narrative information. The stitching of present events with past memories through flashback sequences allows the filmmaker to provide characters with complex subjectivities. And while both Pilar and her mother are given subjectivity through this mode, Pilar's flashback is linked by seamless editing with Sam's flashback about their teenage rendezvous. Thus, with the exception of Mercedes Cruz's flashback, each of the seven flashback sequences is mediated by the presence of the main hero, so that the memories of interracial conflict are structurally folded into the son's quest to

dethrone the "legendary" father. The unearthing of Texas's racist past and the revision of a multicultural social order are always already subsumed and contained within the point of view of whiteness and masculinity that is privileged in the narrative. It is the son's attempt to slay the father that ultimately authorizes the emergence of other points of view. As the vehicle for dominant racial and gender discourse, the white masculine subject also circumscribes the parameters of racial memories of conflict and collusion, marking thus the impossibility of a Tejana/o psychical interiority and corporeality outside of the framework of an Oedipalized white masculinity.

Whiteness is also privileged as the mediating term for interracial contacts, both between people of color and between the sexes. Whites have meaningful interactions with blacks, whites interact with Mexicans, but blacks and Mexicans have no contact outside of whiteness. Each racial group interacts with its "own kind," with no evident relationship between the groups. And while the whiteness privileged in *Lone Star* is no longer the white racist masculinity that framed race relations in a previous era, a new benevolent patron, *amigo* of Mexicans and blacks, is figured in the personaes of Buddy and Sam Deeds.

Narrative resolution takes place in an abandoned drive-in theater, reminiscent of another film, *The Last Picture Show* (1971). It is at the eroticized site of a drive-in, that weathered relic to the fifties, now overtaken by johnsongrass, weeds, and the turbulent memories of Pilar and Sam's adolescent rendezvous, that Sam divulges the truth of his and her existence—namely, that they share the same father. Pilar's response, "We start from scratch—? Everything that went before, all that stuff, that history—the hell with it, right? Forget the Alamo," provides narrative closure for the film. Yet this climactic scene, a tribute to the petrified remains of a bygone social order resurrects a repressed interracial narrative lodged deep within the national imaginary, unmasking further the legacy of disavowal on the borderlands. Since the nineteenth century, the Texas myth of origins has been saturated with the racial politics of exclusion and a discourse of racial purity which disavowed social relations between the races. In fact, the identity of Texas is shaped by a deliberate repression of interracial political, social, and sexual relations. The Anglo denial of the history of Tejano/a-Texan entwinement is disturbed with Sam's discovery of his father's long-

term love-affair with Mercedes Cruz, the restaurateur who is also Pilar's mother. In the process, the film makes evident the ways in which sexuality is as much a transfer point of power as it is of history and social relations. In this respect, the transborder contact zones on the borderlands are not only linguistic, cultural, and social, but marked as well by sexual crossings and mixings. By unearthing the hidden history of miscegenation, the repressed history of interracial social and sexual relations, *Lone Star* appears to rewrite the new social order on the borderlands as racially mixed at its core, in sharp contrast to the Anglo-Texan imaginary, which constructs citizenship and/or membership in the Texas "nation" in terms of racially pure subjects. The filmmaker seems to provide viewers with a new, more enlightened vision of race relations; however, the film is also structured by a very old racial narrative, the story of miscegenation as a model of social inscription, whereby the white man's access to the brown woman's body is naturalized and in which the nation is grafted and etched onto the body of a woman.

There is a long tradition in Western thought of fixing the body of woman as allegory for land and nation, and it is by reading the motif of forbidden love in the film through this form of embodiment that we can gauge the significance of interracial love and sibling incest for cultural politics. The notion of the nation as "mother country" genders the nation as female and further naturalizes woman in her reproductive role as mother.[12] In the nation-building project, women's bodies mark the allusive boundaries of the nation, the race, and the family insofar as the patriarchal imaginary utilizes women's bodies symbolically and literally to shape national, racial, and familial identities. *Lone Star* follows in the patriarchal tradition of gendering the nation as female—a new fantasy of a multicultural nation figured on the body of a Tejana. However, the film also extends the symbolic fantasy to encompass racialized sexual relations. Just as the body of woman figures as allegory for the nation, so too does sibling incest function as allegory for race relations in Texas.

The reunited lovers serve as allegories for Chicana/o-Anglo race relations. Yet to the extent that Pilar and Sam share the same father, rather than the same mother, the film reconfigures race relations in Texas yet again in patriarchal terms, for the siblings derive the truth of their existence from the same paternal lineage, from a his-

tory metaphorized in patriarchal patrimony. And while the film attempts to render the truth of the entwinement of Chicana/os and Anglos through this allegorical brother-sister relationship, it is a partial and mystifying truth, privileging the father while rendering the mother invisible in the reproduction of Texas history.

The film therefore envisions sexuality as a transfer point of phallocentric power, insofar as miscegenation is grounded in the patriarchal colonialist fantasy of authorizing and privileging the white man's access to brown female bodies. For it is white men who cross racialized borders of gender, as in Buddy's illicit affair with Mercedes Cruz. Women in this narrative universe represent the subjects of hybridity, mixing, and sexual crossings on the borderland. The film further recycles racist, colonialist fantasies of interracial sexual relations, first by naturalizing and normalizing white male access to brown women's bodies while simultaneously prohibiting relationships between nonwhite men and white women. By excluding and denying the history of other forms of sexual relations, namely those outside of the white-male/woman-of-color paradigm, the film rearticulates and reaffirms the racist, colonialist interdiction against mixed-race unions between brown men and white women. As we know from the history of race relations, antimiscegenation laws were aimed primarily at nonwhite men and, in the guise of protecting white femininity from these sexual predators, were designed to ensure the racial purity of the white nation.

Ultimately, the narrative not only reproduces white masculine privilege, but also maintains whiteness intact, for unlike Pilar, Sam Deeds is not the product of miscegenation, of sexual contact between a white man and a brown woman. Sam is rather the embodiment of racial purity. As we learn in this climactic scene, the burden of miscegenation rests on his half-sister/lover, Pilar. As the offspring of a white man and a brown woman, the nation is indeed inscribed on her body. Pilar symbolizes the new social order of multiculturalism. From a feminist standpoint, this scene may be read as ambivalent, since Pilar's revelation that she can no longer have children affirms female libidinal energies and locates female sexuality in desire and pleasure rather than in reproduction. In the last instance, however, despite her infertility, as the sole subject of mixed-race parentage, woman embodies the borderlands, serving as the allegory for hybridity, racial crossings, and mixings. White

male access to the multicultural nation takes place through the body of a brown woman.

While *Lone Star* is the first film to represent the complexities of postcolonial Texas with some verisimilitude, much more is at stake than the film's agreement with a preexisting truth. In certain ways, the film's historical revisionism—its rewriting of the primal myth of the nation, its rejection of the absolutism of pure and authentic culture and of racial binarism—aligns *Lone Star* with the project of border theories. However, despite the fact that the film represents power relations on the borderland in terms of complicity, resistance, and domination, the ambivalence *Lone Star* produces differs from the profound ambivalence of critical border theory. In its analysis of asymmetrical power relations, border discourse recognizes that social relations cut across the axes of social identities (that is, class, gender, and so on). Yet this understanding is also linked strategically to a politics of transformation, to affecting social change and to a vision of a more egalitarian social order. There may indeed be no guarantees, but Tejana/o counterdiscourses are driven by a desire to disrupt social hierarchies as well as to alter the centrality of white heterosexual masculinity in the narratives of nationhood. And it is precisely on these grounds that the film's ideological project parts ways with critical border theory's efforts to rewrite the script of the nation. Irrespective of its overture to multiculturalism, *Lone Star* resituates white masculinity as the mediating term that is able to cross racial and sexual boundaries while erecting the borders of its own racial purity and masculine privilege.

other border-crossers: 1949

The discursive construction of the racialized woman as peripheral yet constitutive of the white masculine self not only elides and marginalizes the Tejana/o point of view in symbolic space but it recycles an available colonialist fantasy on the borderlands. Nearly half a century earlier, another image maker crossed the border into Mexican Texas, inserting Tejana/o bodies into representational space. This time, however, the Tejanas/os were actual rather than fictional people living throughout south Texas. And the image-maker was a documentary photographer.

* * *

Late in the afternoon on a hot, humid summer day in 1949, my mother, Lucia Orea, walked to the front of the Tex Mex Newsstand—the store owned by my grandparents in Corpus Christi. She had just sold a copy of the afternoon newspaper and was turning to help her younger brother, Agustin, pull the wagon-crate filled with empty bottles inside the store when an Anglo man carrying a large camera approached and asked if he could take their photograph. My mother and her younger brother both stood for several minutes posing beneath the store's canvas awning, the heat of the sun warming their faces as the Anglo prepared to take their photograph. He left without ever telling them his name, nor why he was taking their image with him.

My mother forgot about the incident until thirty-eight years later, when she received a phone call from a friend who had seen her photograph in the *Texas Monthly*. In March 1987, along with other photos of Tejanas and Tejanos, my mother's image appeared in an article featuring Russell Lee, a prominent documentary photographer who died in 1987. The photographs Lee took were part of a project called "The Study of Spanish-Speaking People," funded by the General Board of Education and the University of Texas. Unlike most of Lee's photographs, these on Tejanos were never published until after his death. According to the feature story, "there is some speculation that they were suppressed, because in Lee's unflinching views of poverty and racism he presented Texas with a vision of itself it did not want to see." As it turns out, we, Tejanas and Tejanos (Mexican-Texans) are the "other" side of the self Texas does not want to see. While some of the photos published in the *Texas Monthly* do depict the actual poverty of Tejanas/os, most do not, and in fact racism is not explicit in the images. The reader/viewer has to surmise that poverty is an effect of racism and segregation, since this interpretation is not conveyed directly by the content of the photos. Where racism does play a major role is in the actual suppression of the photographs insofar as it reproduces the erasure of Tejanas/os from "official" accounts of Texas history.

Texas as whiteness fills the entire frame of reference. Following the stylistic conventions of documentary photography of the thirties and forties (such as the photos of Walker Evans), the Russell Lee photographs render their subjects in their "natural" habitat.[13] Unlike portraiture, which emphasizes interior spaces, the subject's

interiority and individuality, the photographs of Tejanas/os taken by Russell Lee highlight the subject's exteriority, her/his environment. Lee's photographic naturalism inscribes Tejanas/os in otherness and alterity. Yet, despite this framing of Tejanas/os within a colonialist imaginary, an excess in the photographic images undermines a singular interpretation to the extent that the marginalization and elision of Tejanas/os from official historical records are subverted by the documentary evidence of their very presence in the public sphere.

These images of Tejanas and Tejanos, taken by Lee during the 1940s and published in the *Texas Monthly* forty years later, capture the very centrality of Tejanas/os to Texas history and culture: Tejanos engaged in all facets of public life, as active citizens and productive members of Texas society, selling their wares, participating in Church bingos and parades, reading newspapers and books, shining shoes, selling fruits and vegetables, mourning their dead in public. These photographic images conjure up a refusal of their invisibility, a rejection, on the part of Tejanas and Tejanos, of their erasure. The public presence of Tejana/os in the everyday life of Texas is what these pictures communicate, yet none of the Tejanos in these photographs are named, including my mother, whose picture appears above the generic caption, "Newsstand, Corpus Christi." And, while my mother, Lucia Orea, is clearly the central focus of the photograph taken nearly fifty years ago, as in the case of the other Tejanos, she remains misrecognized, framed outside of Texas history and culture, unnamed as subject, undocumented, even in her own image.

Together with Lee's photographic naturalism, captioning the photos in terms of generic events, objects, and situations produces an identity of alterity for Tejanas/os. While forced relations are evident in this attempt at portraying nameless bodies, every single photograph gives form and sense to its own component parts and to the relation of bodies with other objects in the world. Russell Lee was a border-crosser who inhabited the world of Spanish-speaking people for a brief moment, injecting their memories with his presence and sharing as well in the generalized visibility of a Tejana/o-Texan public culture.[14] What is absent from the visual frame is the perceiving mind, the subject of the gaze, as Merleau-Ponty writes: "He who sees cannot possess the visible unless he is possessed by *it*, unless he is of it, unless ... he is one of the visibles,

capable by a single reversal, of seeing them—he who is one of them" (quoted in Grosz 1994, 101).

In naming the gaze of white masculinity—the gaze of he who, since the Enlightenment, is normalized and naturalized as the unmarked and invisible subject—I am attempting to render his body visible as well. If, like in cinema, the photographic image attempts to elide the seer's angle of vision behind the lens, it is when we enter the image, inhabit the body of the seen, embody her memory, that we can remember the colonialist effect of border crossing: the entitlement and privilege of *he* who has constructed the bodies of others in *his* own image.

notes

1. In a high-speed chase on California freeways, Riverside county sheriffs pursued a pickup truck carrying Mexican border-crossers for eighty miles. As the truck pulled over and the immigrants attempted to flee, county sheriffs viciously unleashed their aggression, battering the Mexicans so severely that several were hospitalized. One of the victims, Alicia Sotero Vasquez, declared, "I was beaten worse than an animal."

2. For a critique from the Mexico side of the border of the "symbolic determinism" in postmodernist and poststructuralist appropriations of the "border paradigm," see Eduardo Barrera Herrera (1993). Other postmodern and poststructuralist uses of the term are found in Emily Hicks 1991; Iain Chambers 1990; Henry Giroux 1992; Trinh T. Minh-Ha 1991; Maggie Humm 1991; Bloom 1979a, 1979b.

3. Similar historicized/contextualized understandings of the border can be found in the work of the Mexican theorist García Canclini (1990), as well as in the writings, videos, and works of Mexican performance artist Guillermo Gómez-Peña, who is most credited for popularizing the Mexico-U.S. border paradigm beyond the inner circles of Chicana/o Studies in his essay, "The Multicultural Paradigm: An Open Letter to the National Arts Community" (1989). Even so, Barrera Herrera (1993) criticizes Gómez-Peña's postmodernist "symbolic determinism."

4. See Fregoso 1993; Yarbro-Bejarano 1994; Gutierrez-Jones 1995; José Saldívar 1997. See also the forthcoming works by Sonia Saldívar-Hull.

5. I thank my colleague Sarah Projansky for tempering my initial enthusiasm for the film and reminding me that the film does indeed center white masculinity.

6. This analysis has benefitted from many conversations with Tejanas/os, over the Internet, at parties, potlucks, and happy hours, over the telephone, and at conferences. These conversations have included Armando Peña, Ramón Saldívar, Rosaura Sánchez, Emma Pérez, José Limón, and Aida Hurtado among others. For a favorable theoretical reading of the film see the forthcoming article by José Limón. Film reviews of *Lone Star* include Maslin 1996; Petrakis 1996; Siskel 1996; Tarau 1996a, 1996b; West and West 1996a and 1996b.

7. In a book-length study, Norma Iglesias defines border cinema in terms of the following criteria: (1) the plot or significant portion of the plot

develops on the Mexico-U.S. border region; (2) the plot deals with a character from the borderlands region, irrespective of the setting; (3) the film refers to the Mexican-origin population living in the United States; (4) the film is shot on location in the borderlands, irrespective of the plot; (5) the story makes reference to the borderlands or to problems of national identity (Iglesias 1991, 17).

8. The U.S. film industry has made hundreds, perhaps (if one counts all of the one-reel silent films) thousands of films dealing with the U.S.-Mexico border. While they are too numerous to list, among the better know examples of the border genre films are *Licking the Greasers* (1914), *Girl of the Rio* (1932), *Bordertown* (1935), *Border Incident* (1949) *Touch of Evil* (1958), *The Wild Bunch* (1969), *The Border* (1982), *Born in East L.A.* (1987).

9. Norma Iglesias (1991) notes that between 1979 and 1989, 147 border-themed films were produced by the Mexican film industry.

10. This information is contained in the press packet distributed by Castle Rock Entertainment.

11. This observation was made by my colleague Sarah Projansky.

12. See Shohat 1990.

13. Some of Lee's other photographs of Tejanos/as are published in Ramón Saldívar 1990.

14. Working through the theoretical insights of Merleau-Ponty, Elizabeth Grosz adds: "To see, then, is also, by implication, to be seen." The implication of this insight goes beyond the fact of the potential reversal of the relations of seer-seen, "that is, an "interpersonal" relation. As Grosz explains it, Merleau Ponty's "point is ontological it is a claim regarding the seer's mode of existence...The seer's visibility conditions vision itself" (1994, 101).

works cited

1987. "A Human Focus," *Texas Monthly* 15, 3: 120–27.

Anzaldúa, Gloria. 1987. *Borderlands/La Frontera*. San Francisco: Aunt Lute Press.

Bernardi, Daniel. 1996. "The Voices of Whiteness: D.W. Griffith's Biograph Films (1908–1913)," in *The Birth of Whiteness: Race and The Emergence of U.S. Cinema*, ed. Daniel Bernardi. New Brunswick: Rutgers University Press. 103–28.

Canclini, Nestor garcia. 1990. *Culturas Hibridas*. Mexico, D.F.: Editorial Grijalbo.

Chambers, Iain. 1990. *Border Dialogues: Journeys in Postmodernity*. London: Routledge.

Derrida, Jacques. 1979a. "living On," in *Deconstruction and Criticism*, translated by jame Hulbert. New York: The Seabury Press. 75–176.

———. 1979b. "The Parergon," *October* (Summer), 3–21.

Flores, Richard. Forthcoming. *Remembering the Alamo: Memory, Modernity, and the Master Symbol*. Austin: University of Texas Press.

Fregoso, Rosa Linda. 1993. *The Bronze Screen: Chicana and Chicano Film Culture*. Minneapolis: University of Minnesota Press.

García Canclini, Nestor. 1990. *Cultural Híbridas: Estrategias para entra y salir de la modernidad*. Mexico, D.F.: Editorial Grijalbo.

Giroux, Henry. 1992. *Border Crossings: Cultural Workers and the Politics of Education*. New York: Routledge.

Gómez-Peña, Guillermo. 1989. "The Multicultural Paradigm: An Open Letter to the National Arts Community," *High Performance* 12, 3 (fall): 17–27.

Gray, Herman. 1997. "Anxiety, Desire and Conflict in the American Racial Imagination," in *Media Scandals*, ed. James Lull and Stephen Hiverman. Oxford: Blackwell. 85–98

Grosz, Elizabeth. 1994. *Volatile Bodies*. Bloomington: Indiana University Press.

Gutiérrez, Jones, Carl. 1995. *Rethinking the Borderlands: Between Chicano Culture and Legal Discourse*. Berkeley and Los Angeles: University of California Press.

Gutiérrez, Ramon. 1996. "The Erotic Zone: Sexual Transgression on the U.S.-Mexican Border," in *Mapping Multi-Culturalism*, ed. Avery F. Gordon and Christopher Newfield. Minneapolis: University of Minnesota Press. 253–62.

Herrera, Eduardo Barrera. 1993. "The U.S.-Mexico Border as a Paradigm of Post-NAFTA Mexico," Latin American Studies Consortium of New England, occasional paper no. 3, October 30.

Hicks, Emily D. 1991. *Border Writing: The Multidimensional Text, Theory and History of Literature*. Minneapolis: University of Minnesota Press.

Humm, Maggie. 1991. *Border Traffic: Strategies of Contemporary Women Writers*. New York: St. Martin's Press.

Iglesias, Norma. 1991. *Entre Yerba, polvo y plomo: Lo fronterizo visto por el cine mexicano*. Tijuana: El colegio de la fronternorte.

Limón, José. Forthcoming. "Tex-Sex-Mex: American Identities, Lone Stars and the Politics of Racialized Sexuality," *American Literary History*.

Maslin, Janet. "Lone Star: Sleepy Town with an Epic Story," *New York Times* (June 21).

Minh-ha, Trinh T. 1991. *When the Moon Waxes Red: Representation, Gender, and Cultural Politics*. New York: Routledge.

Moraga, Cherrie. 1983. "Preface," in *This Bridge Called my Back: Writings by Radical Women of Color*, ed. Moraga, Cherrie and Gloria Anzaldúa. Second edition. New York: Kitchen Table.

Pérez-Torres, Rafael. 1995. *Movements in Chicano Poetry: Against Margins, Against Myths*. New York: Cambridge University Press.

Petrakis, John. 1996. "A 10-Gallon Mystery from Deep in the Heart of Texas," *Chicago Tribune* (July 3).

Saldívar, José. 1997. *Border Matters: Remapping American Cultural Studies*. Berkeley: University of California Press.

Saldívar, Ramón. 1990. *Chicano Narrative: The Dialects of Difference*. Madison: University of Wisconsin Press.

Saldivar-Hull, Sonia. Forthcoming. *Feminism on the Borderland*. Berkeley: University of California Press.

Shohat, Ella. 1993. "Gender and Culture of Empire: Toward a Feminist Ethnography of the Cinema," in Otherness and the Media: The Ethnography of the Imagined and the Imaged, ed. Hamid Naficy and Teshome Gabriel. New York: Harwood Academic Publishing. 45–84.

Siskel, Gene. 1996. "Tension, Romance Highlight Well-Scripted 'Lone Star,'" *Chicago Tribune* (July 5).

Tarau, Kenneth. 1996a. "Human Relations the Star of Sayles' 'Lone' Mystery," *Los Angeles Times* (June 21).

Tarau, Kenneth. 1996b. "Master of the Possible: Director John Sayles Exhibits a Determined Vision," *Los Angeles Times* (May 13).

West, Joan, and Dennis West. 1996a. "Borders and Boundaries: An Interview with John Sayles," *Cineaste* 22, 3: 14–17.

———. 1996b. "Lone Star," *Cineaste* 22, 3: 34–36.

Yarbro-Bejarano, Yvonne. 1994. "Gloria Anzaldúa's Borderlands/La Frontera: Cultural Studies, 'Difference,' and the Non-Unitary Subject," *Cultural Critique* 28 (fall): 5–28.

eleven

"home is where the hatred is"

work, music,

and the

transnational economy

george lipsitz

Millions of people around the world no longer feel "at home" in their homelands; they flee the hatred at home to seek a better life someplace else, making displacement, exile, and homelessness common experiences. A brand of economic fundamentalism favoring "free" markets, low wages, high unemployment, slow growth, tight money, and devastating declines in social spending on health, housing, and education has forced people from their homes all around the globe. The structural adjustment policies of the World Bank, the International Monetary Fund, and economic elites everywhere have produced unprecedented concentrations of wealth and power for transnational corporations while relegating the vast majority of the world's people to a future marked by ever-increasing disruption, disorder, and social disintegration.

Transnational corporations now control one third of the world's private-sector assets. At the same time, nearly 30 percent of the world's workers—some 820 million people—are either unemployed or employed parttime at less than subsistence wages. In Latin America, Asia, and Africa as a whole, close to half a million children die every year from hunger or preventable diseases. The poorest 77 percent of the world's population earns only 15 percent of world income. The richest one-fifth of the world earns 150 times as much income as the poorest fifth, while the gap between the rich and poor in the Southern Hemisphere countries doubled between 1980 and 1990 (Gallin 1994, 106, 113, 114, 121; Budhoo 1994, 21, 22; Gershman 1994, 26; Bello 1994, 40, 52)

Under these conditions, migration makes sense. As Walden Bello argues, "Migrants are not obsessed nomads seeking the emerald cities, . . . they are refugees fleeing the wasteland that has been created by the economic equivalent of a scorched earth strategy" (Bello 1994, 19). Of course, the basic contours of this process have been in place for a long time. The creation of homelands and homesteads in industrialized countries has always depended upon the exploitation of displaced and dispossessed workers from somewhere else. Romances of patriarchy and patriotism promising secure, stable, and homogenous homes and homelands have drawn their cultural power as much from the necessity of hiding the heartlessness on which both hearth and *Heimat* have been built as from any explanatory or liberatory power of their own.

Economic fundamentalism and the austerity it imposes on workers around the world destabilize and disrupt traditional economic, political, and social relations. During the 1980s real wages in Mexico fell by 50 percent, while the share of that nation's income earned by working people declined from about 50 percent in 1981 to less than 30 percent in 1990. Structural adjustment policies suggested and supervised by the International Monetary Fund and the World Bank forced Mexico to make drastic cuts in its economic and social wages in hopes of attracting foreign capital. That capital flowed into the country, but Mexico's much-lauded "economic miracle" turned out to be a fraud; a small group of speculators made fortunes at the expense of the vast majority of the population. The North American Free Trade Agreement turned out to be a disaster for Mexican agriculture, while *maquiladora* zones made huge profits for multinationals but brought only low wages,

unsafe working conditions, and health hazards to its largely female workforce.

Confronted with the failure of their own policies, international financiers placed the blame elsewhere: first on the Zapatista uprising in Chiapas in 1994, and then on the pervasive corruption within the Salinas regime, an administration that previously received universal acclaim from these same sources. Ultimately, the U.S. government and international finance sponsored yet another peso devaluation and demanded even more austerity from the Mexican people as the price for restructuring the debt that had brought them these severe problems in the first place. In the context of these conditions, the historic migration of low-wage workers from Mexico to the United States takes on new significance and new meaning.

The new realities of migration and low-wage labor have been imperfectly represented in the political culture of California, but they appear in vivid relief in popular culture. One of the most visible and most important registers of demographic, economic, and political change has been registered in the popularity of *banda* music in sections of the state most settled by new migrants from Mexico. *Banda* music and the practices attendant on it signal a new cultural moment, one that challenges traditional categories of citizenship and culture on both sides of the border, that generates distinctive forms of social organization and style, of dance and dress, that speak to the unique and singular realities facing migrant low-wage workers in California at the present moment. Understanding the connection between this musical form and the social and political matrices that give it determinate shape depends upon an understanding of the historical and current dilemmas facing low-wage laborers from Mexico in the United States.

As a consequence of the labor shortages produced by Asian exclusion acts and the labor surplus made possible by railroad construction and the Mexican Revolution in the late nineteenth and early twentieth centuries, U.S. business leaders have long encouraged and profited from the migration of low-wage labor to the United States from Mexico (Sanchez 1993; Lowe 1996; Gutierrez 1995) Yet Mexican migrants have found repeatedly that while the United States wants their labor, it does not want them. Violent repression by the border patrol and the Immigration and Naturalization Service, as well as by state and municipal law enforcement

agencies has imposed a consistent reign of terror against people of Mexican origin in the United States. Workers crossing the border without documentation or those overstaying their work permits are dismissed as "illegal aliens," but private businesses and public agencies in the United States. routinely condone and even celebrate violations of law by employers—that is, violations of laws that mandate a minimum wage, safe working conditions, retirement benefits, and environmental protection. Contempt for Mexican culture, the Spanish language, and the rights guaranteed to people of Mexican origin in the United States by the 1848 Treaty of Guadelupe-Hidalgo are deeply ingrained in the history and culture of the United States.

Changes in the global economy, the stagnation of real wages within the United States, and the utility of racial scapegoating in U.S. politics has turned the traditional tensions along the U.S.-Mexico border into a prominent public issue. The militarization of the border by the U.S. government through a conscious strategy of low-intensity conflict along with repeated attempts to amend U.S immigration law have proceeded from a perception that ties the migration of low-wage workers to the United States from Mexico to a broad range of social problems including low wages, high taxes, welfare costs, terrorism, drug dealing, disease, and violent crime (Dunn 1996).

During the 1992 Los Angeles riots, more than four hundred out of a total of one thousand federal law enforcement agents sent to quell the rebellion came from the border patrol. These agents poured into neighborhoods inhabited by recent immigrants, rounded up more than a thousand undocumented workers, and designated them for deportation, whether they had been involved in the riots or not. The large numbers of Latinos among those arrested enabled opponents of immigration to place part of the blame for the insurrection on "illegal aliens." Two years later, California governor Pete Wilson overcame extremely low voter approval ratings of his performance in office by connecting his campaign for reelection to Proposition 187, a ballot initiative designed to deny medical care and education to undocumented immigrants and their children and to require schoolteachers and nurses to turn in "suspected" illegal immigrants to the government. Wilson's success at making immigrants scapegoats for California's economic and social problems encouraged other politicians

to advocate even greater repression and suppression of the migrant population through measures such as federal welfare reform, which denies many benefits even to legal immigrants. Wilson, on the other hand, vetoed a bill that would have made retailers responsible for selling products obtained from illegal sweatshop labor, and his administration refused to enforce laws regulating wages, hours, and working conditions by employers taking advantage of immigrant labor. At the same time, he opposed efforts to raise general wage rates above the level paid to undocumented workers.

The power and greed of big business interests in Mexico and the United States stands behind the migration of low-wage labor to California. Displaced from their homes by structural adjustment policies, NAFTA, and peso devaluation, Mexican migrants to California find hatred both at home and in exile. But it is also important to acknowledge that some people have the homes they do precisely because others are forced to live far from home. In California, for example, the immigrants who were demonized and derided as parasites by the successful 1994 campaign to pass Proposition 187 actually do much of the hard work on which California's standard of living depends. These low-wage workers clean yards, pools, offices, hotel rooms, and homes. They plant, trim, and clear trees. They tile, drywall, and plaster new homes, and they lift, move, and haul heavy objects on construction crews. They plant, harvest, prepare, and serve food. They care for other people's children. They sew clothes they cannot afford to buy. They find themselves hated for their hard work, made scapegoats for the harm done to life chances in California by the transnational economy, even though that economy victimizes them much more than it does the middle-class or wealthy employers whose standard of living depends upon the low-wage labor of immigrants.[1]

In 1992 Spanish-language station KLAX 97.9 astonished its competitors by becoming the top-rated radio station in Los Angeles, the nation's most lucrative market, by programming a steady rotation of *banda* music. No Spanish language station in the city had ever enjoyed this level of success before. KLAX attracted a market share of 5.3 percent during the fall 1992 ratings period, 7.2 percent during winter 1993, 5.7 percent during spring 1993, 6.6 percent during summer 1993, and 7.0 percent during fall 1993. (Haro and Loza 1994, 60). Nationally syndicated radio personality Howard Stern charged

that the ratings agencies had made a mistake, that the ratings cred-
ited to KLAX really belonged to those he earned through daily
broadcasts on a station with similar call letters, KLSX. But Stern
was wrong KLAX attracted an average of 1,114,500 listeners at any
given time, making the station one of the most successful radio
outlets of all time. In fact, given the biases in radio survey methods
which tend to overrepresent individual Anglo listeners, it seems
very likely that "La Equis" is even more popular than the ratings
indicate.

Propelled by the popularity of *banda* music, advertising revenues
at KLAX grew from $4 million in 1990 to $20 million in 1993. While
these amounts remain far less than advertisers pay to reach more
affluent demographics, they do reflect increasing appreciation of
the economic implications of demographic change. KLAX moved
from number twenty to number one among Los Angeles radio sta-
tions with its *banda* format, increasing its share of the listening audi-
ence from 2.0 to 5.2 percent during the quarter that it began to
program this music, which originated in rural regions of the states
along Mexico's Pacific Coast and contains strong traces of the polka
and parade music that European immigrants helped bring to Cen-
tral America in the nineteenth century (Puig 1994, 24). At the same
time, *banda* programming enabled KLOK in San Jose in northern
California to increase its ratings from 1.2 to 2.3 (Boehlert 1993, 1).
Actual sales of *banda* cassettes and compact discs are hard to track
because so many of them are sold outside the stores in suburban
malls that provide the basis for the music industry's Scantron
accounting system, but the album *Casimira* by *Banda Machos* has sold
at least 300,000 units in North America—an astounding total for
music from Mexico with Spanish-language lyrics. (Gonzales
1993, B1).

The sudden and unexpected popularity of *banda* might seem like
simply the latest postmodern hybrid, a story about music with a
long history in one location succeeding as a novelty in another.
One could use the popularity of *banda* to argue for the increasing
irrelevance of place—as a significant part of daily life in Los Ange-
les reflects the rhythms of rural Mexico, while a defining moment
in Mexican culture draws its power and force from what happens
in California. But like Dominican *merengue* in New York, Peruvian
chicha in Lima and Arequipa, or the Afro-Cuban music played
largely by Puerto Ricans throughout the hemisphere called *salsa*,

banda music has emerged as a subtle and significant register of the dislocation of low-wage labor, as a complex site where identities appropriate to dramatically new political, economic, and social realities are in the process of being created and deployed.

The morning drive-time show at KLAX, the station's highest-rated program, featured not only *banda* music, but also the humor and social commentary of Juan Carlos Hidalgo and Jesus Garcia. Hidalgo initially entered the United States illegally in 1984 from his native Michoacan, hidden in the spare tire compartment of a station wagon (Puig 1994, 24; Hayes-Bautista and Rodriguez 1994, 10). He worked in the fields near Oxnard picking strawberries before enrolling in a Spanish language broadcasting school in 1987 that prepared him for a career in radio. Garcia, who plays Juan Carlos's comic sidekick, "El Peladillo," also comes from Michoacan. He attempted to cross the border illegally twice and was caught and returned to Mexico each time. But desperate economic conditions in Michoacan motivated him to keep trying; on his third effort he made it across the border and secured work picking avocados and working parttime at a Thrifty Drug store before being pulled into a radio career by Hidalgo, who met him at a Halloween party (Puig 1994, 26).

Garcia adopted his name and the persona of his radio character, El Peladillo—"the little rascal"—from a routine by the legendary Mexican comic Mario Moreno, known as Cantinflas. In their comic routines, Juan Carlos and El Peladillo addressed controversial issues from the standpoint of their largely immigrant and working-class listeners. "When there are problems in the community, like in the case of Governor Wilson attacking immigrants, we don't have, as we say, hair on our tongues keeping us from telling the truth," Hidalgo explained (Hayes-Bautista and Rodriguez 1994, 10). At one point a representative of the Governor's office asked for the opportunity to come on the program and talk about all the good things that Wilson has done for Mexican-Americans, but Hidalgo and Garcia declined the offer because they claimed there were no good things to talk about. "He's using immigration like a political campaign for publicity," Hidalgo retorted. "How can the Governor talk about these people when they provide the food on his table? They're humble, but they pay taxes like everyone else" (Puig 1994, 26).

With their morning program, Juan Carlos and El Peladillo provided a common frame of reference for working class Latinos in Los

Angeles. In a city characterized by dispersed development and which leaves people dependent upon private transportation, radio serves a particularly important role in defining public space. The KLAX on-air personalities delivered audiences to advertisers by entertaining listeners with comedy routines and *banda* music, but they also shaped and reflected the consciousness of community coming into being. In so doing, they drew on a long tradition. As far back as the 1920s, Pedro Gonzales provided information about jobs and ideas about society to the largely Mexican immigrant audience listening to his 4 A.M. to 6 A.M. broadcasts on KELW in Burbank. His political radicalism and mass popularity so worried Anglo elected officials that they harassed Gonzales off the air and railroaded him into prison on trumped-up charges. Yet radio remained an important force in community life; labor organizers from the Congress of Industrial Organizations broadcast appeals to Mexican-American workers in Spanish and in English on a twice-weekly Spanish radio hour throughout the 1930s (Sanchez 1993, 184, 233)

Banda music itself, also has a history, originating in the nineteenth century. It has been consistently popular in some Mexican states—Sinaloa, Nayarit, Jalisco, and Michoacan. Traditional ensembles in those regions play exclusively instrumentals, featuring tubas and bass drums that provide the rhythmic base for the dominant brass and woodwind instruments (Haro and Loza 1994, 61) The *banda sinaloense* enjoyed popularity within Mexican popular music as early as the 1940s, but it was not until the late 1980s that *banda* songs began to attain broad popularity when bands started to feature vocals, replace the tuba and bass drum with the electric bass, modern drum sets, and *timbales*, and add the sounds of a synthesizer, which made it possible to scale down the size of *banda* groups from sixteen to six or seven. These changes allowed for the development of a new style, techno-*banda*, that combined elements of rock and roll with traditional *banda* practices such as playing all the instruments simultaneously at strategic points in songs to generate energy and excitement (Haro and Loza 1994, 62, 63; Loza 1994, 55).

The lyrics of *banda* songs rarely address political or social issues, although on their best-selling album *Casimira*, Banda Machos, a twelve-member ensemble from Jalisco, did feature the song "Un Indio Quiere Llorar" (The Indian wants to cry) about a man rejected by his lover's wealthy and non-Indian family because of his humble background (Gonzales 1993, B1). The band's next album

featured the song "Sangre de Indio" (Blood of an Indian) detailing the struggles of indigenous people who make up such a large proportion of the people in poverty in Mexico. Many *Banda* groups (including Banda Machos) display more dark faces (and more Indian faces) than generally appear in popular music groups from Mexico; but the politics of *banda* lies less in its lyrics or the identities of its stars than it does in the social world and social relations that it has helped create.

Throughout southern California, *banda* dances draw large crowds of working-class immigrants and native-born Mexican-Americans who dance the *quebradita*—the "little break," named after a dip that the dancers perform at a dramatic moment in the music. In most cases couples execute the "little break" by having the male partner dip the woman backward almost to the floor and then guide her back up quickly. This athletic move requires physical strength and flexibility; it depends upon timing and demands cooperation. Many dancers cannot actually do the *quebradita* because it is difficult and dangerous, so dancing *banda* often means dancing *el zapateado* (a heel-and-toe stepping dance), as well as cumbias, polkas, and waltzes (Haro and Loza 1994, 16). The *quebradita,* however, has emerged as an important icon of the present moment, as a physical gesture that encapsulates complex social relations and calls a community into being through performance.

In Los Angeles alone, more than thirty thousand enthusiasts belong to more than eight hundred *quebradita* clubs staging parties and dances every weekend at private homes, union halls, warehouses, and parking lots all over the Los Angeles area (Seo 1994, 1A). The members of these voluntary social organizations forge collective identities by naming their clubs after their favorite songs, designing club logos and costumes, raising and dispensing money, staging rivalries with other clubs, running for office, and planning, promoting, and supervising social gatherings. They appropriate private spaces for public purposes and produce a new cognitive map of Mexicano Los Angeles, one no longer centered solely in the East Los Angeles barrios, but spread throughout the south, central, and southeast urban and suburban neighborhoods that house so many of the new migrants. The friendly rivalries and festive gatherings facilitated by *banda* encourage physical movement across neighborhood boundaries, making visible and immediate the potential social and political unity that might one day be forged from diverse

elements of the community. Movement constrained by police surveillance, by the physical isolation of poor neighborhoods and the lack of public transportation, and by violent rivalries between competing gangs becomes easier because of *banda*.

The social world called into being by *banda* creates discursive as well as physical practices, especially through dress and performance. *Banda* artists and audiences favor *vaquero* (cowboy) styles— Stetson hats (called *tejanos*), fringed jackets, leather boots, and jeans. This clothing flaunts the foreign and rural origins of many immigrants, turning what might seem a source of shame into a point of pride. The titles of instrumental numbers and the lyrics of vocals often refer to the rodeo or to life on the ranch, and dancers frequently carry a *cuarto*, a small horsewhip. Women generally wear tight-fitting jeans or western skirts, belts with big buckles, black stretch tops, and cowboy boots. Men characteristically dress in button-fly jeans, fringed leather vests, straw or felt cowboy hats, and shiny boots. *Quebradita* dancers drape their rear pockets with *correas* (leather straps) engraved with the name of their home state in Mexico, often Michoacan, Colima, Zacatecas, or Jalisco, and more recently Oaxaca, Guererro, Sinaloa, and Puebla. Those who can't afford a *correa* use folded white bandanas with their state's name embroidered on them in green and orange to simulate the colors of the Mexican flag.

These practices affirm an intense affiliation with regional and national identities that have become tremendously important to migrants living in the United States. Using the names of Mexican states registers the massive displacements in that country's national life caused by economic crisis since 1982, by subsequent structural adjustment policies, by the collapse of Mexican financial markets in 1987, and by the adoption of NAFTA in 1993 and its ruinous consequences for Mexican agriculture. Driven to exile by desperate conditions in their native land, Mexican migrants to Los Angeles perform arduous low-wage labor that undergirds the prosperity of California's middle-class and wealthy residents, but they often find themselves reviled and despised by politicians and media commentators. In a country that does everything it can to let them know that being Mexican is a mark of shame, they proudly flaunt rather than hide their foreign origins, seeking solidarity in numbers and catharsis in aggressive festivity.

"It's almost like a response, a backlash, if you want to call it,

against the anti-immigration rhetoric," argues Steven Loza, a distinguished musicologist who for years has chronicled the history of music made in Los Angeles by people of Mexican origin (Martinez 1994, 12). The sixteen-year-old president of Club Dos Amantes, an East Los Angeles *quebradita* organization, told a reporter in 1993 that previously she listened mostly to music by pop star Michael Bolton and rap artist Ice Cube, but she was converted to *banda* after discovering Banda Machos, Banda Superbandidos, and Banda R-15. "I used to be embarrassed by my heritage," Sully Camarillo explained. "If someone played a Spanish song, I'd be like 'Take that off.' But now? I never listen to English music. All I listen to is Spanish, Spanish, Spanish. Banda. And that's about it" (Rochlin 1993, V5). One aspect of KLAX's popularity that particularly surprised media watchers in Los Angeles came from the station's success in winning young listeners away from stations programming rock music and hip-hop, reversing the expected movement away from ethnic culture toward the "mainstream."

Mexican-American life and culture in the United States has been characterized by tensions between citizens and immigrants for ninety years. Conflicts between desires for assimilation and insistent loyalty to Mexico, choices between strategies stressing political action and especially voting in the United States, and strategies based upon exile participation in Mexican politics have existed for years. Conceptions of the southwestern United States and Mexico as one unified region only artificially divided by the imposition of national borders have held sway with some (Gutierrez 1995). The identification with the Spanish language, with Mexican culture and imagery, and with Mexican music expressed in *banda* by U.S. citizens of Mexican origin represents a powerful rejection of assimilation, or at least a recognition of the need for unity and solidarity among Mexicans and Mexican-Americans in the face of a culture, political system, and economy that work inexorably against their interests.

Quebradita clubs, however, reflect emergent as well as residual realities; their activities do not address life in Mexico as much as they speak to what it means to be Mexican in the United States. For example, the lettering on T-shirts proclaiming names of clubs named after banda songs such as "Vaqueros Nortenos," "Casimira," and "La Herradura" follows the style of graffiti writers in Los Angeles and other North American cities (Martinez 1994, 10). The music played for people who "dance *banda*" includes more than *banda*.

Especially in Los Angeles, one hears techno, house, and rock as well as *merengue, bolero, ranchera,* and *cumbia* at dances. But these mixtures display what Juan Flores calls "branching out"—a fusion of cultures and styles that has little to do with assimilation into an Anglo center (Martinez 1994, 12). For Griselda Mariscal, a Chicana activist born in L.A. and educated at Belmont High School and Occidental College, the *quebradita* fuses Chicano and Mexicano identities. She dances banda with a *panuelo* celebrating the state of Nayarit where her father was born. "*Quebradita* is a way of showing you can be into your culture," she explains. "To me it's a way of holding your head up high. It says that I am in college because of the strength of my culture, because of the sacrifice of *mis papis, mis abuelitos*" (Martinez 1994, 10).

Banda helps create new social spaces and ritual practices. Like all distinctively ethnic dance music, it serves as a site for collectivity and mutuality. Through common costumes and collective synchronized motion it transforms individuals into a community. Spanish language lyrics and horn-heavy instrumentation evoke the sounds of Mexico, eclipsing the attention formerly given to U.S. songs sung in English and accompanied mainly by electric guitars. Tight clothes and close dancing encourage erotic desire while demonstrating physical and emotional control. *Banda* performances evoke a sense of unity and power, as ensembles onstage wave their instruments back and forth in time to the music and jump up and down in unison with leather fringes flying, surrounded by smoke and dramatized by lighting effects usually associated with heavy-metal concerts or other spectacles. References to regions of origin in Mexico underscore the heterogeneity of the group's histories while at the same time marking their newfound collectivity as something exceptional and unprecedented. The recognition of different regions allows unity with diversity. It uses traditional symbols and historical memories to unite people with different backgrounds, but who feel a strong commonality about what they face together in the present.

Banda dances conform to José Limón's description of Chicano dancing in Texas (building on the work of Frank Manning) as "an intensive, concrete, but temporary assertion of various kinship ties" in the face of continuing kinship stress and breakdown, as well as a "symbolic statement of wholeness and integrity in the face of external threats" (Limón 1983, 238). *Banda* bears the burden of making

sense out of terrifying changes. It arbitrates the tensions created by the disruptions of life in rural Mexico brought on by peso devaluation, NAFTA, and structural adjustment policies. It speaks to the stress in relations across genders and generations created by the imperatives of migration, resettlement, and low-wage labor. It offers symbolic solutions to real problems and provides rituals for repairing ruptures in the social fabric.

For workers engaged in desperate competition for jobs, for young people often drawn into violent conflicts over urban territory and turf, for laborers who must move from place to place constantly, *banda* creates a site for solidarity. *Quebradita* clubs engage in playful rituals like "baptizing" members of another club at parties by pouring champagne on them, an act meant to symbolize friendship between two groups. For some young people, *banda* dances provide an alternative to gang fighting. "I've been shot in the chest and leg, and I've lost a lot of friends to gang fights," relates eighteen-year-old Sergio Castellanos, president of the club Orgullo Maldito. "So when I moved to Huntington Park, I didn't want to be in anything gang-related. Instead of being out on the streets killing people, a lot of gang members are now in clubs having fun, meeting people and dancing" (Seo 1994, A16). Imelda Flores of the Club Invasion Musical recruited several members of her club from gangs, telling them, "In a way it's the same thing: we act like a big family, we take care of each other. The difference is that they won't always have to be watching their backs" (Rochlin 1993, V5).

Quebradita dancing soothes ruptures across generations as well as within them. In the United States, where advertisers and media programmers routinely divide family members into separate markets segmented by age and gender, the mixed-age demographics for *banda* display an intergenerational solidarity that is unprecedented within North American commercial culture. "La Equis" secured its number one rating in the Los Angeles radio market by scoring first among adults ages 25 to 54, but also by securing status as the second most popular station among teenagers. (Hayes-Bautista and Rodriguez 1994, 10). KLAX drew listeners away from Latin Pop and other formats on Spanish-language stations, but it also made significant inroads among young listeners who previously preferred Top-40 rock music or hip-hop (Boehlert 1993, 1). Nineteen-year-old Imelda Flores of the Club Invasion Musical attends *banda* dances with her forty-year-old mother and her three-year-old sister (Rochlin 1993, V5).

While *banda* creates new forms of unity, it also plays a part in per-petuating and preserving old divisions. Lyrics to *banda* songs are often misogynist, while female musicians play only a minimal role in the genre. *Ranchera* singer Carmen Jara has recorded *banda* albums; vocalist Angelica Maria has been accompanied by *banda* music; and Rosalva secured success in the Los Angeles with a nov-elty hit about the part of a woman's body most prominently dis-played by tight jeans, "La Chica de las Caderas." But the performers in *banda* are usually men, and the lyrics of songs reflect a distinctly gendered view of the world. The overwhelmingly male composi-tion of *banda* ensembles, the self-pitying romanticism and outright sexism of the lyrics of many banda songs, and the dangers that women face from the open eroticism of *quebradita* dancing and the gender politics of the dance floor raise serious questions about the distribution of *banda*'s benefits across genders.

In his studies of Texas-Mexican popular music, José Limón has cautioned us not to ignore the gender hierarchies of popular music, not just in the lyrics of songs or the identities of artists, but in what it means for women when a community's most important social sites mix dancing with drinking, sexual cruising, and the fighting that frequently occurs when a man decides to take "the race and class war within oneself, perniciously transform it into 'manhood,' and sometimes inflict it upon other men—perhaps on the slight pretext of a bump on the dance floor or a prolonged stare at one's woman." Limón observes that "in the sudden violence of a fight, we see the ultimate disarray, the sometimes too final frag-mentation, in the continually fragmented lives of these people" (Limón 1994, 164). In the face of urban austerity, disintegrating social networks, increases in opportunities for female workers, and the stagnation and decline of male wages in many parts of the world, working-class musics in many places express increased dis-paragement of women. From North American hip hop to Domini-can *bachata*, male bragging about violence, illicit sex, and substance abuse has been an increasing feature of the lyrics of popular songs (Pacini Hernandez 1995, 12–13; Kelley 1994, 183–227)

Banda is not immune from these tendencies, but it actually dis-plays them less than comparable musics among other urban work-ing-class cultures. The location of *banda* events in backyards, business parking lots, and private homes combats the exclusionary nature of

clubs with high admission prices and provides less emphasis on consuming alcohol than is the case in commercial clubs. The presence of people of all ages and the emphasis on representing one's region honorably undermines tensions that might otherwise lead to fights. But most important, the need for community solidarity in the face of external brutality and contempt has thus far worked to build an extraordinary sense of collectivity that escapes the worst features of other forms of popular festivity and celebration.

Although rooted in the musical traditions and social conditions of rural Mexico, the *banda* music played in the United States. is not a revival of folk forms, but more an adaptation of them to new circumstances. Recent *banda* recordings have fused *banda* styles with popular North American melodies and lyrics like "Pretty Woman," "Land of a Thousand Dances," and "The Night Chicago Died." In fact, *banda* has emerged as a form of sampling that allows artists and arrangers to produce versions of a broad range of popular tunes including "Gloria," "The Banana Boat Song (Day-O)," "It's a Heartache," "Take Me Home, Country Roads," "Diana," "Judy in Disguise," and—for better or worse—"Itsy Bitsy Teenie Weenie Yellow Polka Dot Bikini." As a hybrid music fusing Mexican and U.S. cultural memories, *banda* helps its listeners negotiate new identities by fusing them together in symbolic form in culture. As twelve-year-old Karen Velasquez, an immigrant from Colima, explained to a Los Angeles reporter, "I like dancing *quebradita* because it reminds me of Mexico and this is the dance of Mexico and Los Angeles. It's a combination of the two. When I'm dancing, it makes me feel happy" (Quintanilla 1993, E3).

Velasquez's comment underscores an important aspect of *banda*—its identity as a diasporic product popular in its country of origin. Of course, there were Mexican bands popularizing *banda* in the 1980s, but the popularity of the *quebradita* and the subcultural practices that accompany it broke first in the United States., and then in Mexico. Its presence on Mexican television and its success in music sales in that country are unusual developments, given monopoly control over Mexican media and that nation's traditional antipathy bordering on contempt for the cultural creations of immigrants from Mexico in the United States.

We cannot understand the production, circulation, and reception of *banda* in isolation from the ways in which the new transna-

tional economy and the migration of low-wage labor has refigured the meanings of neighborhood and nation, of the local and the global, of culture and class. *Banda* music is no longer solely the music of rural Mexico, but it uses the cultural fusions of the nineteenth century to speak eloquently to conditions created by transnational capital at the end of the twentieth century. We can understand the logic of *banda* as a cultural phenomenon by looking at the logic of low-wage labor and its cultural contexts in Southern California's construction industry and its immigrant drywall workers.

Banda music may be the last major musical craze of the twentieth century or part of the first wave of musical innovation in the twenty-first century. But its emergence has everything to do with the historical moment in which it came to the fore. The same year that KLAX made history with its *banda* format, thousands of undocumented drywall workers in Southern California made history of their own through collective mass action that reflected many of the features prominent in the reception of *banda*.

California's contractors and builders reaped a bonanza during the construction boom in California during the 1980s, in part because they used nonunion immigrant labor to drive down the costs of building. Wages for drywall workers, for example, fell from eight cents per square foot in the 1970s to about four cents per square foot in the 1990s. One in four southern California drywall workers were Mexicans when the job was unionized and high-paying, but when contractors broke the union and lowered wages, Mexicans accounted for nine out of ten drywall workers (Farrem 1992a, B8; Flagg 1992, D5). By the early 1990s, drywall workers earned only $250 to $300 for a six day week of heavy and hard work with no medical benefits, no retirement benefits, and no vacation pay. Because many of the workers were undocumented migrants, cash pay predominated in the industry, allowing employers to pocket as much as $2 billion a year in income taxes, Social Security, and workmen's compensation payments. In addition, knowing that workers who could be deported are in no position to complain about violations of minimum wage and hour laws or environmental regulations, employers regularly mistreated drywall workers, sometimes even refusing to pay them for work they had already performed (Flagg 1992, D5).

In May 1992 more than a thousand drywall workers went on

strike. They had no union to represent them and could not avail themselves of NLRB protections; and many of them were not even citizens. Yet they drew upon regional and family connections—hundreds of them came from one village, El Maguey in Guanajuato—to fuse an impressive sense of solidarity. They displayed the Mexican flag on picket lines, turning the stigma attached to their nationality into an emblem of pride (just as high-school students protesting Proposition 187 used the Mexican flag as an icon of shared identity in 1994). Through aggressive picket lines at suburban construction sites, imaginative disruptions of traffic based on driving slowly on crowded freeways, and individual and collective acts of violence to enforce picket lines and stop production, they created a crisis for the southern California housing industry, for law enforcement officials, and even for commuters. Their solidarity attracted attention and allies. Grassroots pressure from their memberships drew previously uninterested third parties (such as the leaders of construction unions and the Catholic Church) into the fray on the side of the strikers.

In August, attorneys for the strikers filed suit in federal court publicizing a fact well known among workers—that subcontractors had skipped out on legally mandated overtime payments to hundreds of drywallers. This move exposed employers to the direct financial threat of having to pay millions of dollars in back pay to workers, but it also provided a great equalizer in the war of words. Journalists had previously framed the dispute as a battle between tax-paying "American" businesses and unruly "illegal aliens." But the August 1992 federal court filing threatened to invert these icons, to expose the employers as tax-evading "illegals" profiting from the vulnerability of hard-working people seeking a decent life for themselves and for their families. Faced with negative publicity, with the prospect of having to open their books and run the risk of revealing other violations of federal and state laws, and with potentially escalating picket-line violence and vandalism, building industry officials granted union recognition (through the Carpenters Union) and medical benefits to the strikers. Even though subsequent actions by both organized labor and management as well as specially targeted harassment from the Immigration and Naturalization Service threatened to undermine the victory they had won, the solidarity of the drywall workers resulted in an important vic-

tory in a tactical situation where a common culture and class solidarity constituted two of the very few resources at their disposal (Flagg 1992a, D5; Stokes 1994, B4).

In their reliance on regional identities and their strategic deployment of the Mexican flag to flaunt their marginality in the United States—but turn it into a strength at the same time—the drywall workers drew upon many of the same cultural dynamics informing *banda* music. In fact, as demonstrated by Fred Lonidier's 1994 video for Labor Link TV—*Los Drywalaros: Huelgistas*—*quebradita* dancing and banda music played a vital role in the everyday lives of the drywall workers, as a diversion on picket lines and as a central component of off-hours recreation. Looking for neither a return to an idyllic homeland nor assimilation into a society hostile to them and their culture, they nonetheless fabricated a social world capable of transforming their lives. *Banda* groups such as Banda Machos, whose members have worked on both sides of the border, come from the communities they sing for and sing to (Haro and Loza 1994, 69). The Mexican identity invoked in *banda*, in student demonstrations against Proposition 187, and in the drywall strike revolves around being Mexican in the United States. It asks nothing of the Mexican government and has no real corollary within Mexico. It is not so much a nationalism connected to the nation-state, but rather an icon of national identity that becomes all the more important as an active social force at a moment when nation-states appear powerless to combat the imperatives of transnational capital and when the categories of national citizenship do nothing to protect the rights of low-wage laborers.

In their aggressive festivity and their insistence on celebrating a recombinant Mexican identity inside the United States, drywall strikers and *quebradita* dancers alike express in culture the slogan that Mexicanos and their supporters chanted in mass mobilizations against Proposition 187 and other anti-immigrant measures: *Aqui estamos, y no nos vamos* [We're here, and we're not going away]. Unfortunately, the same is true for the transnational economy that frames the circumstances in which they find themselves. It remains to be seen how soon the rest of us will learn what the drywall workers learned well: that the transnational economy and the people who profit most from it are creating a world where no one can feel at home because the hatred is everywhere.

note

I thank Lisa Lowe for calling this relationship to my attention in her presentation at the 1992 Minority Discourse Conference in Los Angeles, the 1992 Modern Language Association Meetings in San Diego, and her indispensable book, *Immigrant Acts* in 1996.

works cited

Bello, Walden. 1994. *Dark Victory: The United States, Structural Adjustment and Global Poverty.* London: Pluto Press.

Bellow, Walden. 1994. "Global Economic Counterrevolution: How Northern Economic Warfare Devastates the South," in *50 Years Is Enough: The Case Against the World Bank and the International Monetary Fund,* ed. Kevin Danaher. Boston: South End.

Boehlert, Eric. 1993. "Banda Machos Takes Old Sound to New Heights," *Billboard* 105, 16 (April 17).

Budhoo, Davison 1994. "IMF/World Bank Wreak Havoc on the Third World," in *50 Years is Enough: The Case Against the World Bank and the International Monetary Fund,* ed. Kevin Danaher. Boston: South End.

Dunn, Timothy. 1996. *The Militarization of the U.S.-Mexico Border, 1978–1992.* Austin: University of Texas Press.

Farrem, Julie. 1992. "Drywallers Protest in Loma Linda," *San Bernardino County Sun* (June 27).

Flagg, Michael. 1992a. "Southland Drywall Hangers Hold Out in Hope of Nailing Down a Union," *Los Angeles Times* (July 5).

———. 1992b. "Unions Get A Wake-up Call as Drywallers Achieve an Unlikely Victory," *Los Angeles Times* (July 5).

Flores, Juan. 1989. "Que Assimilated Brother," *Journal of Ethnic Studies* 13, 1.

Gallin, Dan. 1994. "Inside the New World Order," *New Politics* (summer).

Gershman, John. 1994. "The Free Trade Connection," in *50 Years Is Enough: The Case Against the World Bank and the International Monetary Fund,* ed. Kevin Danaher. Boston: South End.

Gonzales, Christine. 1993. "Banda Rides Wave of Hispanic Pride," *Wall Street Journal* (October 4).

Gutierrez, David. 1995. *Walls and Mirrors.* Berkeley: University of California Press.

Haro, Carlos Manuel and Steven Loza. 1994. "The Evolution of Banda Music and the Current Banda Movement in Los Angeles" 10, in *Selected Reports in Ethnomusicology,* ed. Steven Loza. Department of Ethnomusicology and Systematic Musicology, University of California.

Hayes-Bautista, David, and Greg Rodriguez. 1994. "Technobanda," *New Republic* (April 11).

Kelley, Robin D. G., 1994. *Race Rebels Culture, Policies, and The Black Working Class* (New York; Free Press), 183–227.

Limón, José. 1994. *Dancing With the Devil: Society and Cultural Poetics in Mexican-American South Texas.* Madison: University of Wisconsin Press.

———. 1983. "Texas-Mexican Popular Music and Dancing: Some Notes on History and Symbolic Process." *Latin American Music Review,* 4.

Lowe, Lisa. 1996. *Immigrant Acts: On Asian American Cultural Politics.* Durham: Duke University Press.

211

Loza, Steven. 1994. "Identity, Nationalism, and Aesthetics Among Chicano/Mexican Musicians in Los Angeles," in *Selected Reports in Ethnomusicology* 10, ed. Steven Loza. Department of Ethnomusicology and Systematic Musicology, University of California.

Martinez, Ruben. 1994. "The Shock of the New," *Los Angeles Times Magazine* (January 30).

Pacini Hernandez, Deborah. 1995. *Bachata: A Social History of a Dominican Popular Music.* Philadelphia: Temple University Press.

Puig, Claudia. 1994. "Banda," *Los Angeles Times Magazine.* (June 12).

Quintanilla, Michael. 1993. "Que Cool," *Los Angeles Times* (June 16).

Rochlin, Margy. 1993. "Loud and Proud," *New York Times* (July 25).

Sanchez, George 1993. *Becoming Mexican American: Ethnicity, Culture, and Identity in Chicano Los Angeles, 1900–1945.* New York: Oxford University Press.

Seo, Diane 1994. "Dancing Away From Trouble," *Los Angeles Times* (February 3).

Stokes, Sandy. 1994. "INS Picking on Drywallers, Leader Claims," *Riverside Press-Enterprise* (March 22).

by the

bitstream

twelve **of babylon**

cyberfrontiers

and

diasporic vistas

ella shohat

Two of Hollywood's superproductions for the summer of 1995, *Congo* and *Pocahontas*, encapsulate some of the paradoxes I hope to highlight in this chapter. Haunted by atavistic images, *Congo's* futurist trip to Africa focuses on the scientific mission of a tree-hugging Berkeley professor, who is returning to Africa his well-educated gorilla, named Amy, who dreams of the green grass of home. (She communicates through a digital sound device attached to her wrist that translates her paralinguistic cries into American-accented English.) The dangerous return to the jungle is accomplished thanks to the digitized technology of laser weapons and cybercommunications, which prove to be indispensable in the fight against savage tyrants and cannibal gorillas. Although shocked by the Darwinian reality of black Africa, the gentle New Age gorilla decides to give up her Fulbright privileges and diasporic identity. Amy stays

"home," and her devoted companion of many years, the blond professor, after a lachrymose farewell, returns to the sunkissed greenfields of the Berkeley hills.

Although gorilla narratives have been in our midst for several centuries, the traveller in question is quite unusual. Primate tales often revolve around a Western hero/heroine traveller to Africa to rescue a species dying at the indifferent hands of backward Africans. Yet here it is a diasporic gorilla who desires to return. In this 1990s version of *Roots* in reverse, home and identity are defined according to genetic origins clearly linked to geographical spaces. If the homecoming in *Roots* entailed the "saga of an American family," *Congo* reverses the "stolen-from-Africa" narrative. In this futuristic homecoming, laser machines and cybercommunications play a central part in an atavistic, originary discourse whereby diasporas go back to where they came from—for their own good, of course. In the final shot the sophisticated gorilla, shorn of her backpack, cap, and digitized speaking device, is indistinguishable from her noble-savage siblings, rescued from the true savages by the Americans. If *Gorillas in the Mist* ends with the famous quasi-erotic handholding between Sigourney Weaver and the gorilla, *Congo* closes with a separation tale. In this colonial Manichean allegory, the return to geographic origins also entails a new world order of undoing the dangerously hybrid erotic tale.

Pocahontas, screened in the national and global cineplexes, also projected blood purity for the cyberera. In this computerized cautionary tale, Pocahontas stays in her magical land, while Johnny Smith returns to his scientific land— England. Although historically Pocahontas married an Englishman (John Rolfe), learned the English language and European etiquette, and departed with her husband to England, where she later died, this cyberera historical narrative carries on the venerable Euro-American phobia concerning miscegenation. While *Pocahontas* shies away from narrating an actual historical mating of a Native American woman with an Englishman, the implicit allegory of *Congo*, in a twist to Garveyite and Rastafarian ideas of return to Africa, projects a desire to reclaim America as a home shorn of the Africa diaspora.

These contemporary digitized tales call for examining the paradoxical relationship between the new media's transgeographical structures and originary discourses of geographically and biologically defined identities. Like most technological-scientific innova-

tions, cyberspace confronts the cultural critic with a plethora of ambiguities. In a transnational world typified by the global circulation of images and sounds, goods and people, which impact complexly on communal belonging, what do we make out of the new media's promise of shaping *new* identities? Here I hope to delineate the consequences of the new media for the definition of home and homeland in a world undergoing, simultaneously, intense globalization and immense fragmentation, a world where transnational corporations make sure that "we're all connected," but where at the same time borders and passports are under surveillance as a reminder that some have more "connections" than others.

What are some of the political implications of the new media in terms of geographical location, national affiliation, and homeland imaginaries? As I explore the contradictions generated by the new technologies in terms of cyberdiscourse itself, its impact on material struggles over land and labor, its applications for the multiculturalist feminist project, and its import for questions of transnational dislocations, my stance will, perhaps inevitably, be somewhat ambivalent. I will reflect on the metaphorical and metonymic relationships between cybertravel, imperial narratives, national belongings, and diasporic displacements. Throughout, I will perform a delicate balancing act, negotiating between a critique of an ahistorical Eurocentric cyberdiscourse linked to transnational globalization, on one hand, and an examination of some intriguing possibilities opened up for diasporic communities and for feminist transnational multicultural practices, on the other. My emphasis, overall, will move from a qualified pessimism concerning overall structures toward a qualified optimism concerning specific uses of cyberspace. I will be moving from a critique of an overly celebratory and implicitly Eurocentric cyberdiscourse, toward an examination of alternative, diasporic cyberpractices, always calling attention to the dissonances of the national and transnational as mediated by cyberspace.

215

cyberland and the traveling gaze

The contemporary futurist euphoria of cyberdiscourse clearly updates and extrapolates Marshal McLuhan's "global village." The digitized world, within this perspective, will facilitate neighborhoods and cities free of geographic limits on streetwalkers, border-

crossers, and transcontinental *flâneurs*. The migrating homesteader, or "armchair traveler," sits in front of the computer screen but makes gigantic leaps from cybersite to cybersite. But is it really possible to historically detach the facility of movement in cyberspace from the imperial culture of travel? The colonial exhibition and the ethnographic camera had already enabled the secret pleasures of imperial voyeurism. Does cybertravel continue to authorize the pleasures of predatory glimpses of otherized cultures, mapping the globe as a disciplinary space of knowledge? And does the interactivity of cyberspace promise to facilitate such knowledge differently? After all, isn't this how digitized communication defies a unilateral gaze, by allowing for dialogues from in and from multiple sites, diverse in their geography, culture, and politics?

Interactive cyberspace might potentially create democratic zones, but cyberdiscourse remains trapped within an imperial imaginary and corporate Big Brotherism. Behind Net politics one detects a pioneer settler philosophy of self-reliance and direct action. Safety and freedom of mobility in cyberspace are once again relayed in Eurocentric masculinist terms. The same cyberdiscourse that lauds the shrinking world thanks to instant communications, also mobilizes archaic, allochronic discourses about the Stone Age "backwaters" of the globe. Cyberdiscourse is rich in imperial metaphors figuring the early days of cyberspace as the "frontier" or "Wild West." The fledgling early computers were compared to "isolated mountain valleys ruled by programmer-kings" and "savage" computer interfaces, in a "hitherto-unimagined territory opening up for exploration," a "tough territory to travel," given the "Internet's Khyber Passes," and the "dangers of an uncontrolled cyber territory." But the Net, we are told, lacks a "Banana-republic-like center of authority."[1] The exciting brave new world of cybernetics comes to us shaped and textualized, then, by a tired rhetoric of historically suspect metaphors. While cyberspace seems to transcend the gravity of geographic location, the metaphors remain grounded in specific third world sites. The Khyber Pass associated with British colonialism in Asia, stands in for tough and dangerous roads, while banana republics, associated with unpredictable Latin American coups, signify authoritarian takeover. As in imperial literature and film, the cyberfrontier narrative is focalized through the civilized explorer who gradually masters dangers in the terrain of the mysterious, the savage, and the despotic.

The problem with this cyberdiscourse is not only that it deploys imperial tropes and a modernizing narrative of progress historically linked to the dispossession of indigenous peoples, but also that the technologies themselves are embedded in the history of the military staking out of geographical territories and spheres of influence. The politics of the new media, in this sense, are imbricated in the politics of transnational economics. Since cybertravel takes place across open digitized frontiers, for example, it is necessary to erect virtual means to protect acquired "territories" from individual or institutional break-ins into a computer system. Robinson Crusoe's fortress mentality and the frontiers' fenced landscape reappear in connection with protecting military, state, and corporate transnational information. Cyberdiscourse evokes the good-fences-make-good-neighbors ethos, where the fence was seen as the fixed boundary between civilization and savagery; where communities without walls seemed vulnerable to perpetual invasion, while lacking legitimate territorial claims.[2] Thus the intertwined frontier tropes of sanctuary homes and free movement are transplanted into cyberland. Passwords, which open the gates into shared public space and fenced-off "private houses," become the passport to the Web, permitting entry for some voyagers but not for others. Therefore even cyberenthusiasts predict a future of power struggles over cyberspace, network topology, connectivity, and access (though problematically anticipated as substituting for the geographic battles over borders and chunks of territory that have been fought over in the past).[3]

Yet cyberfrontier discourse, like frontier imagination as a whole, implicitly prolongs the literal or metaphorical annihilation of cultures that stood in the way of progress. In his apologia for the new technologies, Lanham, for example, points that the "shift from print to the computer does not mean the end of literacy"; rather, "what will be lost is not literacy itself but the literacy of the print, for electronic technology offers us a new kind of book and new ways to write and read."[4] However, the content that Lanham and others imagine for the new technologies remains explicitly Eurocentric:

> Unlike most humanities discussing technology, I argue an optimistic thesis. I think electronic expression has come not to destroy the Western Arts but to fulfill them. And I think too that the instructional practices

built upon the electronic word will not repudiate the deepest and most fundamental currents of Western education and discourse but redeem them.[5]

In Lanham's figural, biblical language, the "old testament" of the book is fulfilled by the "new testament" of hypertext.

Cybernetic metaphors cannot be seen as merely old language intended to facilitate understanding of the new media, which are complex, nonlinear, and not-geographically bound. Nor is it simply a matter of the inadequacy of linear language superimposed on the multiply interwoven spatiotemporality of a new medium. The same discourse that carries old colonial tropes of voyages of discovery and exploration is also linked to the new world order of late capitalism and transnational arrangements that perpetuate and even exacerbate the unequal distribution of resources, labor and power according to stratifications of gender, race, class, and nation. In this sense the critique of globalization as well as of "scattered" or "dispersed hegemonies" is amply relevant to the material structures of cybertransnationalism.[6]

the end of geography?

Cyber travel metaphors, furthermore, implicitly render physical travel across national borders as obsolete and substitutable. In fact the new cyberworld is eloquently charted by William J. Mitchell:

> Click, click through cyberspace; this is the new architectural promenade.... This will be a city unrooted to any definite spot on the surface of the earth, shaped by connectivity and bandwidth constraints rather than by accessibility and land values, largely asynchronous in its operation, and inhabited by disembodied and fragmented subjects who exist as collections of aliases and agents. Its place will be constructed virtually by software instead of physically from stones and timbers, and they will be connected by logical linkages rather than by doors, passageways, and streets.[7]

It is indeed indisputable that such technology displaces the familiar sorts of geographical neighboring and physical connections that have provided access to the places where people lived, worked, worshiped, and entertained themselves. And when what is at stake is largely libraries, news, music, films, and audiovisual commercial

communication across the globe, all of which can be cybernetically mediated, physical travel does seem to be superfluous. Travel would seem, in this sense, to be an outmoded mobilization of privilege, replaceable by an even more comfortable and privileged mode of travel. However, the "antispatial" and "indeterminate" locations of cyberspace seem to be conflated with the ways in which material geography and history shape complex production, consumption, and usage of technology.

In many recent cybercelebratory writings, cybergeography is imagined virtually as a flight from the gravity of geography. Cyberspace, according to writers such as Mitchell, subverts the idea that "geography is destiny":

> the Net's despatialization of interactions destroys the geocode's key. There is no such thing as a better address, and you cannot attempt to define yourself by being seen in the right places in the right company.[8]

But such narratives of geocode liberation detach cyberusers from their gendered, classed, sexed, raced and nationed locations. (In fact, there are many battles over domain names on the Internet, and some even argue to increase the number of domains in order to accommodate different statuses.) Where cybercombat zones and leisure clubs still exist, where hate groups and "minorities" can both maintain their private cyberspaces as well as interact in the public sphere of the Internet, we cannot speak of total despatialization. Rather than celebrate the destruction of the geocode, I would argue for examining the ways in which the geocode gets to be recodified. The literal and metaphorical spaces of belongings are now carried over into the conflictual cyberzones, while forging intricate relations between cyberspatiotemporality and the material corporeality of its users.

One senses in the contemporary air a desire for a (bearable) lightness of geographical being. A facile declaration of the end of the physical in an era that also celebrates globalization points to a deep connection between such parallel intellectual currents. Having absorbed the postmodern claim of the "end of history," are we now witnessing an "end of geography?" But just as one might ask of a certain postmodernism exactly *whose* history was coming to an end, we may also ask, Whose geography is coming to an end? The portrayal of the complex architecture of cyberspace as a leisure

retreat or corporate energy field raises the question: for whom? Who will be allowed to walk or to jog inside it? And in what ways? In what company? In which material contexts? And for what purposes? What does one then make of this crisscrossing of bits within asymmetrical power relations?

In the Iranian-American film *The Suitors* (Ghasem Ebrahimian 1983) the Iranian woman who emigrates to the United States with her husband (who is murdered by the police, who assume that all Middle Easterners are terrorists), finds herself passportless when, at the end of the film, she tries to escape from her suitors to Europe. She packs herself into a huge suitcase in order to smuggle herself outside the United States, passing through the baggage scanning lasers of JFK. Such images vividly illustrate that access to national passports and geographic location still do matter in the age of transnational globalization and supposedly disembodied and fragmented cybersubjects. While people with access to the new multidirectional media cross oceans with a click, recent immigrants and refugees—such as Chinese, Egyptians, and Mexicans— who attempt to cross by boat, plane, or foot are bound by their homeland passports or by their lack of any passport. Does despatialization mean that the future cybernation will have no place for "Proposition 187"? To put it bluntly, does the virtual voyage mean that immigrants and refugees trying to cross borders would no longer have any reason to do so?

While we become euphoric about the enhanced communications enabled by cybertechnologies, we often forget that the same technologies can be used for repressive purposes. In the context of strict immigration laws and abusive detention centers in places such as New York, New Jersey, Florida, and California, the cyberspace "traveling" of information is clearly used against the travelling bodies of refugees, immigrants, and border crossers. The digital's world's "wireless bodynet," the space of the cyber *flâneur*, is also used against such border-crossers as the "illegal aliens" whose physical bodies are under surveillance by a digitized panopticon. The very same apparatuses that empower Chiapas revolutionaries to communicate with a PCS at the same time allow digital surveillance to keep "infiltrators" from crossing to what was once their own homeland. Euphoric new media texts, giving the futurist sense of worldwide wandering disencumbered of geography and history, in other words, shape what I would call "cybermeta-

physics," where the struggles against racism, anti-Semitism, sexism, homophobia, and classism all seem strangely passé.

from cybermetaphysics to multicultural feminism

Cyberenthusiasts anticipate that territorial borders and physical travel would gradually become meaningless. One gets the impression that the new media will generate new communities where geographical boundedness will be obsolete. Such projections are seductive if not articulated in a historicized fashion. Within such a vision of the cyberfuture, history itself becomes "history," over. That is, "history" in the sense of contested visions of such issues as colonialism and sexuality, becomes a matter of an irrelevant past, rather than something that shapes our perception of contemporary identities, and with even larger implications for the coming cyberyears. One detects in this notion of the end of history a sense of anxiety about contemporary identity politics, and the presumably unacceptable demands made by people of color, women, and gays/lesbians. In a future cyberworld where "nobody knows you are a dog"—that is, nobody knows your real identity— but where anyone can open a homepage—that is create his or her identity— contemporary categories defined by gender, sexuality, race, ethnicity, and nationality are eagerly, and prematurely, dismissed as no longer relevant. In a society negotiating between the so-called contract with America, on the one hand and identity politics on the other, one discerns a desire for a futurist paradise of gender and ethnic tabula rasa(s) interacting fluidly in an infinite oceanic flow of self and community. Such facile color-blind utopias, however, escape the haunting history of the tabula rasa, of whiteness and heteromasculinity, the fact that subject invisibility is historically associated with Anglo-American heteero-masculine privilege.

Futuristic cyberdiscourse implies a transcendence of nationally and regionally bound identities, eroded in favor of new identities shaped by terminal interactions. But there are political traps embedded in the discourse of new identities. To begin with, virtual communication among strangers *is* still grounded in national languages and ethnic identity, since it has to be performed in a globally empowered lingua franca— English. Speakers of languages such as Arabic, Hebrew, or Chinese have to use the Latin script in e-mail, even when they wish to communicate in their own language—a

very difficult task that most adhere to only partially. Arabic speakers on the Net must write English and not Arabic, and even words used in specific dialects— Tunisian, Lebanese, Moroccan— are typed and clicked in Latin script. Even for Middle Easterners, English is the "open sesame" to a thousand and one bytes. To navigate the Net one must be literate in English. My illiterate grandmother, who speaks only the Iraqi dialect of Arabic, even if taught to click, won't be able to communicate unless oral cybercommunications are popularized. (I hope Masouda, who is still in the Middle East, will still be there in the age of oral/image cybercommunications, since she does not trust airplanes.)

Recently I attended a lecture on the new media for educators, offered by some whiz kids, envoys from the cyberfuture. This polished, well-documented performance of the magic available to us somehow did not leave me with a happy feeling of a brave new world. Searching for an example of a nonviable CD-ROM pedagogical project, the whiz kid cited what he called the "ridiculous" idea of translating Chinese literature into Spanish. But only a Eurocentric perspective would find the prospect of translation and communication between one billion or so Chinese-speakers and five hundred million Spanish speakers a laughable idea. This prevailing post-Babel desire for homogeneity in the "world of the future" clearly suggests that non-Anglo subjectivities might not feel completely at home in cyberland. Given such national, racial, class, and gender fissures, I am concerned about the implicit dismissal of multicultural feminist struggle as, so to speak, ancient history.

Within this context, we have to question the prediction that the new media will create new identities. "New Adam" discourses of self-shaping elide the histories of the eliminated. Just as the "discoverers" of "virgin lands" did not create being from nothingness and still carried their Old World cultural baggage, the "new frontier" of virtual voyages, unless challenged, might merely extend a Eurocentric vision of history, geography, and identity. The new media, like all technologies, are embedded in ambient political struggle. Our role as cultural critics, activists, and educators is to prevent the erasure of critical perspectives on history, and to support a polycentric multicultural project of transforming global and local power relations.[9] Cyberhomes in this critical perspective will not be simply castles for Eurocentric thought and transnational

megapower, but part of a continuous terrain of competing discourses, where the battles over resources that rage outside cyberspace continue, even if in a fragmented fashion, inside it as well.

The idea that cyberspace would make everyone "at home in the world," furthermore, has to be articulated in the context of cyber-combat zones and imaginary homes, especially for those communities literally shorn of homes and/or homelands. While computer networks do radically redefine our notions of place, community, and urban life, one cannot separate this fact from the ways in which cybercommunities are entangled in unequal material realities. Cybernetics itself does not transform existing local and global power relations: it extends them into a new space and inflects and shapes them through its diverse formats, even when they are interactive. As with the history of previous technologies, the democratization associated with cyberspace can still be limited to those who are economically, culturally, sexually, and racially at home in the world, a tiny privileged transnational jet-set elite, now cyberized and online. Access to the Net, for example, is not universal and uniform. Apart from the fact that one's access is determined by one's class and national location, it is also determined by goverments who restrict access to it physically (by, for example, creating locally controlled computer centers) institutionally (by locating these centers within specific institutions such as the military, intelligence, or the university), and economically (by driving the cost of linkage and electronic mail so high that only the elites can afford to hook up). As a result of this multifaceted unequal access, the decentering of the new media does not exactly materialize for all sites, nor does it materialize in the same ways for all sites.

Communities invisible in the "old media" have began to relocate their struggles over land and resources to online technologies. Even histories of dispossession gradually find their way to notices on the Net board, where activist exchanges, and even racist and antiracist battles, continue in cyberspace. Thus, in the Americas, as the homeland of diverse indigenous people who became refugees in their own homeland, the new media are used to recuperate the symbolic space of Pindorama, Land of the Condor and Turtle Island. Such virtual spaces come to stand for an imaginary homeland. In this sense the notion of an originary and stable home, encapsulated in phrases such as "home sweet home," "my home,

my castle," and "no place like home," is cybernetically redefined for dispossessed nations not simply as a physical location but as a relational network of dialogic interactions.

Permeating cyber-discourse, colonial metaphors evoke a corporeally violent history and brutal policies toward racialized communities. Such metaphors can also be seen as prefiguring transnationals' digitized expansionism in and outside cyberland. The fact that cybercartography— like the colonial mappings of the Americas— relies on old territorialized metaphors points to an envisioning of a future cyberworld that would still be implicated in transnational powers. Computer corporations such as IBM and Apple create a discourse in their own image. Just as cybercommunications transcend a specific geographic home and a single national homeland, transnationals have long since shaped mobile locations for their digitized production of digital technologies. (In fact many U.S. companies have moved their operations outside the United States to avoid taxes and to profit from the international division of labor.) Cheap labor in places such as Taiwan determines at which site transnationals chose to produce their hardware and software. In this sense trasnationals still reproduce a world where cyberprivileges are constructed not so much on the backs but rather on the fingers and eyes of largely female third world workers.[10]

Although the new technologies were largely developed by and for the military, they have at the same time become the site of activism and grassroots organizing. *Cyber-* in this sense becomes an embattled space for becoming " at home" in the world. Indeed, coming years might witness an ever-growing use of the Net for transnational labor organizing; technologies can thus be hijacked for jujitsu purposes, ones quite different from those initially intended.[11] And if the Net has been used to promote militias and neo-Nazi organizing, it has also been used for antiracist and antihomophobic mobilizations. IBM workers, Chiapas revolutionaries, South African labor organizing, women's antiviolence networking in the United States and human rights groups in Palestine have used the new media for internal and external communication. The Net has helped Palestinian and Israeli Human Rights advocates, for example, to inform the world about abuses by both Israeli and Palestinian authorities, allowing for a certain democratic human rights forum, as well as for fostering a transcommunity feeling of solidarity. When counterhegemonic information still travels across

national, cultural, and political borders, we cannot say that a whole new world is simply transformed; rather a new terrain has been opened for what used to be called *"a luta continua."*

the gravity of history: transnationality and the exiled nation

Clicking on an icon to open a file filled with messages from around the world has provoked celebratory ideas of the new global village. Cyberdiscourse projects a future utopia where there will be no "remote places" where one would feel "far from the center of things," since the digitized future will be decentered. For those who, already since the 1960s and 1970s, have engaged in debates about center and periphery this digitized decentering of fluid spaces should sound like good news. And for those engaged in postcolonial debates on hybrid diasporic identities, it might sound like a relief to imagine a future free of the gravity of geographies of identity. Postcolonial writings on the hybrid and the diasporic have performed a double-edged critique of colonial discourse and of third world nationalism.[12] In nationalist discourses, the tropes of home and homeland were often represented as the site of fixity as opposed to the suspect instability and mobility of the nomadic. And while colonial discourse privileged the figure of the voyager, the explorer, as the dynamic center of the text/discourse who teleologically settles on the range, postcolonial theory has privileged the figure of the traveler, the diasporic, the hybrid, the exile as a destabilizer of fixed centers. Since the very definition of house, home, and homeland requires a boundary, whether that is a fence, a wall, or a border, the metaphors of fluidity in diaspora and postcolonial discourses express the critique of a fixed notion of identity. If the concept of the third world was about generating an intellectual and political home for colonized nations, the postcolonial, I would argue, is about generating a home for displacements in the wake of such decolonization. And while the third worldist discourse suppressed diversity, conflicts, and "minority" perspectives within "the nation" in order to chart a homogenous anticolonial master narrative, the postcolonial has tended to privilege diasporic, migrant, nomadic identities, where access to power among those wandering, and their relation to their nationstate of origin and destination, have been obscured.

Cyberspace's nonlinear stream seems to make a good analogue

for the poststructuralist sense of the fluid slippages of identity. And the cyberwritings' emphasis on decentering seems to overlap with a certain postcolonial imaging of fluid dwellings and moving home-lands, where no home is presumably central or marginal. It might even seem as though diasporas (demographically decentered by definition), peripheralized nation-states, and marginalized com-munities would all have a natural affinity and concrete interest in the new media. This enthusiasm for the cyberdream, I have tried to argue, must be accompanied by a number of caveats. But it is still worth contemplating the potentialities of cyberspace. Despite the political ambiguities of the new technologies, they open up intrigu-ing transnational possibilities for multicultural feminist practices as well as for the agency of displaced communities.

Cybertransnationalism on one level would seem to transcend some of the pitfalls of nationalism, especially for those minority communities displaced in the wake of postcolonial and colonial partitions. In the cyberfuture feeling at home in the world might mean that digital technologies will exist in the service of currently marginalized communities. In a virtual world of communication where sound, image, and text can synchronously cross distances in less than a second, upper-middle-class diasporic communities split by circumstances might be able to perform a ritualistic get-together at the computer dinner table or in the computer livingroom or diwan. One can even imagine a digital linking of displaced commu-nities of migrating computer bits through global networks, where the new media allow for new virtual communities of people whose sense of national and geographical homeland is fragmented and fractured. The new media can become the imperfect means by which dislocated people who lost their geographic home retain their home imaginary, while also struggling for a literal and metaphorical place in new countries such as the United States and Britain, whose foreign policies have concretely affected their lives. Each interaction, however, is layered by a distance at once temporal and spatial, each situated, produced, and received in precise histori-cal and geographical circumstances. Although cyberspace's multi-sitedness would seem to favor a dispersed existence, such communities are not suddenly extracted out of geography and his-tory. Digitally mediated environments, with their information highways and *infobahns*, furthermore, do not necessarily shed the narrative of searching for a national home, in both its liberatory

and repressive senses. Cyberspace, in fact, can permit a new mode of fetishizing "our" lost homeland. Yet even in this act of logging in nostalgia for ancestral homes, virtual communities reshape and alter the diasporic subjects. Thus interactive networks of links, cementing dispersed communities, also enact a virtual performance of what constitutes the nation.

Cyberspace allows for diverse forms of diasporic linking and interacting: temporal links that bring together the clashing historical perspectives of contesting communities, spatial and geographical links between different parts of the world. In this way downloaded images, sounds, and texts enable critical communities to pass on their perspective, and identifications, and their affiliations. Interactive media disperse the hegemony of nation-states through virtual proximity, enabling exilic communities to share, teach, and inform beyond the often unbearable familial devastations. Whereas cyberspace allows for the creation of interactive communities of strangers, it can also empower the diasporized to overcome the estrangement of displacement. The digital undermining of territoriality can thus operate simultaneously with the virtual reterritorialization of immigrants and refugees.[13] This is not to suggest that such virtual transnational gatherings of the "nation" are necessarily oppositional. It is rather to say that such virtual spaces can become, in specific contexts, important for critical practices.

The implicit promise that terminal identities will eventually transcend geographies of national identity raises interesting questions for displaced and diasporic communities whose very existence already transcends the boundaries of the nation state. The case of Gawat Izzawi—Izzawi's Cyber Cafe—of which I am a member, illustrates some of the political issues at stake. An exilic e-mail community from Iraq, the original site of the Babylon of this title, is composed of strangers of Iraqi origins who met largely through notices on the Net board. "Gawat Izzawi" refers to an actual popular café in Baghdad, about which many popular songs were written. The electronic-mail café name functions as a chronotope, expressing nostalgia for both a place and a period, since Iraqis from diverse religious backgrounds and ethnic communities used to socialize in the physical Gawat Izzawi. Exilic nostalgia is freely exercised in the "private" public space of the electronic Gawat Izzawi, a community of intimate strangers.[14] Gawatt Izzawi points to the cyberintimacy

of people who have never met but who have developed an Arablish language (Arabic and English) and a set of references that draw on Iraq, the Arab world, and the traces of their dislocations. Baghdad of the historical Gawat Izzawi is an emotional site for all of us who became refugees and exiles. This evocation of a multicultural past extends into cyberspace a certain reading of Baghdad as multicultural, in a doubly temporal desire for both a lost past and a hopeful future. Multicultural Iraq, prior to its multiple exoduses over the past fifty years, included Sunnis, Shiites, Jews, Assyrians, Assyrian Christians, Caldian Christians, Kurds, Turkomani, and Persians, with diverse dialects and languages, ethnicities, religions, and political affiliations. But that multicultural fact was never transformed into a multicultural *project*; it was always threatened by the ideology of the "Nation" as embodied by Sunni Muslim hegemony.[15]

The nation-state ejected its Iraqi Jews several years after the partition of Palestine and the establishment of the State of Israel, while the Kurds in the north remain stateless, and the Shiites in the south oppressed. A kind of "return to the future," where history reconfigures a desired future, was evoked when one of the members e-mailed me: "Ahlan Habiba [Welcome Habiba], looking forward to sharing with you a piece of Iraq that was lost."[16] Not coincidentally, she also wrote that she was Assyrian, one of the Christian minorities in Iraq—where Babylonian Jews and Assyrians predated the Arab conquest of Mesopotamia, but who over the centuries became Arabized. My family and community were exiled by the erection of two mutually exclusive national narratives: Jewish and Arab, which on both ends allowed no room for Arab-Jews, that is those Jews who were Arab in language and culture but Jewish in religion. In other words, the Arab national narrative became difficult for Arab-Jews, especially since Arab nationalism reproduced the Zionist master narrative of "Arab" versus "Jew."

Within the context of postcolonial displacements, nation-based cyberspaces fill in a certain vaccum within the dominant old media. The experiences of marginalized communities can be narrated despite their invisibility and lack of access to transnational storytellers such as CNN, the Associated Press, Reuters, ABC, BBC, and Hollywood. The new media allow for multisited clashing perspectives to combat and convince. Middle Easterners and North Africans in the United States have used the Net to put themselves on the cybermap.[17] At this historical conjuncture, watching televi-

sion and surfing the Net give totally different impressions of the "American" environment we live in. In the case of Middle Easterners, their media invisibility in the United States is challenged by their presence on the Net. The Net in this sense challenges the otherizing of Middle Eastern and North African cultures as something that presumably belongs *only* "over there," thus challenging the exclusion of these communities from the U.S. multicultural debate.

The desire for a multicultural Iraqi nation is chaneled through cyberspace, which in this sense provides an imaginary home. For Arab-Jews, abruptly disconnected from the Arab world, relocation to the United States, Brazil, Canada, and Europe requires a medium whereby such dialogic interactions can be enabled and revitalized. The Net intensifies this process, mediating between diverse regional communities that otherwise wouldn't meet because of both physical and ideological borders. Therefore, Iraqis, Iranians, Moroccans, and Egyptians who grew up in Israel and never had the possibility of meeting the peoples inhabiting their countries of origin now engage via the Net. If the postmodern Babylon of the Iraqi diaspora throughout Amman, London, New York, Chicago, Ramat Gan, Toronto, Paris, and Berlin is sometimes traceable on the Net, Iraqis in Iraq itself are largely absent.[18] "All you need," the promotional brochures inform us, is "access to a computer." That is exactly why such communication is not allowed in a dictatorship such as Iraq, while Iraqis in the diaspora, some of them victims of the Gulf War's digitized warfare, do maintain a sense of community, thanks to electronic mail, and "run into" people from their own community on the Internet. For the millions of displaced Iraqis, cybertravel across national borders becomes a travel of recuperation and reconfigurations as well. Religious and ethnic "minorities" have had to play the role of historical narrators, telling of massacres and violence, rewriting the official national Iraqi history. Virtual travel in cyberspace, where personal identities might be masked but where ethnic, religious, and gender identities are revealed, create dialogical networks for people, even if they come from the opposite ends of the political spectrum of the nation. In fact, the very act of computer communication for exilic Iraqis is an act of imagining a democratic home, since PCs are not permitted in Iraq. (If you try to e-mail Baghdad, you can be sure that you have reached the Ba'ath party and that the Muhabarat—

security services—are watching.) The nostalgia associated with exile and diaspora is dialogically reshaped through explicit and implicit contestation of who and what constitute the nation. In the case of women, in particular, virtual cafés or clubs permit a partially disembodied dialogue, subverting a masculinist history where women—with the exception of dancers, singers, and prostitutes—were formerly not welcome in the café, their bodies seen as transgressive of male public space. That many female members of the Iraqi cybercafé ended up developing parallel channels of communications alongside the official one only testifies to the ways the "nation" is contested and reinvented within the transnational cyberspace.

Since cyberspace can maintain a long-distance sense of community or, better, of overlapping interactive communities, current nationalist and ethnic pressures of committing oneself to one or two geographies of identity are challenged by a quintessentially postmodern technology. The increasingly popular usage of e-mail and the Net already allows geographically dispersed communities to interact beyond the literal and metaphorical boundaries of nation-states. Such communications, especially for exilic communities, produce a simultaneous rejection of the "nation" while also forging a kind of a cyberhomeland shaped by and from the palimpsest of geographical, national, and transnational dialogics. Cyberspace can potentially facilitate a discussion of community identities—not in isolation, but in relation. Cyberspace in this sense is a negotiated site of multiple community positionings within diverse temporalities. Each positioning of communities in relation generates a different sense of affiliation. Like diasporic deterritorialization's crucial role in shifting and redefining hybrid identities in diverse contexts, cyberspace becomes a process where, without physical travel, communities might experience the liminal borders of their subjectivity. The very nature of cyberspace, in a sense, forces a rearticulation of the idea of homeland, as subject constructions become multiple with overlapping and contradictory identifications and affiliations.

* * *

I have tried here to communicate a sense of both the possibilities and the limitations of the new media technologies, displaying a

kind of optimism of the local in terms of the uses to which these technologies can be put, and a pessimism of the global in terms of larger overriding structures. The new media, I have tried to suggest, have significant implications for charting diasporic movements across national borders, and perhaps for envisioning a creative navigation of diverse cultures and historical points of view, and of conflictual claims to homes.

notes

1. "There are few *Khyber Passes on the* Internet. . .and there is no effective way to gain control of it. Unlike *Banana Republics*, it does not have a clear center of authority to take over in a coup. The *uncontrolled territory* has its dangers." (William J. Mitchell, *City of Bits: Space, Place and the Infobahn*, Cambridge, Mass.: MIT Press, 1995, p. 150) (Emphasis, ES).

 "The early days of cyberspace were like those of the *Western frontiers*. Parallel, breakneck development of the Internet and of consumer computing devices and software quickly created an astonishing new condition; a vast, *hitherto-unimagined territory began to open up for exploration.* Early computers had been like *isolated mountain valleys* ruled by programmer-*kings*; the archaic digital world was a far-flung range in which narrow, unreliable trail provided only tenuous connections. . . .An occasional floppy disk would migrate from one to the other, *bringing the makings of colonies*. . .Cyberspace is still *tough territory to travel*. . ." (Mitchell, 109–110, in a section entitled "*Wild West/Electronic Frontier*) (Emphasis, ES)

 "Cyberspace is a *frontier region*, populated by few hardy technologies who can tolerate the austerity of its *savage* computer interfaces. . .the general lack of useful maps or metaphors" (Mitch Kapor and John Perry Barlow, in "*Across the Electronic Frontier*," Electronic Frontier Foundation Washington D.C., July 10, 1990) (emphasis, ES)

2. But in other instances fences can be a witness to dispossession: the sabra-cactus plant, whose Arabic etymolgy (s.b.r) means patience, were originally planted to mark borders, and they remained, even after the Euro-Israeli settling of the destroyed villages, as a reminder of an absence.

3. Mitchell, 151

4. Richard A. Lanham, 1993, *The Electronic Word: Democracy, Technology and the Arts.* Chicago: The University of Chicago Press. x.

5. Lanham, p. XIII

6. "Scattered hegemonies" is Inderpal Grewal and Caren Kaplan's, see their edited *Scattered Hegemonies: Postmodernity and Transnational Feminist Politics* (Minneapolis: The University of Minessota Press, 1994); "dispersed hegemonies" is Arjun Appadurai's, see "Disjunction and Difference in the Global Cultural Economy," *Publica Culture* 2, 2 (spring 1990)."

7. Mitchell, p. 24.

8. Mitchell, p. 10

9. On polycentric multiulturalism, see Ella Shohat and Robert Stam, *Unthinking Eurocentrism: Multiculturalism and the Media* (New York: Routledge, 1994)

10. It is not only imperial ideologies that travel in cyberspace. The transnational shipment of hardware and software allows corporations to dump old technologies on the third world and on minoritarian communities in the first world. New technologies are celebrated also for minimizing "travel" to work. Although certain types of office jobs and business can be performed from anywhere via cyberspace, other jobs still require a delimited physical location. While the garment industry uses cybercommunication to save time and money, the Chinese and Chicana workers in the sweatshops labor on the assembly line.

11. See Teresa Carillo, "Cross-Border Talk: Transnational Perspectives on Labor, Race and Sexuality," forthcoming in Ella Shohat, ed., *Talking Visions: Multicultural Feminism in a Transnational Age* (Cambridge, Mass.: MIT and the New Museum, 1997)

12. In this sense the "postcolonial" is actually a post-third worldist critique, moving beyond the ideology and third worldism, rather than colonialism. On my critique of the "postcolonial," see my "Notes on the Postcolonial" *Social Text* 31/32 (spring 1992) and "Post Third Worldist Culture: Gender, Nation and the Cinema" in Jacqui Alexander and Chandra Talpade Mohanty, eds., *Feminist Genealogies, Colonial Legacies, Democratic Futures* (New York: Routledge, 1997).

13. For a complex analysis of "de/territorialization in contemporary intellectual thought, see Caren Kaplan, *Questions of Travel: Postmodern Discourse of Displacement* (Durham, NC: Duke University Press, 1995).

14. For an elaborate discussion of exilic nostalgia, see Hamid Naficy, *The Making of Exile Cultures: Iranian Television in Los Angeles* (Minneapolis: University of Minnesota Press, 1993).

15. On the distinction between the multicultural fact and the multicultural political project see Shohat and Stam, *Unthinking Eurocentrism*.

16. Habiba is my Arabic name, that was not officially registered on my Israeli ID card because of fears of antagonism and racism from Euro-Israel. See my "Sephardim in Israel: Zionism from the Standpoint of Its Jewish Victims," *Social Text* 19/20 (fall 1998)

17. Despite the growing numbers of immigrants, refugees, and exiles from the Middle East/North Africa in the United States, Middle Easterners tend to be absent from the public sphere even in debates on "ethnic identities." Although this presence dates back to the late nineteenth century, the waves of immigration from the Middle East have been rendered invisible, while more recent ones are often associated with terrorist infiltrations.

18. In a country where communications are government-controlled, access to computers is out of the question, especially in a post–Gulf War Iraq, where food and medicine are rare commodities. Given the difficulty of establishing communication with Iraq, and given the American media invisibility of Arab culture, e-mail information becomes even more precious.

notes on

contributors

Homi K. Bhabha is Chester D. Tripp Professor of the Humanities at the University of Chicago, and visiting professor at University College, London. His publications include *Nation and Narration* (edited with introduction, Routledge, 1990) and *The Location of Culture* (Routledge, 1994).

Thomas Elsaesser is professor at the University of Amsterdam and chair of the Department of Film and TV Studies. From 1972 to 1991 he taught English, film, and comparative literature at the University of East Anglia (England). His essays on film theory, history, genre, and national cinema have appeared in over a hundred collections and anthologies. Books as author and editor include *New German Cinema: A History* (1989), *Early Cinema: Space Frame Narrative* (1990), *Writing for the Medium: Television in Transition* (1994), *Double Trouble* (1994), *Hoogste Tijd voor en speelfilm* (1995), *A Second Life: German Cinema's First Decades* (1996) and *Fassbinder's Germany* (1996).

Rosa Linda Fregoso is an associate professor of Women's Studies at University of California, Davis. She is the author of *The Bronze Screen: Chicana and Chicano Film Culture* (University of Minnesota Press, 1993), and writes on cinema, culture, and feminism.

Teshome H. Gabriel teaches film studies at the University of California, Los Angeles. His books include *Third Cinema in the Third World: The Aesthetics of Liberation* (UMI, 1982) and *Otherness and the Media: The Ethnography of the Imagined and the* Imaged, co-edited with Hamid Naficy (Harwood Academic Press, 1993). He has written extensively on third world cinema, third cinema, and nomadic cinema and is currently preparing a collection of his essays for publication. His latest essay (with Fabian Wagmister) is "Weaving Digital: Computers Third World Style," *Suitcase* 2, 1 (1997).

George Lipsitz is professor of ethnic studies at the University of California, San Diego. His Publications include *Dangerous Crossroads* (Verso, 1994), *Time Passages* (Minnesota University Press, 1990), *The Struggle* (Temple University Press, 1995), *The Sidewalks of St. Louis* (University of Missouri Press, 1991), and *Rainbow at Midnight* (University of Illinois Press, 1994).

David Morley is Professor of Communications, Goldsmiths College, University of London. He is the author of *Television, Audiences and Cultural Studies* (Routledge, 1992) and coauthor (with Kevin Robins)of *Spaces of Identity* (Routledge, 1996).

Margaret Morse is an associate professor of film, video, and new media at the University of California, Santa Cruz. She has published widely on subjects ranging from aerobics, art, food, and freeway driving to news, sports and the z-axis. Her book *Virtualities: Television, Media Art and Cyberculture* is published by Indiana University Press (1998).

Hamid Naficy teaches film and media studies in the Department of Art and Art History, Rice University. He has published extensively on exilic cultures and media and on non-Western cinema, including Iranian cinema. Among his latest books are: *The Making of Exile Cultures: Iranian Television in Los Angeles* (University of Minnesota Press, 1993), *Otherness and the Media: The Ethnography' of the Imagined and the Imaged,* coedited with Teshome Gabriel (Harwood Academic Press, 1993), and *Making Films with an Accent: Diaspora and Exilic Cinema* (Princeton University Press, forthcoming).

John Durham Peters is associate professor in the Department of Communication Studies at the University of Iowa. His most recent essays are in *Musical Quarterly, Javnost—The Public, Public Culture, Critical Studies in Mass Communication.* His research interests include the intellectual history of media.

Patricia Seed teaches history and postcolonial theory at Rice University in Houston. Her recent books include *To Love, Honor, and Obey in Colonial Mexico* (Stanford University Press, 1988), *Ceremonies of Possession in Europe's Conquest of the New World* (Cambridge University Press, 1995), and *Colonial Pentimento: The Pursuit of Riches and the Invention of Indians* (in press).

234

Ella Shohat is professor of women's studies and cultural studies at the City University of New York. She is the author of *Israeli Cinema: East/West and the Politics of Representation* (University of Texas Press, 1989) and the coauthor (with Robert Stam) of the award-winning *Unthinking Eurocentrism: Multiculturalism and the Media* (Routledge, 1994). She is coeditor of *Dangerous Liaisons: Gender, Nation and Postcolonial Perspectives* (University of Minnesota Press, 1997) and editor of *Talking Visions: Multicultural*

Feminism in a Transnational Age (The New Museum and MIT Press, forthcoming).

Vivian Sobchack is associate dean and professor of critical studies at the UCLA School of Theater, Film, and Television. Her books include *Screening Space: The American Science. Fiction Film* (Rutgers University Press, 1997), *The Address of the Eye: A Phenomenology of Film Experience* (Princeton University Press, 1993), an edited anthology, *The Persistence of History: Cinema, Television and the Modern Event* (Routledge, 1996), and a collection of her own essays, forthcoming from University of California Press, *Thoughts: Bodies, Texts, Scenes and Screens.*

index

index